# NUEVO MUNDO

## Latin American Street Art

Maximiliano Ruiz

gestalten

# N

−−−−−−−− uevo Mundo—which means New
World—was the name Spanish colonizers gave
the American continent upon its discovery in
the fifteenth century. It was a land that was
incorporated into the Known World bringing
with it new and unknown things.

−−− It represented a whole new realm of things
that had never before been seen, heard, spoken, or
even imagined—"new" as synonymous with fresh
and also mysterious; "new" as the possibility to
change cultures and ideas.

−−− This New World, which was once discovered
and conquered by modern civilization, has since
struggled between the negative and positive aspects
of a symbiotic relationship with the Old World,
creating a reference for the rest of the world through
its culture and art—a New World where those who
once were conquered are the conquerors of today.

**L**———————atin America can almost be regarded as a continent in itself, or perhaps as a large island made up of different countries that mainly share the same language and indigenous local and African cultural heritage, as well as the sorrow brought on by military dictatorships, social marginalization, and economic instability.

——— Surprisingly to many, Latin American countries have always known how to look beyond all the misfortunes they have suffered. In different periods, the people of this region have managed—and still manage today—to create a strong artistic identity, even during difficult times. Indeed, one could say that adversity has become the basis of Latin American identity.

——— Military dictatorships have played an important role in Latin American history. They obliged society to follow schematic, predetermined ways of life, preventing the development of local Latin American art scenes. Paradoxically, and also unexpectedly, the dictatorships' strong repression also indirectly inspired the search for new forms of clandestine expression with the streets as their backdrop.

——— Street painting then became a subtle but unerring weapon of free expression for the Latin American people. Groups found a way to rebel with these urban interventions. Risking their own lives, these painters opposed the dictatorships with confrontational messages of freedom.

——— An underdeveloped local art scene was then quickly offset by a period of high development. With new democratic governments, and due to the immense need of the people to speak freely and to develop their own culture, street art increasingly became more visible throughout the streets and on the walls of every Latin American city.

**S**———————treet art has always been a very important weapon in every social and political event or revolution in Latin America, either as a tool to reclaim an urban culture or tribe, or as a strong and powerful means for airing political and social grievances. The ability to record a concrete and explicit message cheaply and quickly allowed various groups from different social spheres to have a tool at hand with which to go out into the streets to voice what many think but few dare to express.

——— Latin American streets are decorated with messages ranging from politics and religion to poems and declarations of love, the words of football fans or advertisements for houses and apartments for sale or rent, and even notices of job openings. Even the politicians who loudly advocate cities clean and free from these "terrible and illegal" visual invasions are those covering the cities with their own political graffiti, the quantity and size of which cannot be matched by any street artist.

——— Although Latin American countries share laws that hold street art to be illegal, repression

and punishment for this crime is, in fact, rare. Not least because both governments and police forces have far more important issues to which to devote their attention than groups of young people who paint in the streets.

– – – It is even common to see Latin American street artists working in the most exposed locations, next to governmental buildings or police stations in broad daylight without receiving a fine or getting into trouble for it. However, if the police receive an isolated complaint or allegation, they generally ask the artist to stop painting or in the worst case, and depending on the police in question, the artists will know how to come to an "agreement" in order to continue painting there. Still, there is no shortage of exceptions in which artists are detained or the police ask them to paint their houses.

– – – Another very popular artistic trend in Latin America is the mural. Great and renowned artists emerged in the late 1970s and 1980s with their various styles–abstract, baroque, and even cubist– almost always with reference to local social issues or commemorating local cultural figureheads of the past and revolutionaries.

O– – – – – – – ver time, once democracy was restored, these young Latin American cities full of cultural potential began showing the first signs of graffiti as an urban artistic intervention that had already covered cities in the United States and Europe. Little by little, graffiti began to take its first steps through Latin America, mainly due to young immigrants returning to their home countries after living in big cities like New York, Paris, or London, and bringing with them all they knew about graffiti.

– – – Given the scarcity of specialized graffiti documentation, all graffiti production was based on the words of those who "knew something about it", or from close inspection of photographs or magazines where you could see some graffiti in the distant background. Thus, young graffiti artists made do with what they had.

– – – The first solid wave of graffiti in Latin America began in the 1980s, when spray paint was a luxury and what little there was didn't cover the walls well, but instead dripped all over then. Creativity and the ability to improvise abounded in artists who painted with any sort of material, including pitch and chalk.

– – – Graffiti is a rich and varied art form that owes its evolution to a constant search for the unique and personal style of each artist. It is through this journey that all kinds of artists look for new paths and options, leading them to gradually find new forms of urban intervention without having to commit to graffiti or painting with spray paint, perhaps because they always had to find more accessible materials. This expanded and enlarged the available range of urban intervention methods.

– – – The streets suffice and young Latin street artists have plenty of creativity and desire for fun. Thus, by experimenting and searching for new means, artists use stencils, brushes, rollers

with extenders, fire extinguishers filled with paint, markers, as well as all kinds of homemade devices. They draw, cut, and paste papers on the streets, make stickers in their makeshift workshops, then put together everything that comes to their minds to place their wonderful work on the streets. The possibilities are endless because with illegal activity there are no rules.

– – – This ever-surprising range of possibilities that comprises street art means that it can never really be defined, limited, or classified. Anything goes. Even the artists themselves often don't want to define themselves as street artists. The means or technique is entertaining, but what matters most is the end in itself. The important thing is not the artist, but the intervention.

W

– – – – – – – – – ith an area of 21,069,501 km², a predominantly warm and pleasant climate, and four of the ten largest cities in the world, Latin America is presented as the promised land of Street Art. The number of large walls available in Latin American streets is simply infinite.

– – – However, artists often work on neglected or abandoned walls on the brink of collapse, so the interventions they carry out help give life not only to the walls but also to the landscape of the city itself. People don't object to street art. Instead, they appreciate and enjoy it when they see it. In

fact, their gratitude has been the main incentive for artists to gain momentum and put more effort into their work. There have been more than a few occasions when Latin American artists began a small piece of work and ended up painting the whole wall on the insistence of the neighbors. They often even lend them ladders to paint with or invite them for a meal. This loving acceptance and social support acts as an important trigger for the rapid growth and evolution of the local art scene.

– – – However, not all forms of street art are equally appreciated. "Pixaçao" for example, a form of tagging native to Brazil, consisting of large hand painted letters and made by hundreds of gangs, has covered countless buildings, walls, and cities and is considered by many Brazilians to be a virus or disease that destroys the image of their country. The opposite is the case in city of Valparaíso in Chile. Today it is considered a mecca of urban intervention, where absolutely all the streets and many houses are covered in art, which has, in fact, helped promote tourism.

– – – Talking about street art in Latin America as something that beautifies cities instead of spoiling them may seem strange. But a lack of resources means that many Latin American cities feel improved by street art, while cities in the developed world might feel that the same intervention ruins them. It is also true that street art in Latin America has less of a character of vandalism than it does in the United States and Europe.

– – – Over time Latin American cities gained international renown as cities that are easy to paint in, where people do not bother street artists, and authorities do not seem to be a problem. Latin America has thus become the favorite destination

*of street artists around the world. They are also encouraged by the fellowship that abounds among all Latin American artists, far from the stereotypical old rivalries of graffiti crews. Even devoted vandals travel from across the world to paint the trains of Latin America.*

T

*—————— he street art scene in Latin America is striking in terms of its youth and its rapid growth and consolidation. Despite being around for only half as long as other street art scenes around the world, today Latin American street art stands out and has more than caught up with all of its predecessors.*

*——— At the same time, the artists' large indigenous and folk influences also form one of their most important ingredients. The incorporation of different cultures into their art—be it through the use of icons, traditions, dances, and costumes or indigenous painting styles and various techniques of prints and graphics—is unique in the artists' creation of cultural identity. The occasional lack of tools and socio-historic or economic limitations are part of the art's DNA. Latin American street art shows how much can be done with very little.*

*——— This creative identity cannot be classified easily in an artistic sense but can be seen in the way the artists use the streets as a source of unlimited ideas and inventions that speak from*

*a shared Latin American reality. It is a unique identity that has meanwhile traveled from the New World to other continents in the hands of the artists themselves.*

*——— "Nuevo Mundo: Latin American Street Art" is envisaged as the first documentation of the creativity and capacity of Latin American street artists. For this purpose, the most representative and varied artists from the Latin American scene have been selected so that they may describe their art in their own works and words.*

**Maximiliano Ruiz** ——————————————

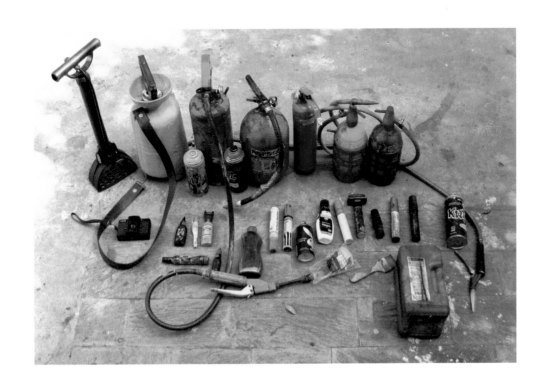

· Alexandre Orión ·

· B-47 ·

· Cripta Djan ·

· Dalata ·

· Dedablio ·

· Emol ·

· Ethos ·

· Fefe Talavera ·

· Firme & Forte Records ·

· Flip ·

· Medo ·

· Nove ·

· Onesto ·

· Os Gêmeos ·

· Piá ·

· Ramon Martins ·

· Raul Zito ·

· Rodrigo Level ·

· Selon ·

· Smael ·

· Thiago Alvim ·

· Titi Freak ·

· Treco ·

· Vitché ·

· Yusk ·

· Zezão ·

· 6emeia ·

# BRAZIL

I

––––– n the mid-1970s during the military dictatorship you could already see some graffiti from artists like John Howard and Alex Vallauri in the streets of São Paulo. Legend has it that John Howard was basically the first to intervene in the streets of São Paulo, forever pursued by the dictatorship of the time as he painted on utility poles. His work was very personal and distinctive, he painted these heads you could see all over the city. Even today as a 70-year-old, he still goes out with his colors to paint on the street. Alex Vallauri used stencil as his technique and his most famous figure was a black boot. Along with John Howard he was one of the first artists to intervene in the streets of Brazil.

––– The first generation of graffiti artists in São Paulo showed how to use the city in different ways. Each artist had their own image like a registered trademark—Rui Amaral, the Tupynãodá group, Carlos Delfino, Celso Gythay, Zé, Carratú, among others—formed part of the first national school of graffiti, and many since then have painted in the full light of day.

––– *In the mid-1980s with the arrival of the hip hop movement in Brazil the second generation of graffiti artists began to form. The influence of hip hop and movies like* **Beat Street, Style Wars, Wild Style** *and* **Breaking,** *led to the emergence of artists like Os Gêmeos, Vitché, Binho, Speto, Tinho, Guerra de Cores, Rooney, Def Kid, Zelão, Bad, Robo...*

––– *It was during this time that so-called 'Graffiti Hip Hop' was born, where we'd write our names and the names of our crews in graffiti letters accompanied by characters that were often created and also copied from comics and cartoons. It was a period of discovery. With the small amount of information we had we improvised a way of painting, new both in style and technique.*

––– *Every Saturday at about two in the afternoon in the São Bento metro station in São Paulo, b-boys, b-girls, rappers, DJs, and graffiti artists got together to practice, observe, learn, and exchange information with each other. Around 1986-87 we decided to begin painting the streets by day. We began in our own neighborhood of Camuci and shortly afterwards we painted some key spots in the city.*

––– *At this time everything was so new to us as well as to the police, it was a period of continuous discovery. In 1994 the local scene was shaken by Barry McGee a.k.a. Twist in São Paulo, an artist from San Francisco who was super active on the graffiti scene and respected in the contemporary art world. Then in 1996 Raven and Sonik did an article for the American graffiti magazine* 12 oz Prophet *about our work and the Brazilian scene, which awakened international curiosity about what was happening here. It was at the end of the 1990s that artists like Loomit, Chintz, Zak (Germany), Doze Green, Daze (U.S.), among others began to visit us and it ended up as an exchange of styles and techniques. What the foreign artists most loved was the way we did our graffiti in the plain light of day, right in front of the police and always with this Brazilian knack for avoiding jail. These days the scene is broad and varied; it's no longer linked to hip hop.*

––– *We think the fact that there are much bigger problems than fighting graffiti in Brazil leads to lots of people using the streets as a way of recovering something and expressing themselves, to escape from chaos. It is within this street art resistance that groups emerged who paint trains, subways or streets like VLOK, 163GANG, PV, TOTAL, DST, PIF, TSC, among others.*

––– *One of the characteristics of Latin American graffiti is the fact that we use latex paint to fill in and spray paint to make the borders; it's a cheap and efficient technique. Especially in São Paulo some artists always use the same color to give themselves a unique stylistic identity.*

**Os Gêmeos** – – – – – – – – – – – – – – – – –

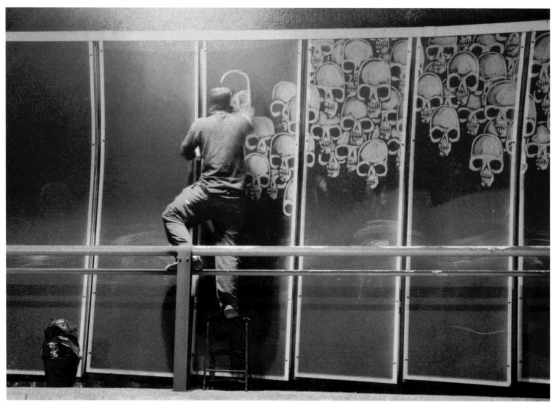

*São Paulo, Brazil · 2006*

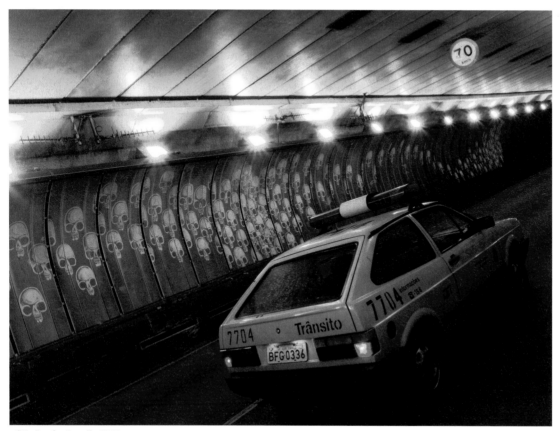

*São Paulo, Brazil · 2009*

# ALEXANDRE ORIÓN

*—————————————————————————————— I grew up next to*
*a very busy street in the city of São Paulo. I saw people in constant movement*
*during the day and slept to the sound of cars at night. These days,*
*I try to play with the limits of urban space and the consequences of human*
*interaction. I try to make my art an inseparable extension of the city to*
*provoke people to rethink the everyday. –––*

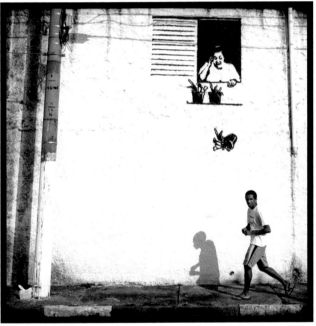

*São Paulo, Brazil · 2004*

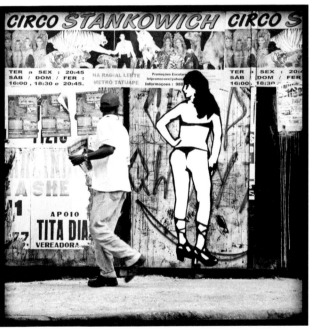

*São Paulo, Brazil · 2004*

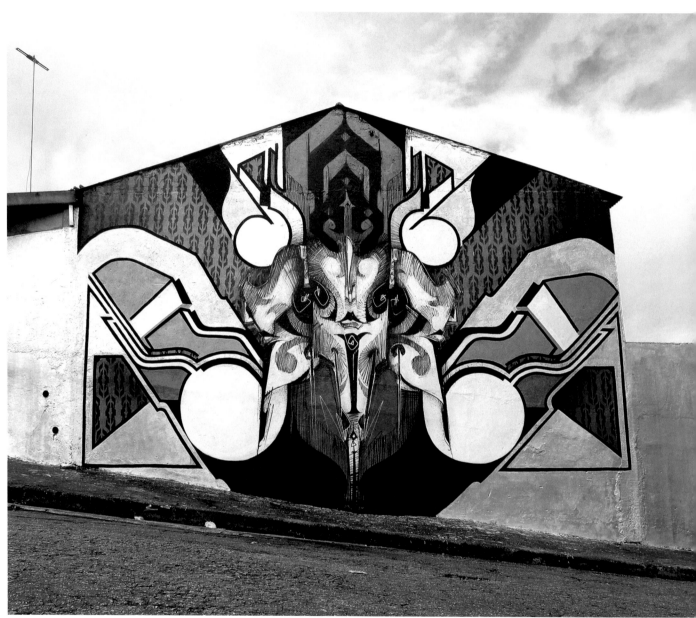

*São Paulo, Brazil · 2010*

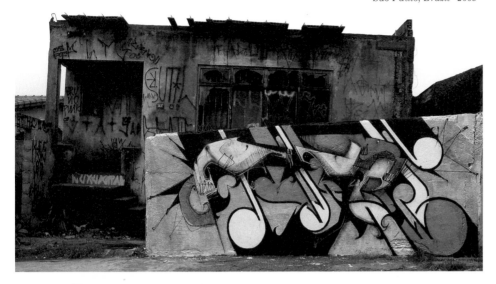

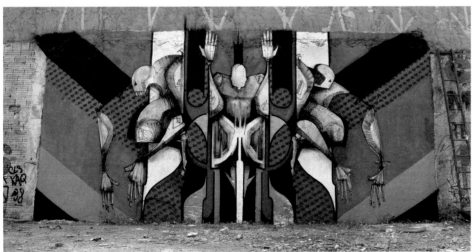

*São Paulo, Brazil · 2010*

# B-47

– – – – – – – – *We—DME and FRG—began with graffiti in the late 1990s and since then we have been working together, although we also work on individual projects. In 2005 we created B-47, inspired by the name of the bus line that covers our region of Santo André, São Paulo. Our collective proposal is to unite our individual styles to make a unique and integrated composition. – – –*

São Paulo, Brazil · 2009

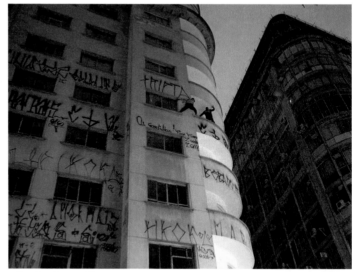

São Paulo, Brazil · 2009

# CRIPTA DJAN

—————————————————————————— *I am Djan Ivson, and I have been part of the Cripta gang since 1997 I began to do pixação in 1996 when I was 12 years old. Pixação is a street movement created in the late 1980s that has since snowballed through all of São Paulo. One of the fundamental objectives of pixação is the battle for space in the city's landscape—walls, doors, viaducts, and buildings are the primary targets. ———*

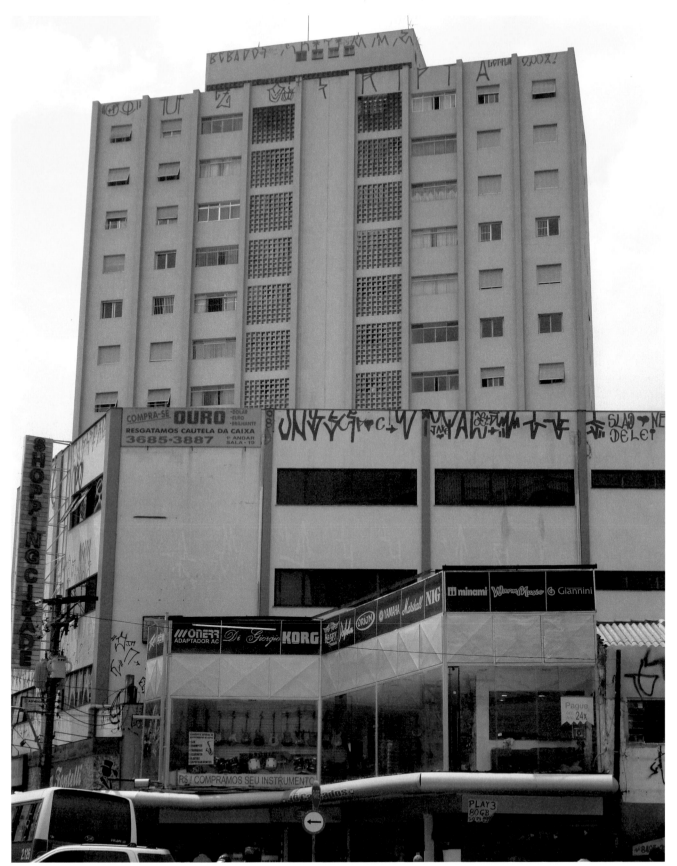

*São Paulo, Brazil · 2009*

# DALATA

*—————————— I've been on the graffiti scene since 1997, working with abstract art and surrealism using a mix of different techniques. I believe in a positive universe, rethinking life in a different place, creating scenes and characters from a ludicrous planet, in a play on thinking forms that I call bizarre and exciting. I explore beat-up surfaces that fight against nature. ———*

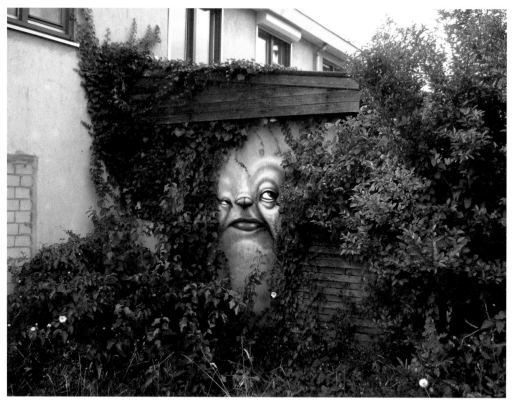

*Rotterdam, Netherlands · 2009*

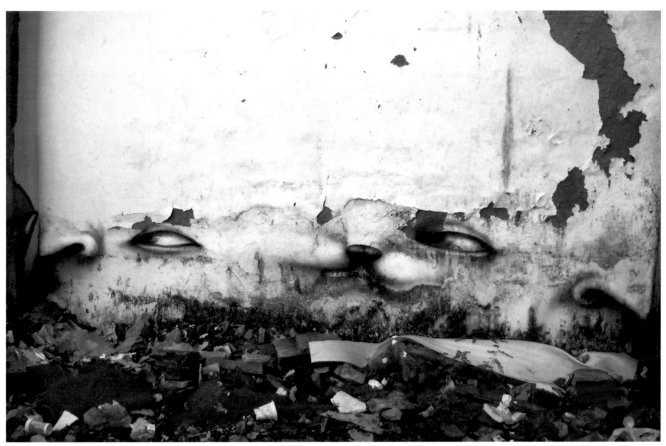

São Paulo, Brazil · 2009

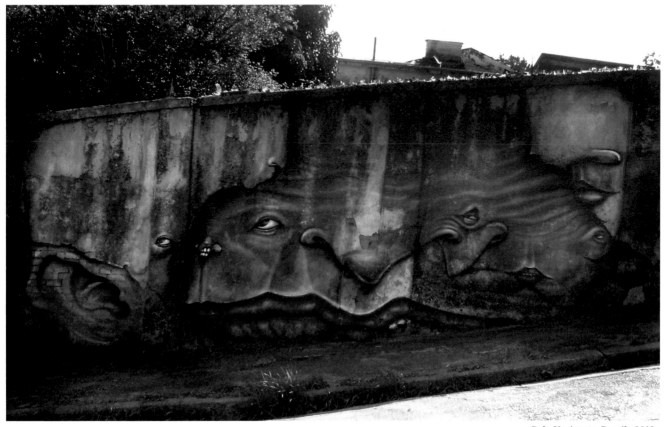

Belo Horizonte, Brazil · 2009

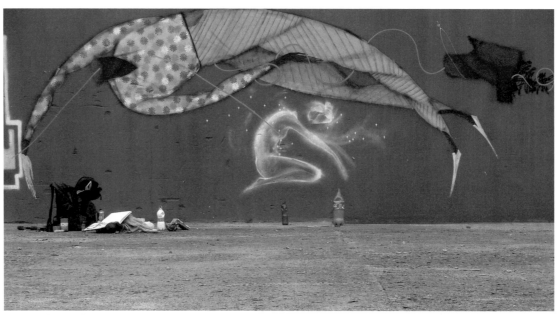

*São Paulo, Brazil · 2009*

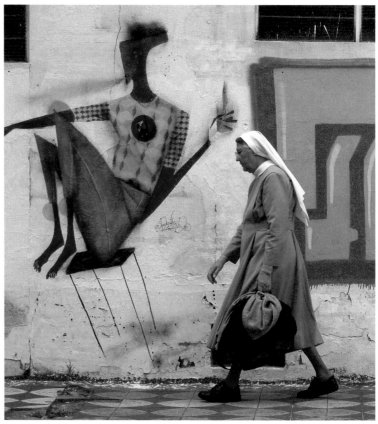

*São Paulo, Brazil · 2009*

# DEDABLIO

*It arrives and looks like a momentary light.*
*The images.*
*Silence is an image, with the deepest sound that exists,*
*Inside which reside the images my pulse transfers outwards.*
*Like a telegraph, each pulse means something.*
*They fulfill the feelings of the executor or executed.*
*Their truths exposed to the world.*
*It is tactile.*
*The soul becomes tactile.*
*Like its own perspiration.*
*A tear.*

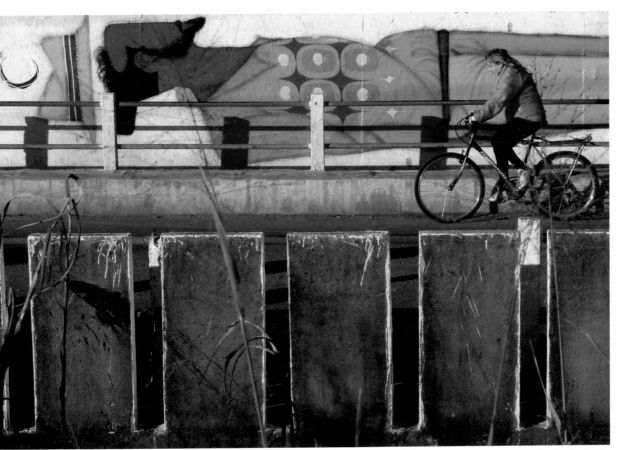

*São Paulo, Brazil · 2009*

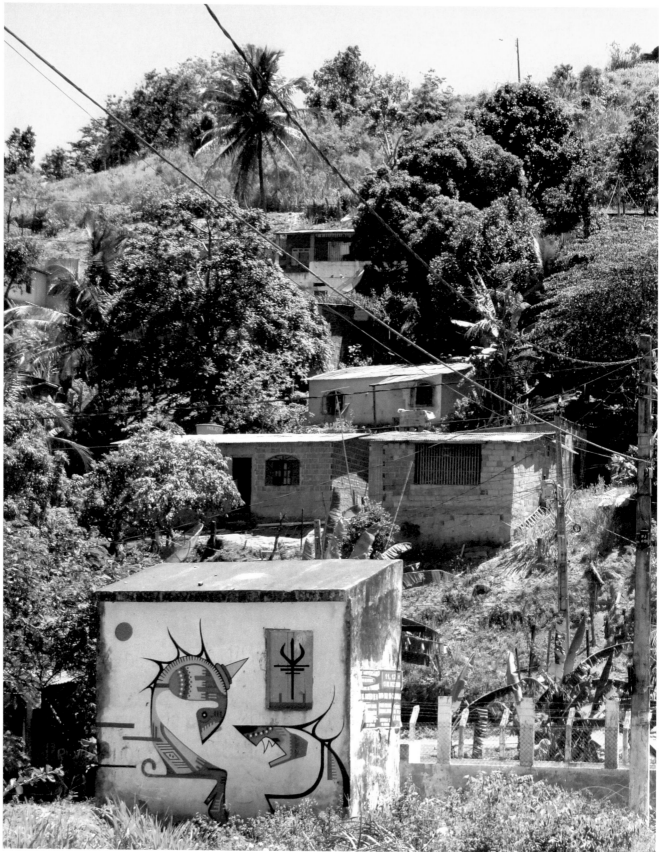

*Viana, Brazil · 2009*

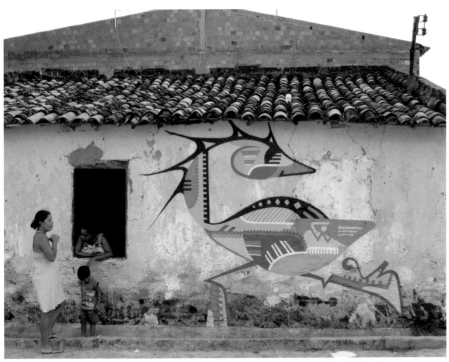

*Serrinha, Brazil · 2009*

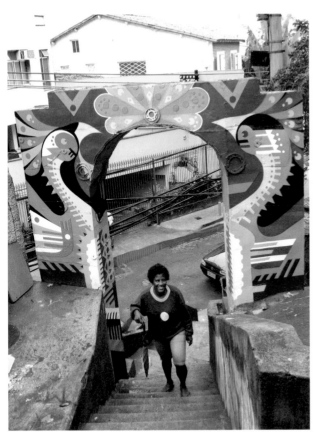

*Rio de Janeiro, Brazil · 2009*

# EMOL

————————*I am a character from the life of poetry looking to take control of my internal gods. I will take an adventure to the jungle to discover everything that hides nothing, and this is how I will learn to care for my garden. Everything has its time and now I am a bird from the heavens that lives.* –––

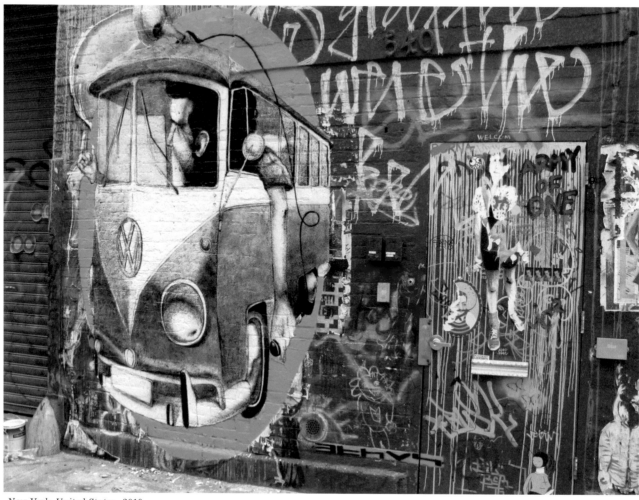

*New York, United States · 2010*

# ETHOS

– – – – – – – – – – – – *The binary states of consciousness—wakefulness and sleep—prompt a condition of temporary lucidity in us. In a series of paintings and drawings of one universe in relation to the other, my work looks for small breaches that let out signs of this mutual influence between the subconscious with its unceasing activity and the conscious mind. – – –*

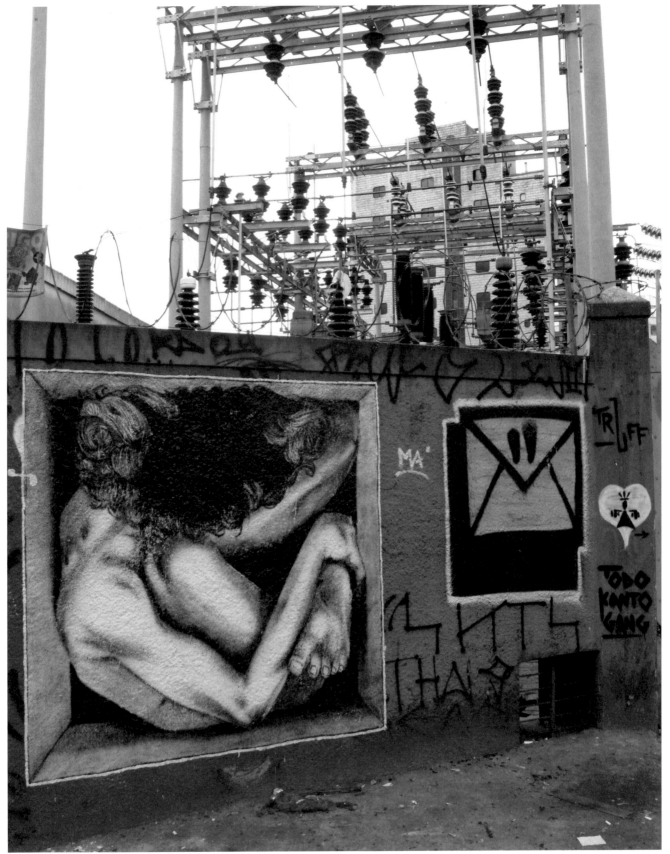

*São Paulo, Brazil · 2010*

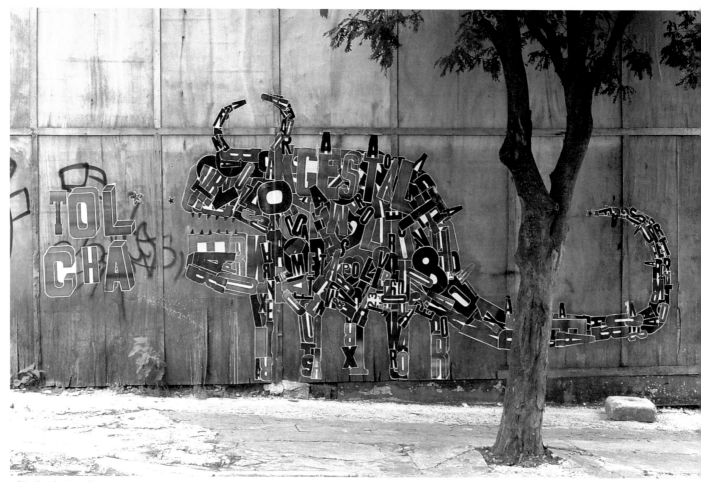

*São Paulo, Brazil · 2006*

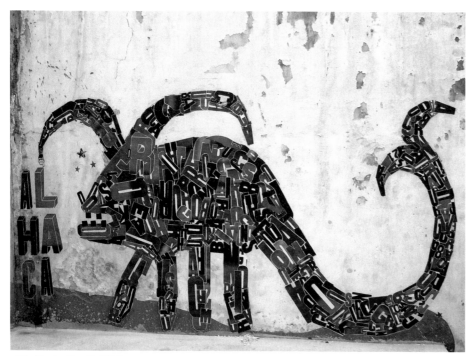

*São Paulo, Brazil · 2006*

# FEFE TALAVERA

————————————————————————————— *My paintings of monsters are metaphors for strong and subconscious human emotions like anger, fear, dreams, or desire. These colorful, fantastic beasts connect with the dark side of my inner self standing for the Mexican-Brazilian blood I carry, as well as the primitive and powerful energy of my work in streets all over the world. ———*

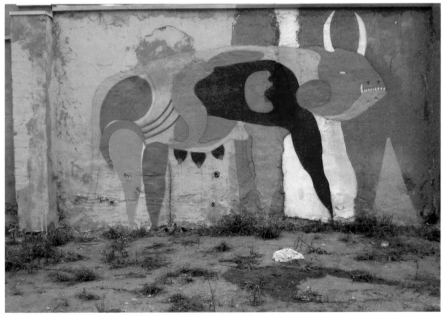

*Wroclaw, Poland · 2010*

# FIRME & FORTE RECORDS

––––––––––––––––––––– *We, Ananda Nahu and Izolag, created Firme & Forte Records in 2006, a recording of images that uses music and the surrounding world as its principal references, transforming rhythm into multicolor graphic art, working with posters, paint, graffiti, and photography, creating harmony from image and sound.* –––

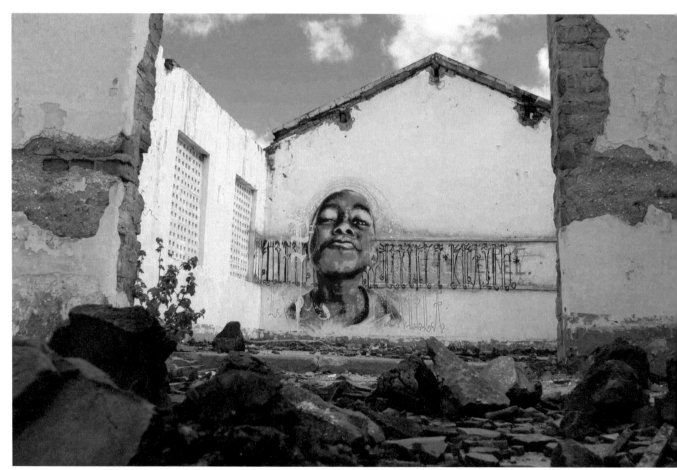

*Pernambuco, Brazil · 2009*

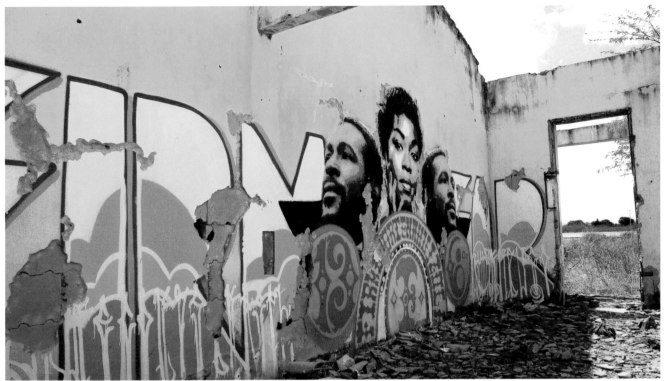

*Pernambuco, Brazil · 2009*

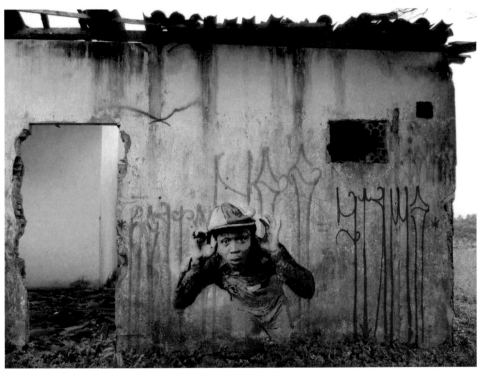

*Bahia, Brazil · 2007*

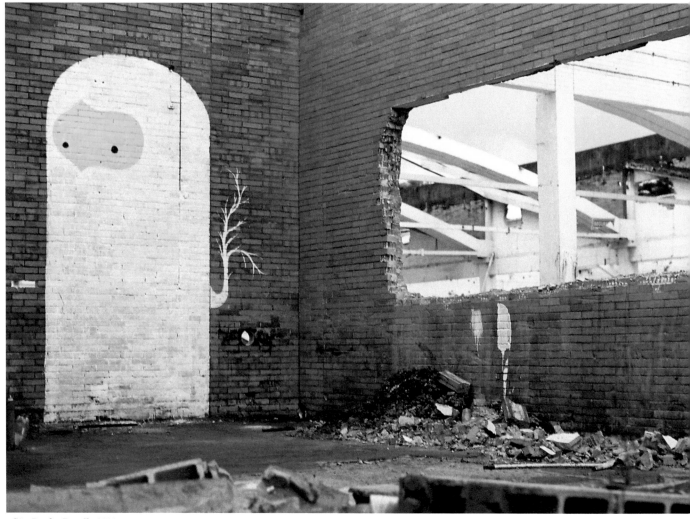

*São Paulo, Brazil · 2010*

# FLIP

————————— *I've been studying and researching trees, roots, camouflage, monsters, calligraphy, Asian culture, and sexual content. These subjects became the mixed flavor of my work. The concrete jungle and nature inspire me. A member of Famiglia Baglione since 2006, I've done shows and painted all over the world, but my roots are strong in my hood Vila Mariana, São Paulo. ———*

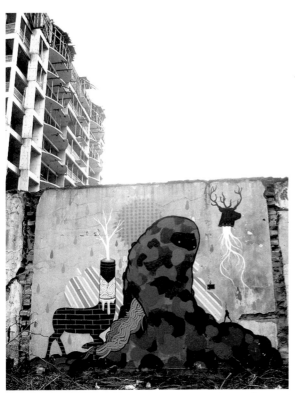

with Okuda · São Paulo, Brazil · 2008

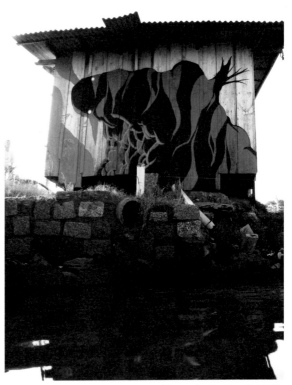

Florianópolis, Brazil · 2009

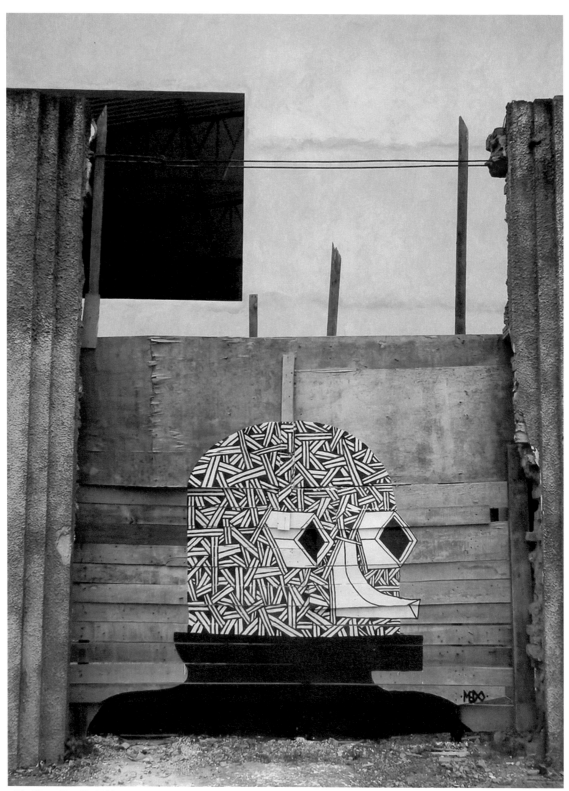

*Rio Claro, Brazil · 2008*

# MEDO

————————— *I was born in a small town in southeast Brazil. Even though I've moved to several other cities since I was ten, it was in my hometown that I started to paint and discovered what I wanted to express: abandonment, angst, and some sense of hope. Ruined buildings and old houses near nature and silent places are what inspire me to paint what I try to portray: people trapped—be it by themselves or by others. ———*

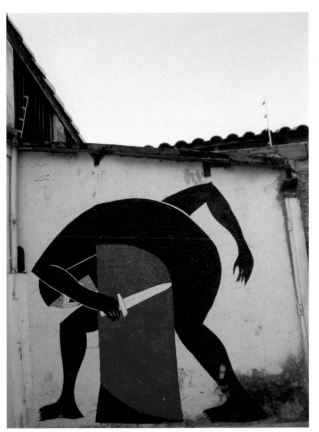

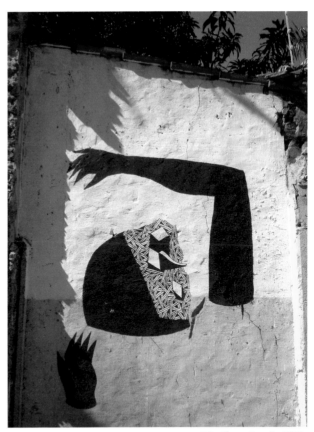

Goiânia, Brazil · 2009

Rio Claro, Brazil · 2009

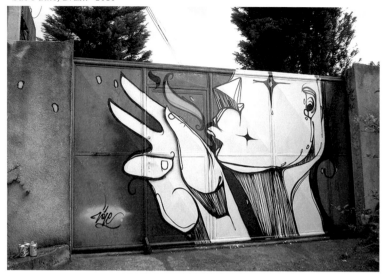

São Paulo, Brazil · 2010

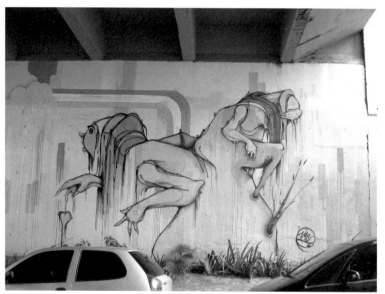

São Paulo, Brazil · 2009

# NOVE

—————————— *Painting in the street means interacting
with the space and its inhabitants, since graffiti becomes
part of the urban landscape. Digitalorgânico is the fusion
and contrast between technology and nature: the artificial
and the natural. It's the concept I've created to define my
work. Graphics and vibrant colors that refer to technological
language interacting with nature.* ———

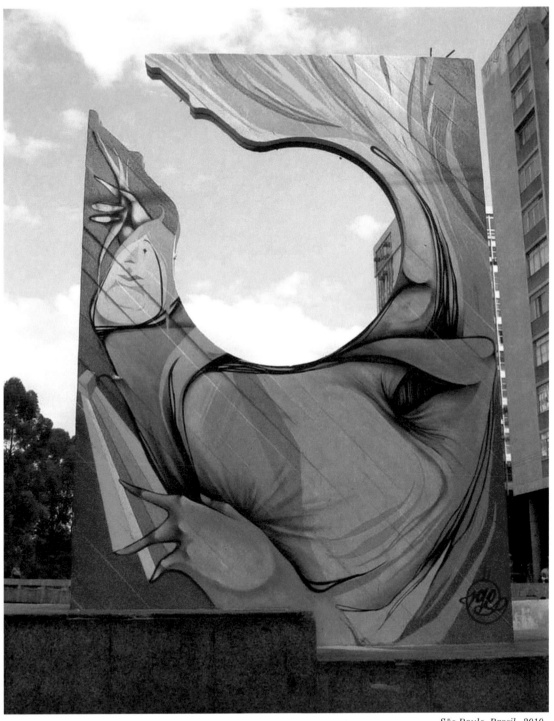

*São Paulo, Brazil · 2010*

# ONESTO

*————————————— I live and work in São Paulo, a place that inspires me and makes me reflect on urban themes that are playful and introspective. My characters interpret my ideas, in which lyricism, chaos, and agitation combine to form our reality. I am inspired by everything around me and when creating a work of art I search for a possible interaction between the reality of a place and the spectators. ———*

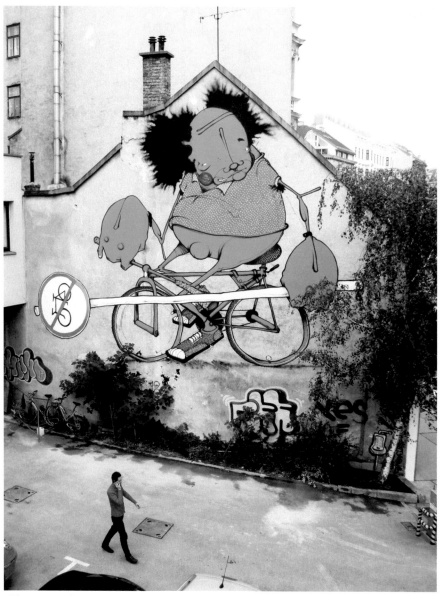

*Vienna, Austria · 2010*

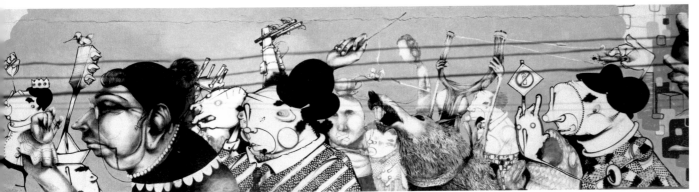

*with Ethos · São Paulo, Brazil · 2010*

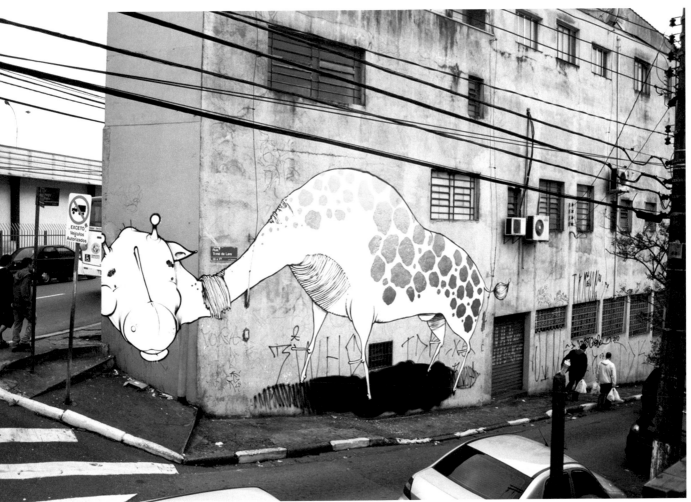

*São Paulo, Brazil · 2010*

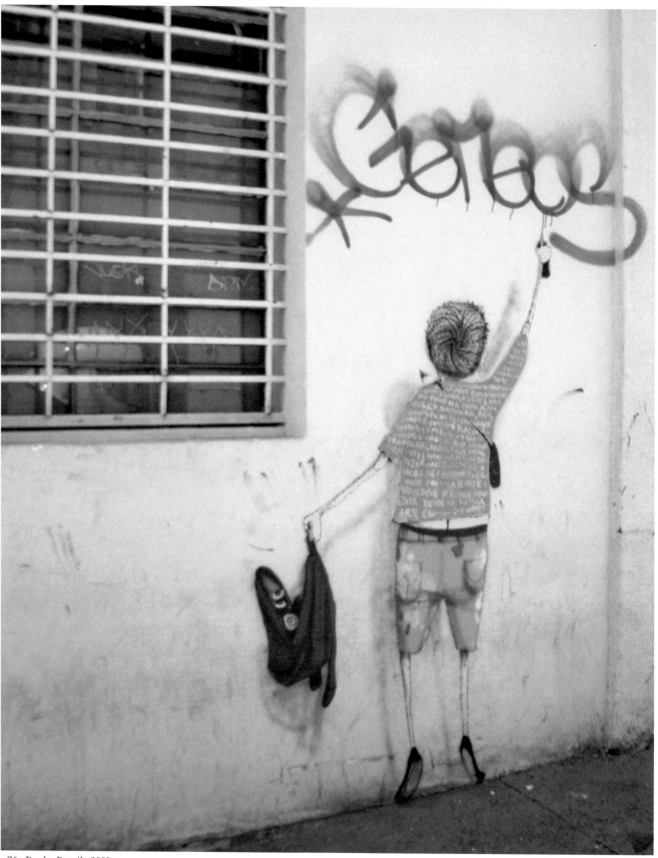

São Paulo, Brazil · 2009

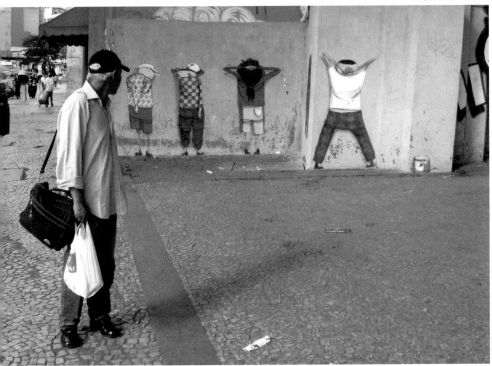

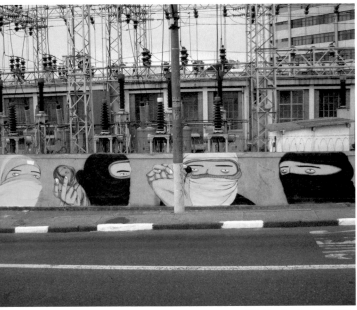

*São Paulo, Brazil · 2009*

# OS GÊMEOS

—————————————————— *Our work is a portrait of life, dreams, the everyday, surrealism, playfulness, truthfulness, love, hate, sex, diversion, protest, joking, seriousness, family, friends, the underground, adrenaline, satisfaction, change, flying, traveling, making friends, tasting, trying, discovering, letting yourself go, believing, music, dance, performance, theater, paint, and many other things we are still discovering. — — —*

# PIA

––––––– *Marcio Ribeiro, a.k.a. Piá, FBC crew member. Rio de Janeiro is a city that offers places to paint that look like postcards —Ipanema beach, Cristo Redentor, etc. I think the fact that it's a city of immense natural beauty is reflected, along with the problems we experience, in the local art. Art here has always had its own style and a good relationship with the city.* –––

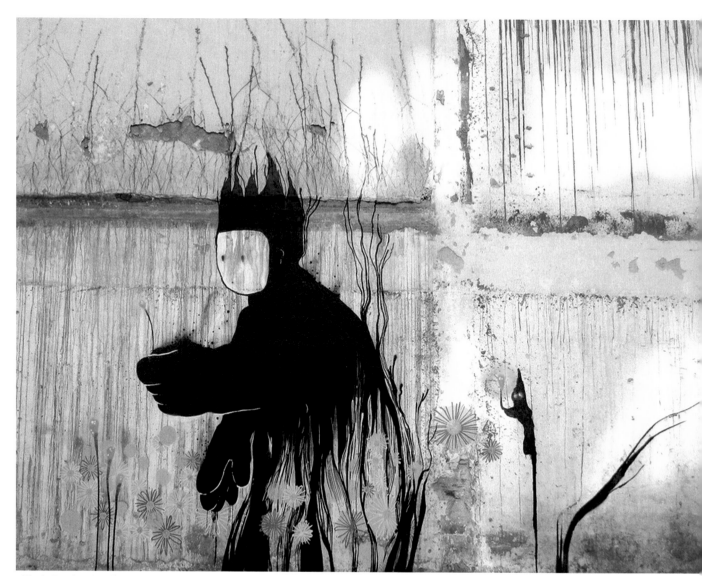

*Rio de Janeiro, Brazil · 2010*

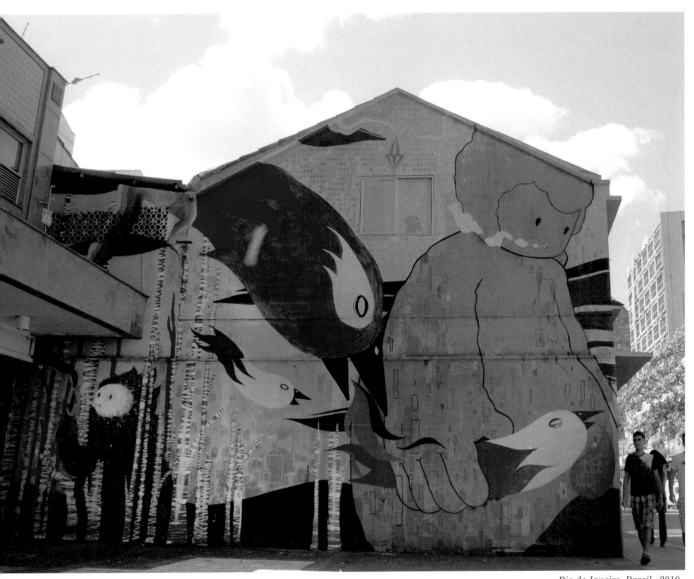

*Rio de Janeiro, Brazil · 2010*

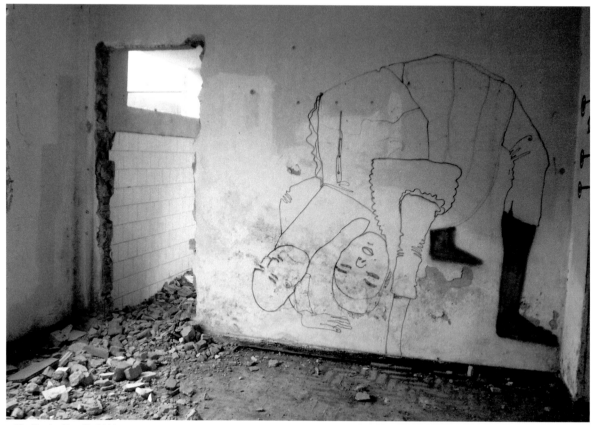

*São Paulo, Brazil · 2010*

# RAMON MARTINS

–––––––––––––––––– *Born in São Paulo, brought up in Minas Gerais, living in Brazilia, Ramon is varied even in the way he mixes baroque aspects with absolutely contemporary ones in his graffiti. His diversity comes from his background, references, and a way of seeing the world that goes beyond the limits that create unbreakable barriers for many.* –––

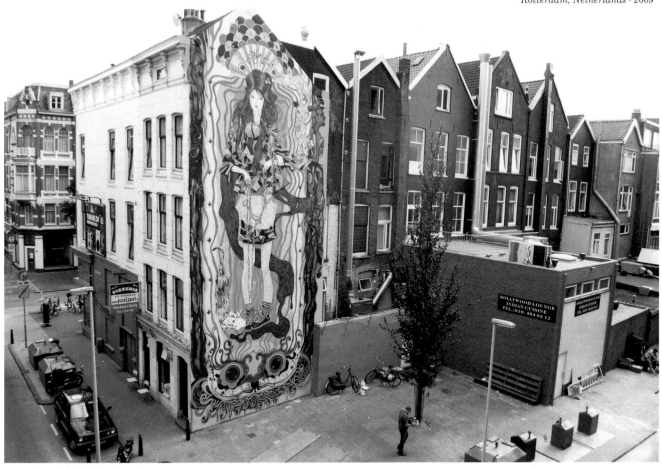

*São Paulo, Brazil · 2010*

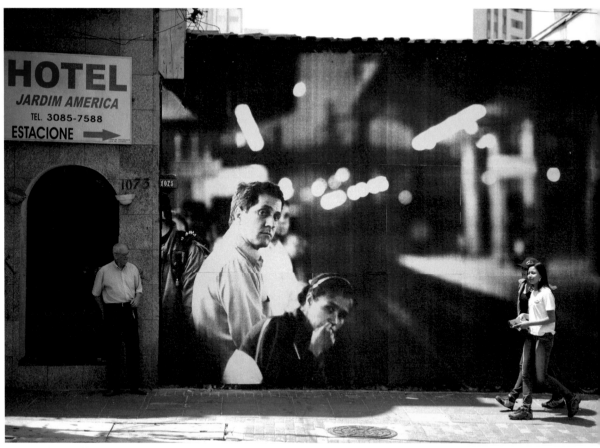

São Paulo, Brazil · 2010

# RAUL ZITO

—————————————————— *Being on the streets is about knowing yourself, meeting people, and recognizing places. Street art is free and spontaneous, just like life, but with the difference that we don't need anyone else to exist. We don't need many things; we just go out and do it. And no one can turn us into slaves because our contribution is open, free, ephemeral, and for everyone.* ———

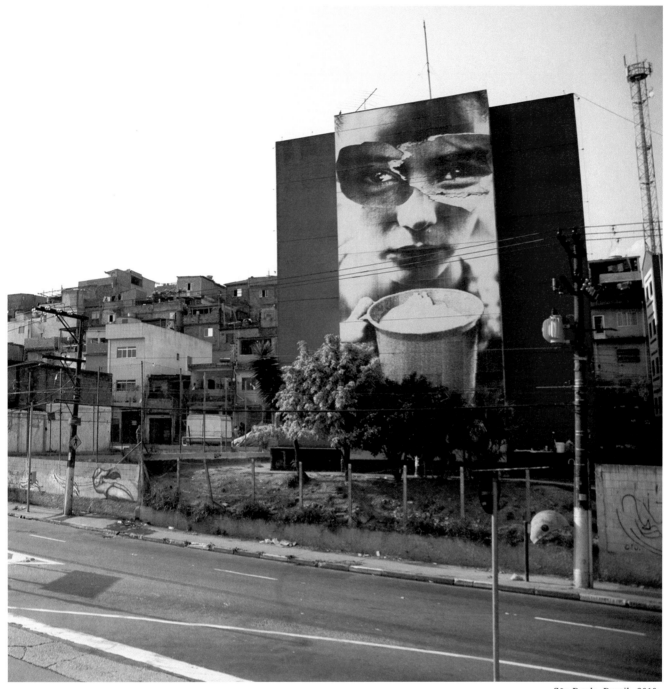

*São Paulo, Brazil · 2010*

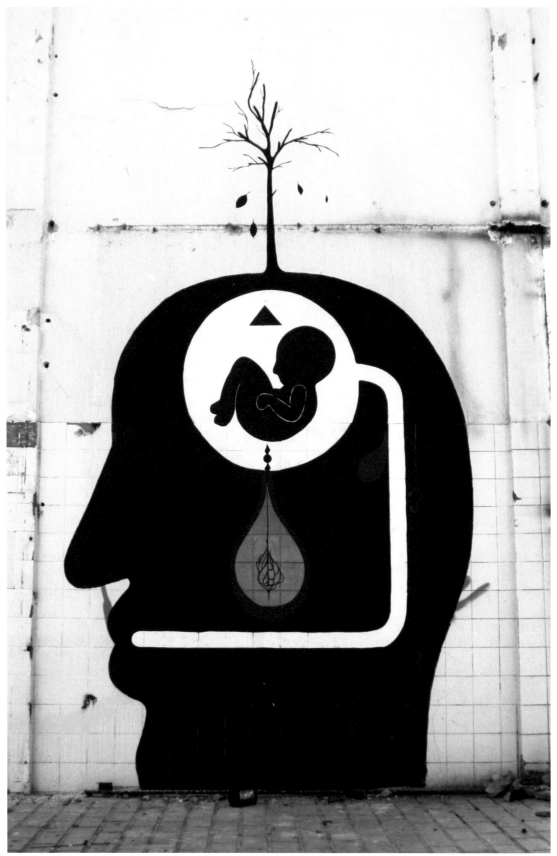

*Brazilia, Brazil · 2009*

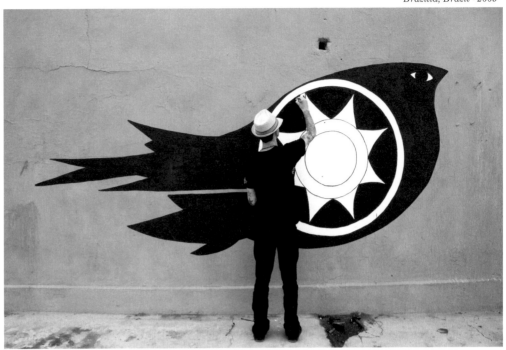

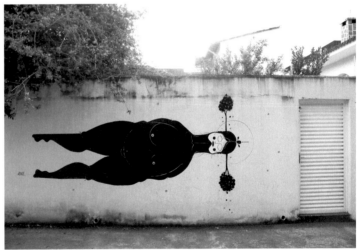

*Brazilia, Brazil · 2009*

# RODRIGO LEVEL

———————— *Art that gives the feeling of doing something positive and of great importance to tackle issues like sin, error, vanity, lust, fear, and people's dual personalities; dividing his time with the simple act of painting. His personality is his painting and his colors. He shares his dreams in the many places he explores, to leave a question in your eyes. ———*

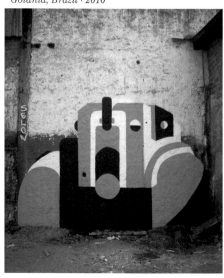

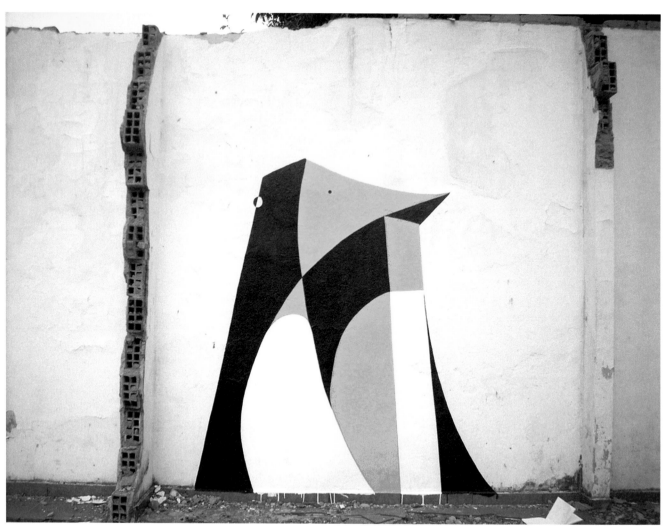

Goiânia, Brazil · 2009

# SELON

*———————————— The paintings and interventions that I develop are drawn objectively with normal expressions inspired by architectural relief and urban landscapes. I use them as an essence with which to elaborate and compose these forms, a subjective counterpoint formed by everyday sensations and the experiences the city grants me. ———*

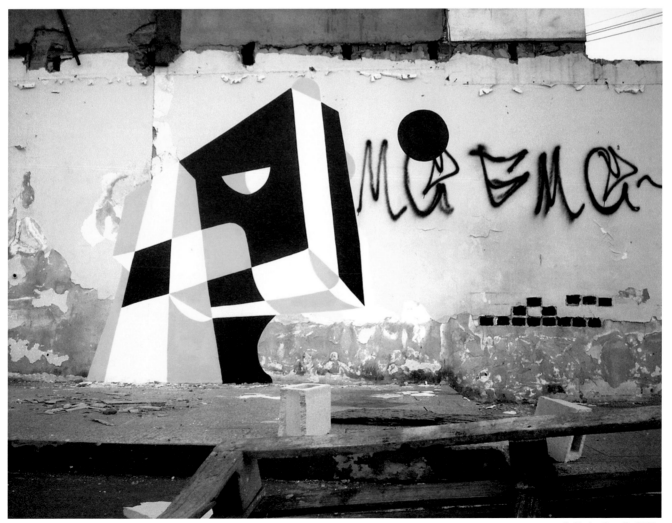

*Goiânia, Brazil · 2009*

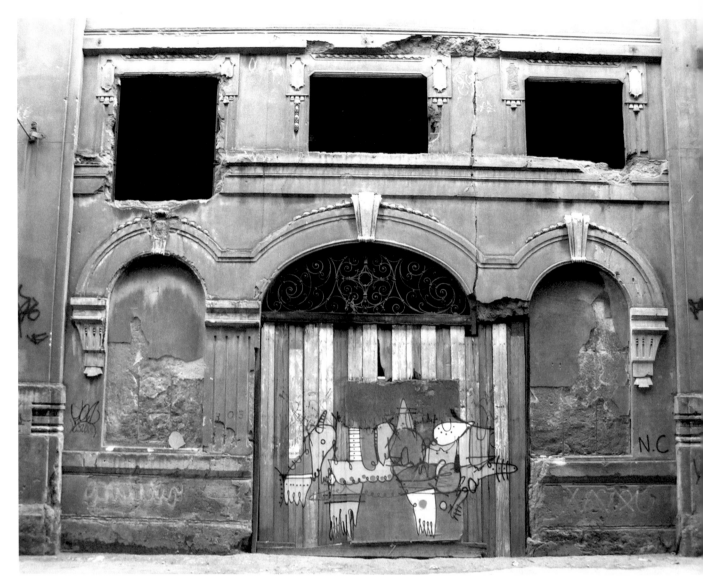

*Rio de Janeiro, Brazil · 2008*

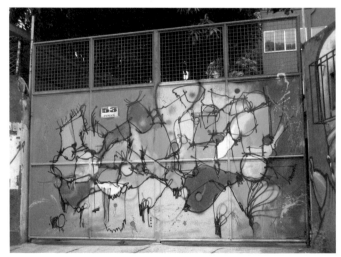

*Rio de Janeiro, Brazil · 2007*

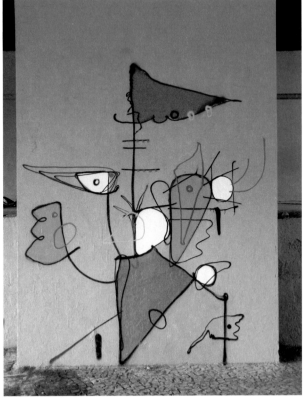

*Rio de Janeiro, Brazil · 2010*

# SMAEL

–––––––––––––*I began making graffiti in 1998 as one of the precursors to the movement in my city. With a unique style and characteristics I was already searching for a different way to paint. I intuitively began to create fantastic and playful creatures, beyond deconstructing everyday objects. Through color and lines I challenge the spectator to take an internal journey, where logical and vulgar forms sit side by side. –––*

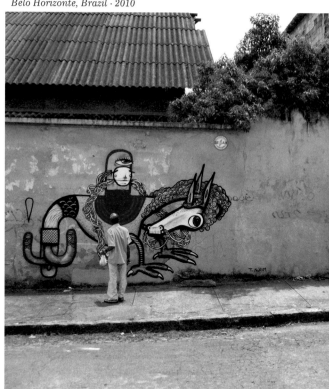

# THIAGO ALVIM

–––––––––––– *A self-taught artist born in Ouro Preto in 1988, who has been drawing since infancy. Alvin is a graffiti artist, designer, writer, and musician. He leaves his mark with his own style creating surreal and integrated characters, using lines of varied thickness, textures, vibrant colors, and other fruits of his imagination.* –––

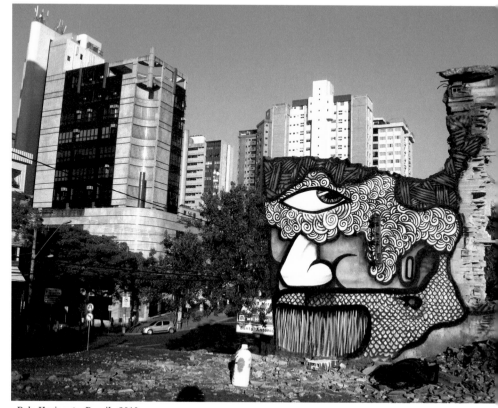

Belo Horizonte, Brazil · 2010

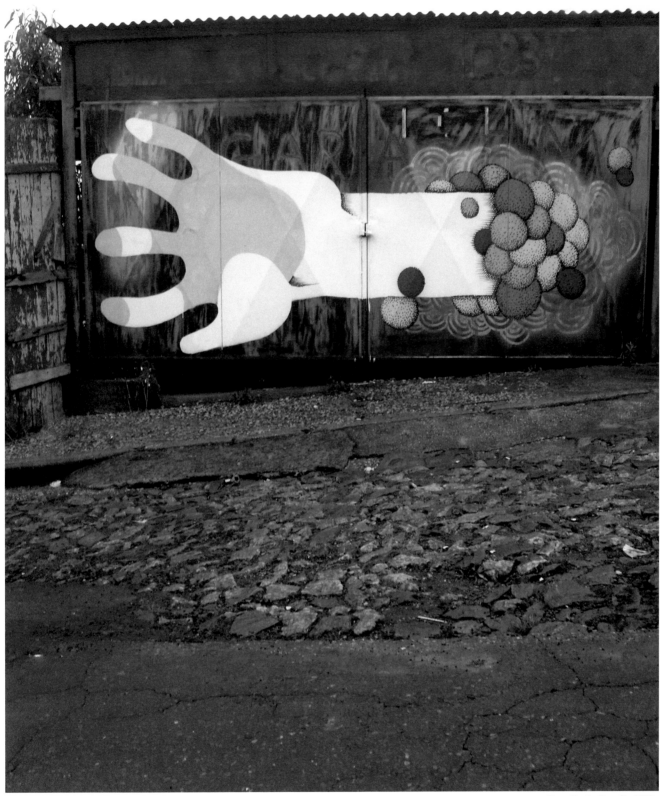

*Ouro Preto, Brazil · 2010*

São Paulo, Brazil · 2009

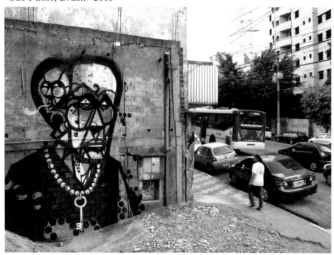

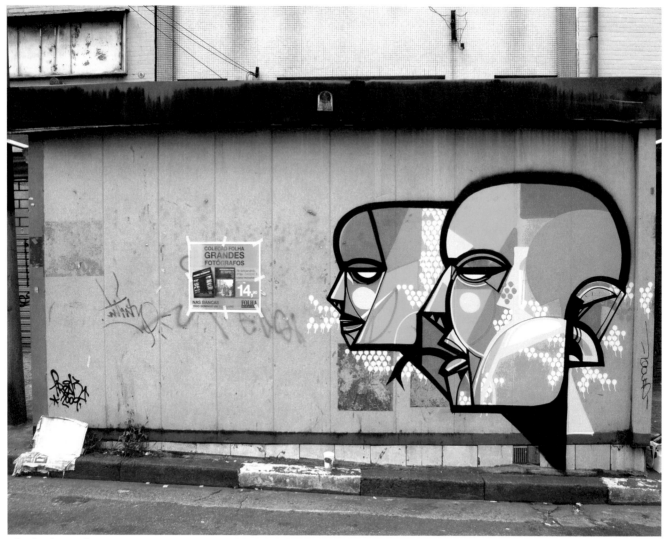

São Paulo, Brazil · 2009

# TITI FREAK

---------------------------- *Hamilton Yokota a.k.a. Titi
Freak. In 1996 I made my first drawing with spray on the street,
and so graffiti helped me find my vision! Other techniques, other
references and attitudes in my life contributed as well, and after
that I saw my work with fresh eyes, adding feelings, people, chaos,
dreams, urban calligraphy, culture, and nature. ---*

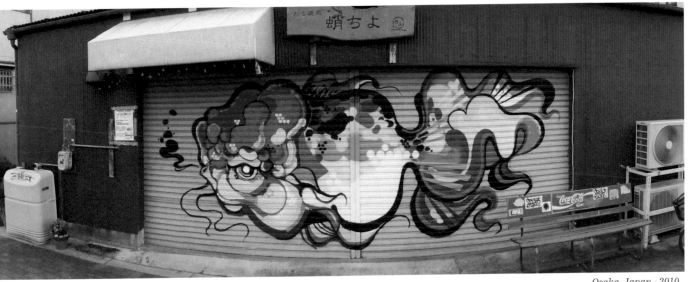

*Osaka, Japan · 2010*

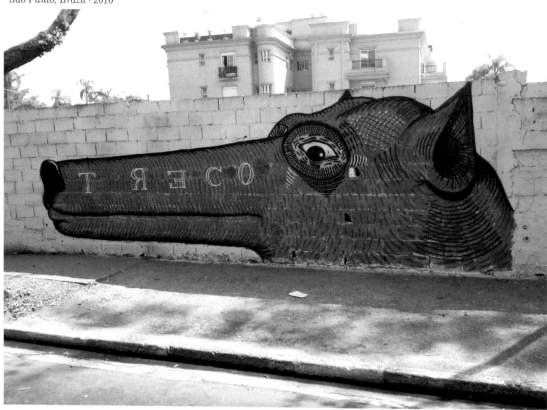

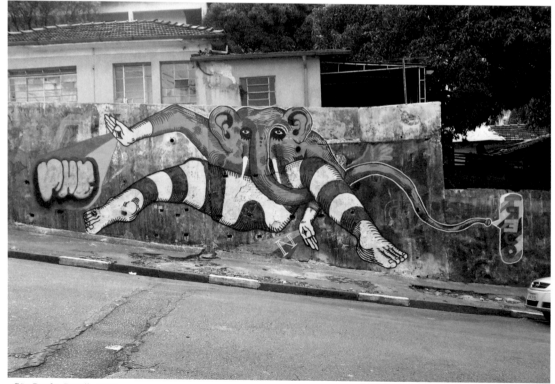

São Paulo, Brazil · 2010

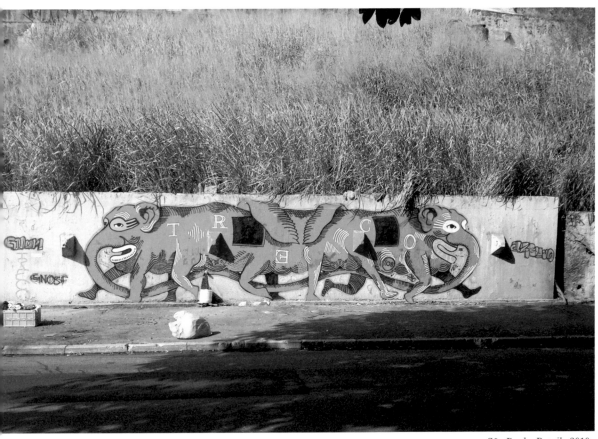

*São Paulo, Brazil · 2010*

# TRECO

—————————— *I lived in São Paulo until I was 23 years old without ever having known graffiti or pixação. The only thing I saw was grit and grime on the walls. I lived trapped in my house and car until I was 23, scared and frightened like the wealthy. I began to really live in my city when I started getting on my bike and painting in the streets. These days I live in and see the streets, I don't fear them.* ———

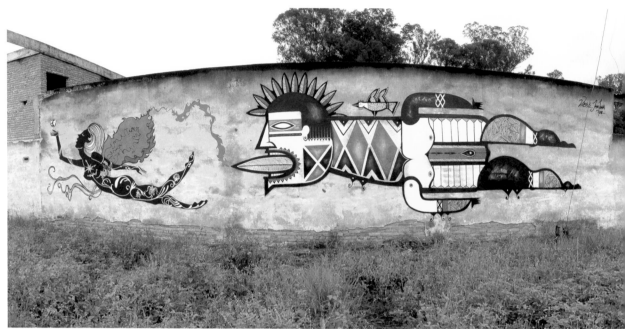

*with Janajoana · São Paulo, Brazil · 2010*

# VITCHÉ

––––––––––––––– *For me, the streets are like
a hungry dragon. They eat nature, transforming
dreams into emptiness. They make us lose
connection with the planet and close our eyes.
For me art is like a sword I wield to rescue an old
friend. Although I know I can't stop it, I can walk
joyfully on a tightrope, keeping my soul alive.
I also know I will never achieve my big dream. –––*

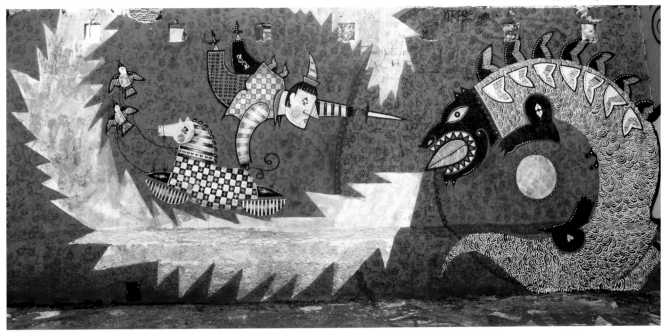

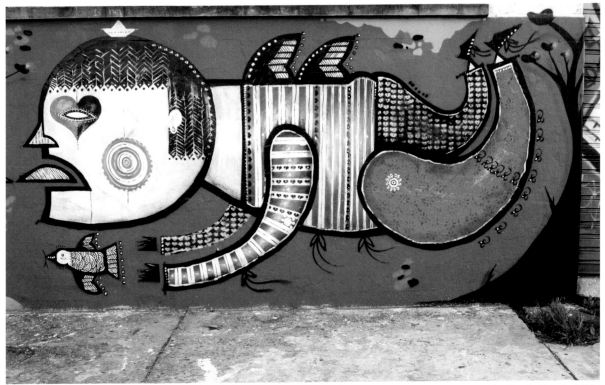

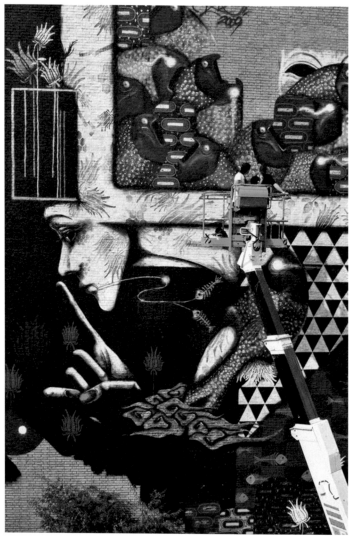

Rotterdam, Netherlands · 2009

# YUSK

————————— I do not consider myself a North American or a Brazilian or a Japanese. The roots I've been taught to respect are no longer real to me. I don't know what I am searching for, I do not have concepts and theories to explain what I do, nor do I care to develop them. I just keep trying to improve my skills; it's my main obsession, along with mourning this ridiculously short life that I so blindly waste sometimes. ———

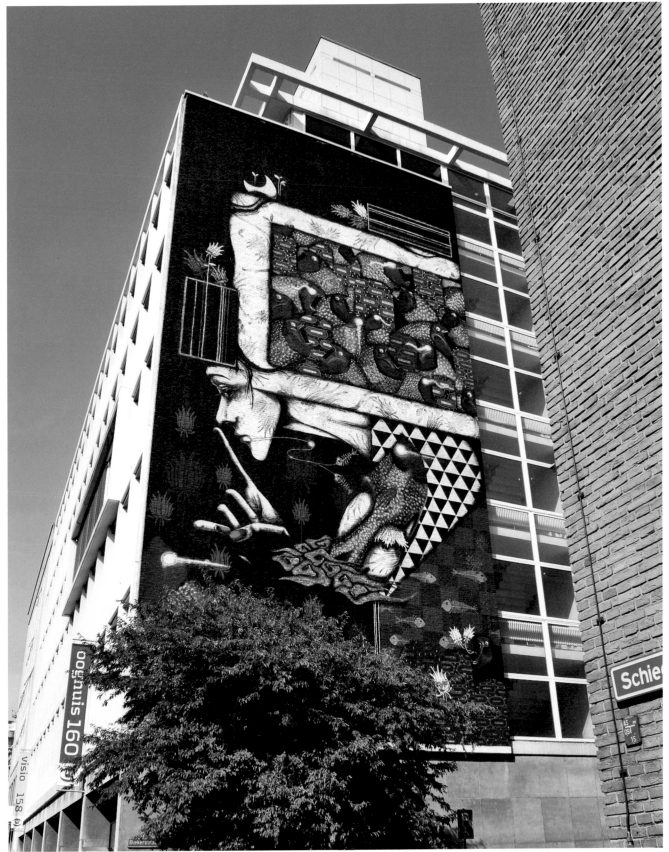

*Rotterdam, Netherlands · 2009*

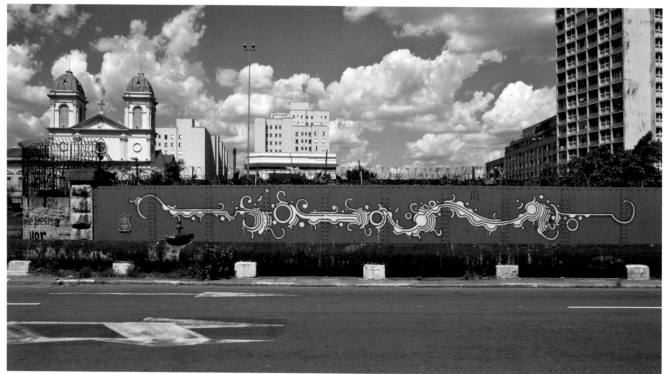

*São Paulo, Brazil · 2010*

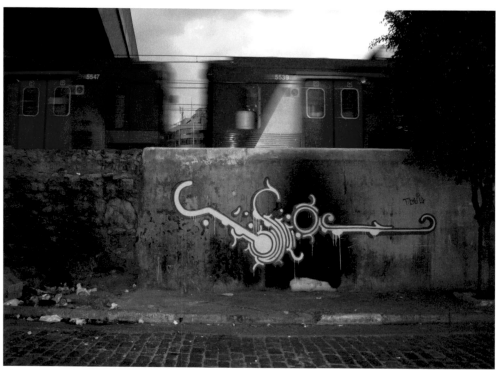

*São Paulo, Brazil · 2010*

# ZEZÃO

——————————Zezão's work has a socio-political dimension, because the artist deals with the urban outcasts who inhabit this world and reveals the existence of such misery through the photos taken to document his work, which are inaccessible to the general public. The work of Zezão is written in letters that are rude but very poetic. A self-taught artist, the intuitive and abstract Zezão takes site-specific and performance art to unprecedented levels. ————

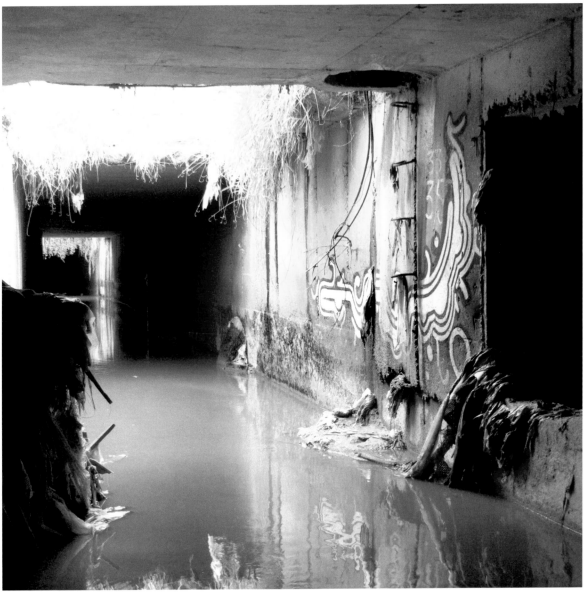

*São Paulo, Brazil · 2010*

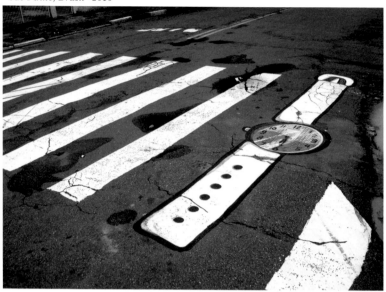

*São Paulo, Brazil · 2009*

# 6EMEIA

———————————— *6emeia was created in Barra Funda, a central district of in São Paulo, in 2006 by Anderson Augusto and Leonardo Delafuente. The duo creates works in the streets using urban furniture, proposing a new language between the art of the city and the people. They demonstrate that even the most indifferent object can exhale art. The drain covers painted by 6emeia are like drops of color in a huge gray cube.* – – –

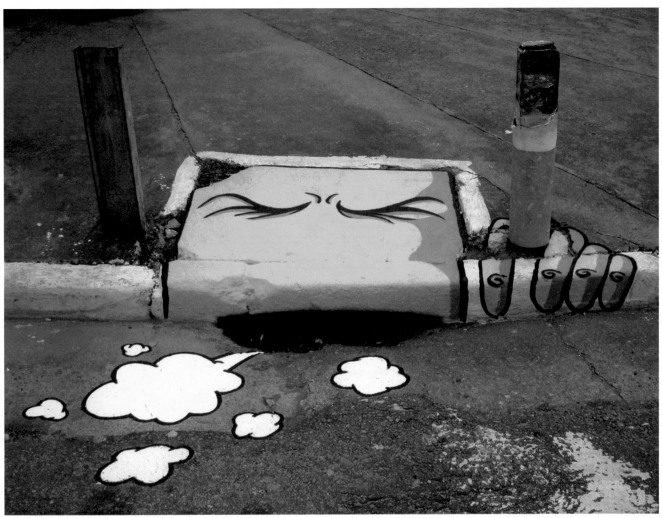

*São Paulo, Brazil · 2008*

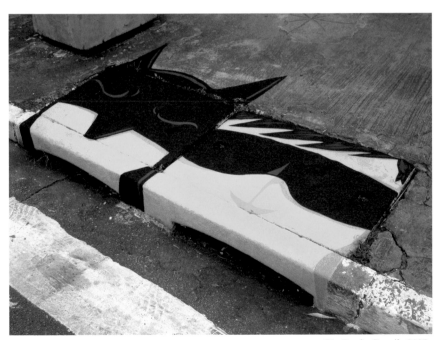

*São Paulo, Brazil · 2007*

· Bastardilla ·

· Caifas ·

· DjLu ·

· Guache ·

· Lesivo ·

· Nadie ·

· Nómada ·

· Rodez ·

· Stinkfish ·

· Toxicómano ·

# COLOMBIA

"**B**——————— ecause I don't know how a carpenter, a cabaret doorman, razor salesman, (...) farmer, accordion player, baptism photographer, can make it in this country." *Lyrics from "Sin Oficio" by Systema Solar.*

––– *Images come to represent some symptoms of the state of our regional identity. In Colombia, street art is used among other things as a tool of change that can modify customs and thus blur laws. This has been demonstrated in many instances of street art that haven't been properly executed by artists or people accredited as such. The arguments for why many foreign and local works of art have acquired value have not had anything to do with ostentatious monetary resources, significant support from the official government, marketing, publicity, or because urban galleries are particularly interested in them and in street artists. On the contrary, their self-administered continuity has allowed a movement to be created that coexists with unrepeatable everyday events, and has gained the complicity of the community, provoked smiles and also problems.*

*A broad perspective is required to get to know this turbulent paradise called Colombia, where each complex idiosyncrasy has developed. Outside of the capital, various cities and towns are increasingly being transformed by this phenomenon.*

––– *The journey it has required to reach this point began in the 1980s, when ideological groups, feminists, unions, and political fronts on the border of the law such as a student group called Sin Permiso and a guerilla group called M19, gave aesthetic values to their slogans, converting them into thousands of political murals in the streets or inside public universities. In carrying out these acts they won the fight for democracy by saying something on the walls, using mineral earth, tar, and chalk, without legal consent and covering their faces with hoods.*

––– *At the beginning of the 1990s the autonomous movement waned, but not without allowing public art to appear that certainly enriched other artistic outbreaks in the streets. By the end of this same decade, characters of the Frenchman Nemo proliferated in the capital, which was possibly the prelude to various stencil artists like Excusado, Lesivo, Toxicómano, SUB Crew, Mano Firme, Zokos, DjLu and Miscelánea Visual. They fed a strong new wave of stencils seen throughout principal cities with high-contrast images and characters that were both globalized and also mixed with indigenous elements. At the same time, independent publications were growing in Barranquilla, Medellín, Bogotá and the birthplace of 'zines, Cali, where the SUB crew printed topics aligned with street art, music, and other social movements. From 2005 until now interesting*

exponents appeared, who are impossible to name in their totality. They began to periodically disseminate investigatory projects and practices like Desfase, Trewa, Memoria Canalla, and Bogotá Stencil, among others. In general they maintain a notorious presence in street art, such as the illustrative tendencies in murals by Ródez, Nómada, Guache, Era, Gris, Somos, Orfanato; tendencies from comics in work by Puro Amor, Fuzil, Pulpa, Malk, La Plaga, M79, Notable; and powerful graffiti writing, which has undoubtedly been the main feature on the walls.

— — — Evidently all this history hasn't escaped the interest of destructive institutional campaigns from the self-determinative class, but the legitimate tendency is still independent and continues to use popular and accessible tools like photocopies, newspapers (as seen in Aeon's work), glitter, lost documents and digital photography (Stinkfish) and stencils (as can be seen in the most recent scenes from Darkas, Liliana Cuca, Hello Bollo, Zavo, Zancudo), silk screening, etc. Without wishing to generalize, these artists are nourished by cultural exchanges with colleagues from other countries, information found online, in the histories of Latin American villages, from the mixture of races, from the jungles, and the southern colors that prevail over this territory.

— — — The history of street art in Colombia has undoubtedly come from various foreign and local influences. Through leaps, stumbles, and effort it has remained strong and as time passed it broke the mold. Having influences in your work is not dishonest, because it is part of learning. However, in societies with confused identities that don't make a practice of looking deeply into their past and that see the future through a filter, conserve colonized customs, and allow walls to be erased along with blood-stained, unofficial messages, "influence" is confused with "copy". In contrast to prevailing methods of communication that esteem social alienation, in Colombia meaningful stains circulate that contrast with cheerful storefronts and can be seen live and in person. Property loses its frontiers in the middle of these sincere narratives, which are an efficient means of stimulating awareness.

— — — Talking about "Street Art" also implies thinking about people, their relationship with walls and with history. Here, street art is not just a means of painting, an intervention, and a self-adhesive that can be defined by one technique. It has to do with the city's attitude. Even so, you can't start off with a simple term that leads you to a specific location. It has to do with the places we walk around, what we see, what or who accompanies us. It has to do with expropriation, industry, corners, squares, meeting places, and closed-off spaces. That's why street art belongs to those who live in these spaces. Which is to say that those who paint in shared spaces aren't just the ones who sow them with images, but also those who see them from another perspective, lend them value, enlarge them, reject or cultivate a memory of them as though it were a platonic love that can't be brought home but can live on in memory, just as they say "the mind remembers what pleases it." Because despite social control the legends on the walls will continue, and fortunately, when one more place is censored, a new possibility to reinvent it will appear.

**Bastardilla** — — — — — — — — — — — — — — —

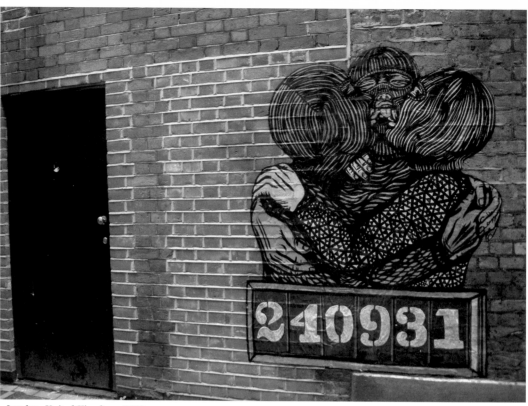

*London, United Kingdom · 2010*

# BASTARDILLA

– – – – – – – – – – – – – – – – – – – – – – – – – *It's a misappropriation; it belongs to everyone and to no one. "Outside," "inside," what's the difference if what you think and feel appears in the intimacy of the facades, revealing itself on walls that are like mirrors reflecting people and the world? You can apparently "enter" or "exit" from boredom, from questions, but the stains of our intentions are still indelible. – – –*

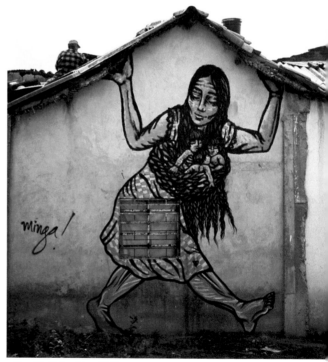

*Bogotá, Colombia · 2009*

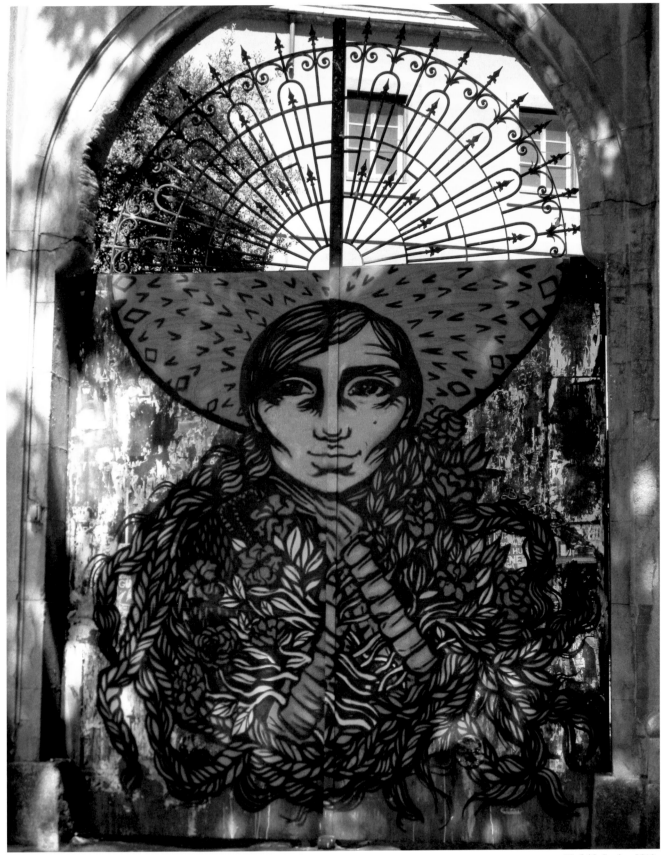

*Madrid, Spain · 2010*

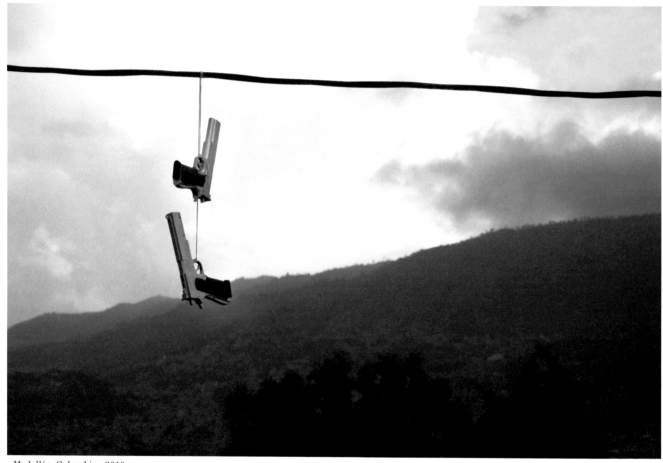

Medellín, Colombia · 2010

# CAIFAS

———————————— *I'm a normal, everyday person who has had the fortune of living in marginalized neighborhood in the city of Medellín, Colombia. In our community, when shoes are worn out they are disposed of by hanging them off a power line, as if to renounce something, but without forgetting its whole history. The intention of my intervention plays with this idea, renouncing weapons in a neighborhood known for its drug-related violence, which is organized by the cartels that want to control the streets.* ———

*Medellín, Colombia · 2010*

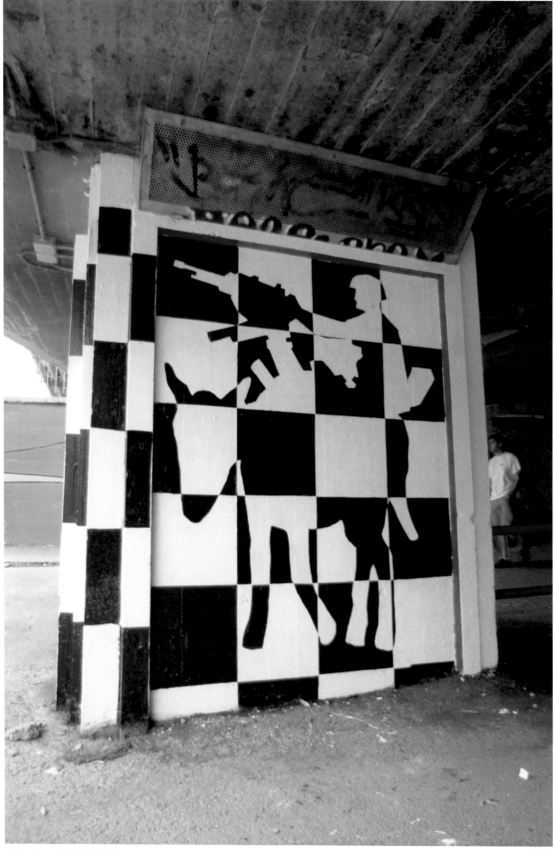

*Barcelona, Spain · 2009*

Bogotá, Colombia · 2009

# DjLu

—————————DjLu's work gathers
aspects of signage and semiotics in
order to combine and collide images
that are not normally related, sending
out a message using situations we are
all part of but often prefer to ignore.
The incredible simplicity of graphics
proposes a free way of inviting the
spectator to investigate different
interpretations. ———

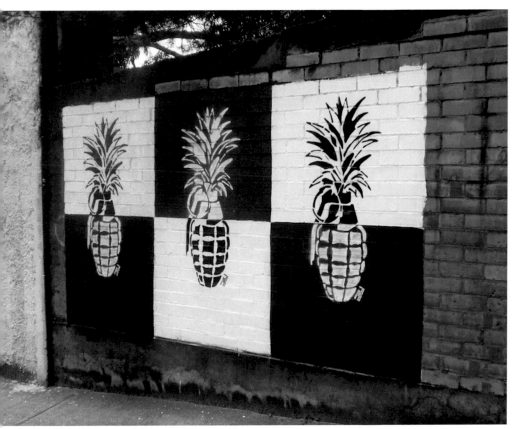

Bogotá, Colombia · 2009

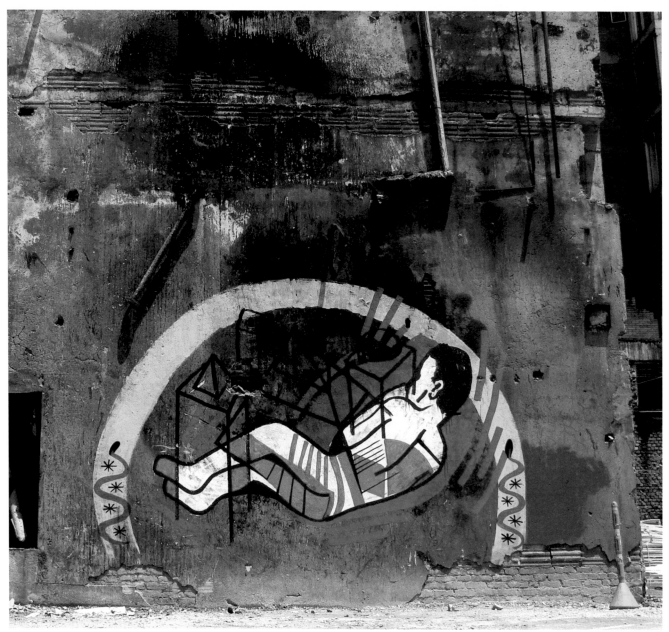

*Bogotá, Colombia · 2009*

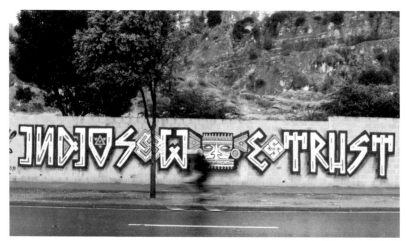

*Bogotá, Colombia · 2010*

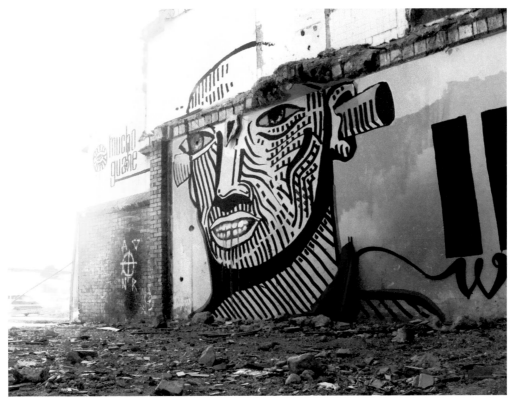

*Bogotá, Colombia · 2009*

# GUACHE
— — — — — — — — — — — — — — — — *Searching for a sign of the future in the past, following ancestral footsteps in the hybrid streets of Colombia, over five years ago I developed a visual proposal with other artists in various languages, knitting together colors from street interventions with mixed techniques, uncovering symbols in independent design, interspersing words in murals and street art in a new hybrid style. — — —*

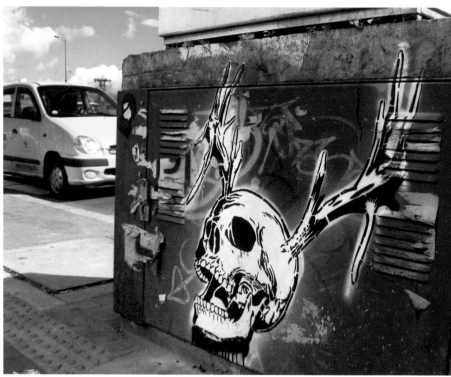

*Bogotá, Colombia · 2009*

# LESIVO

—————————— *Lesivo is a street art project that uses images as a way to communicate in public spaces. Stencil and screen printing are techniques I use to produce murals, stickers, and posters. My characters refer to militarism, education, work, etc. and I create montages made from catalogs, instructions, and brochures inspired by the advertising styles of the 1930s and 1960s.* ———

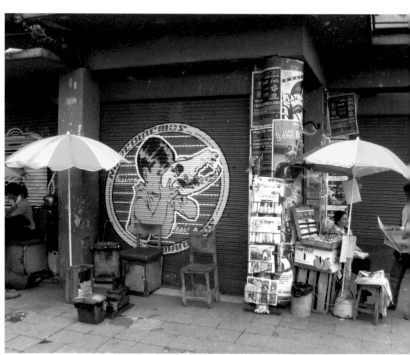

*Bogotá, Colombia · 2007*

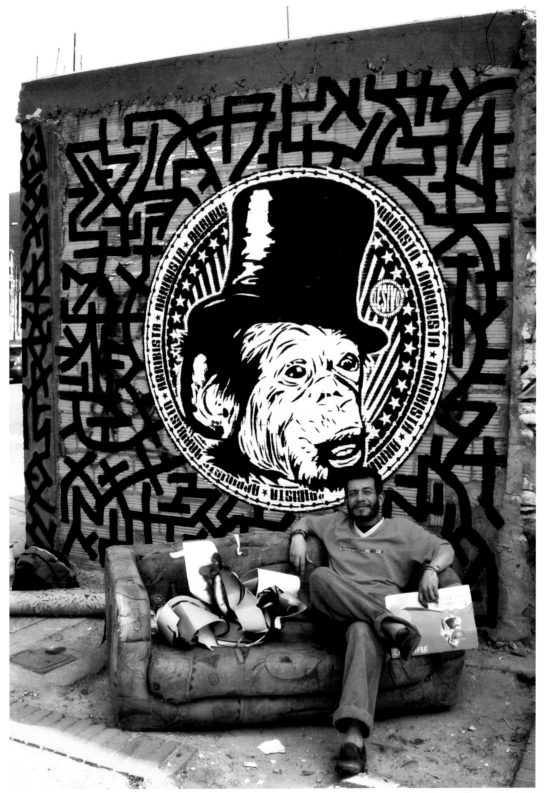

*Bogotá, Colombia · 2010*

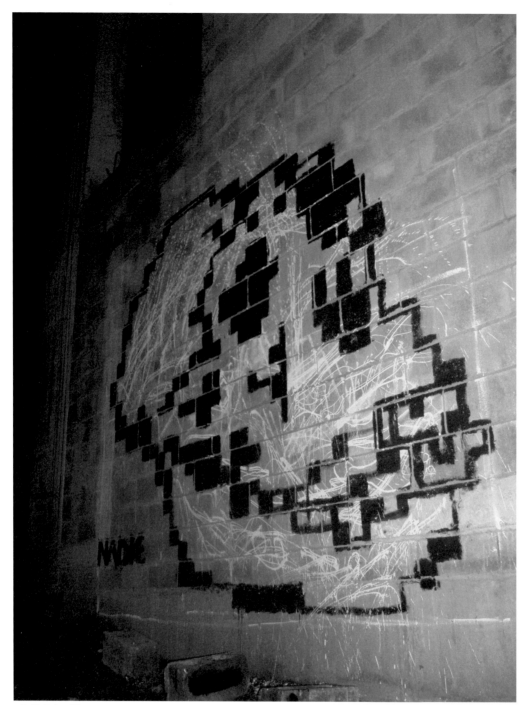

*Cali, Colombia · 2010*

# NADIE

— — — — — — — — — — *The street is loaded with different types of meaning, symbols, signals, stories, business, customs, characters, and other things that make each place unique, with its own special rhythm. By affecting these spaces you try to understand and intervene in these dynamics. Aiming to bring people outside themselves, to disarm them for a brief moment of elevation.* — — —

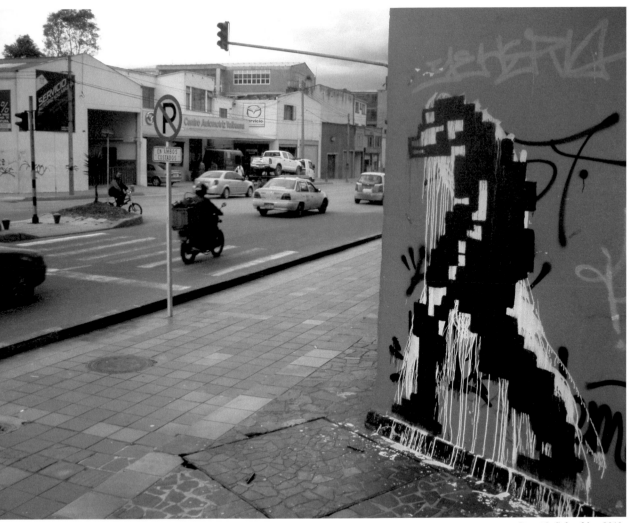

*Bogotá, Colombia · 2010*

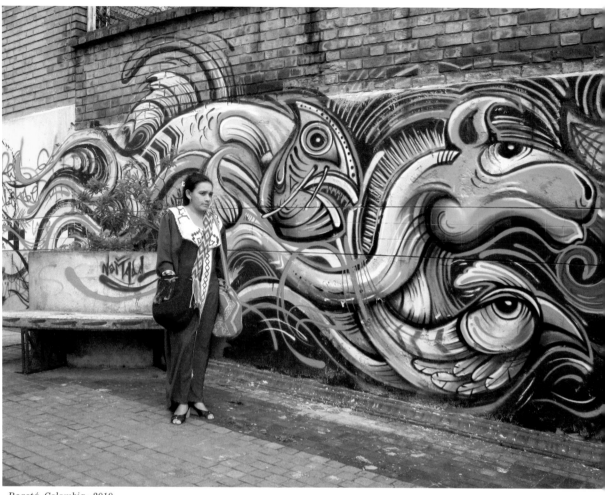

*Bogotá, Colombia · 2010*

# NÓMADA

———————————————————— *Ten years ago I began to paint graffiti influenced by old school pieces from New York. Since then my work has evolved, mixing different techniques and styles, which has given rise to characters from other worlds. And although my work now includes various street art forms, I've never left illegal graffiti behind.* ———

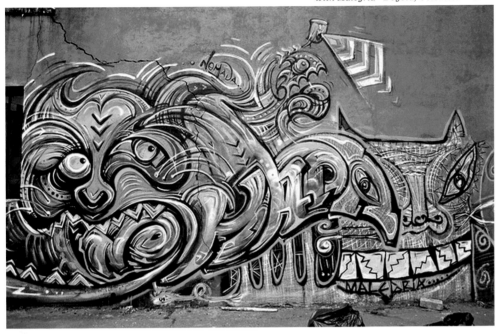

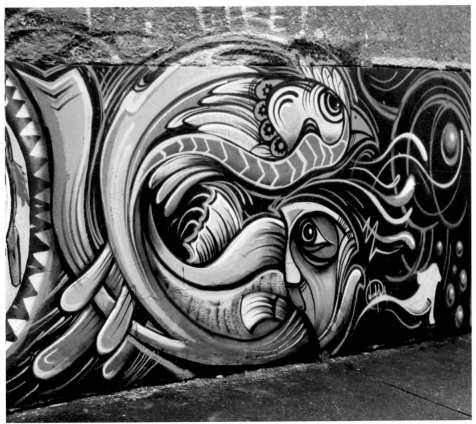

*Bogotá, Colombia · 2009*

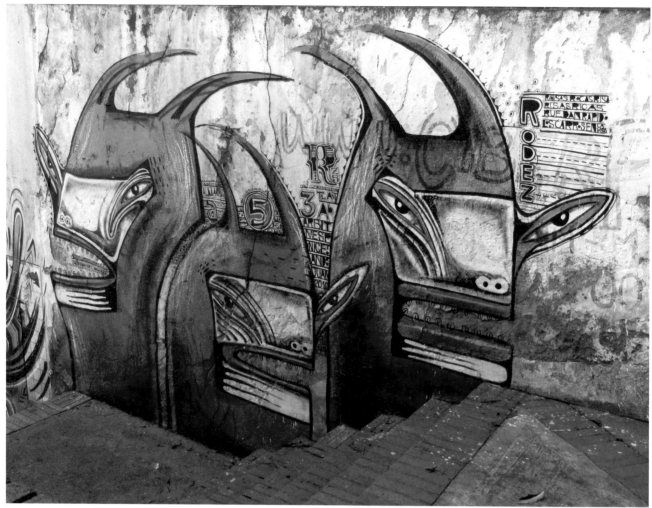

*Bogotá, Colombia · 2010*

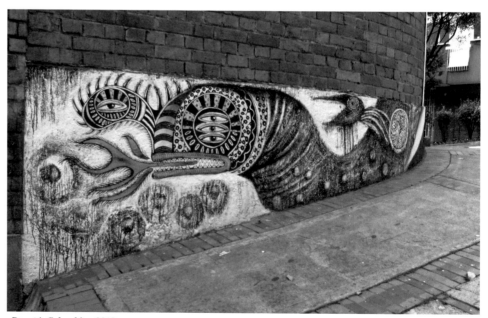

*Bogotá, Colombia · 2010*

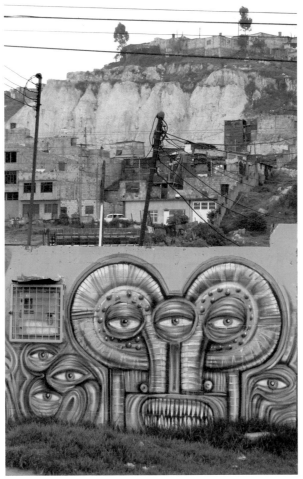

*Medellín, Colombia · 2010*

# RÓDEZ

———————— *Rather than searching for a public for my artwork, what I do is paint on the walls and wait for a spirit on the same frequency as mine to find my drawing, my color, my stains, and the intimate content I produce: like-minded spirits find each other in an urban scene.* ———

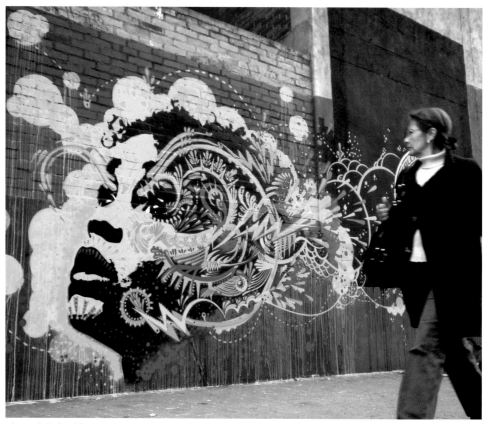

*Bogotá, Colombia · 2010*

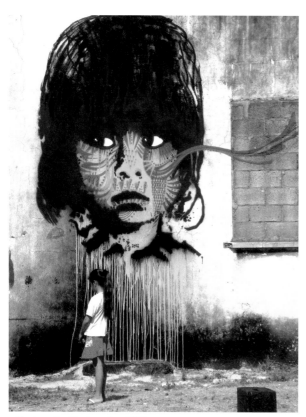

*Guatemala, Guatemala · 2008*

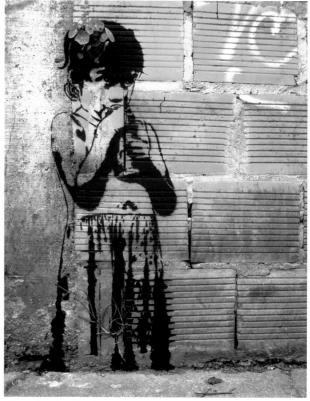

*Bogotá, Colombia · 2010*

# STINKFISH

*—————————— This is my memory, a memory from the street, from the street where we grew up, far from cities out of postcards. These are our real cities, where we live in an order that appears chaotic, multitudes that bump into each other over and over again until they find a way to organize themselves and survive, from necessity alone, from what is missing, from impossibility. ———*

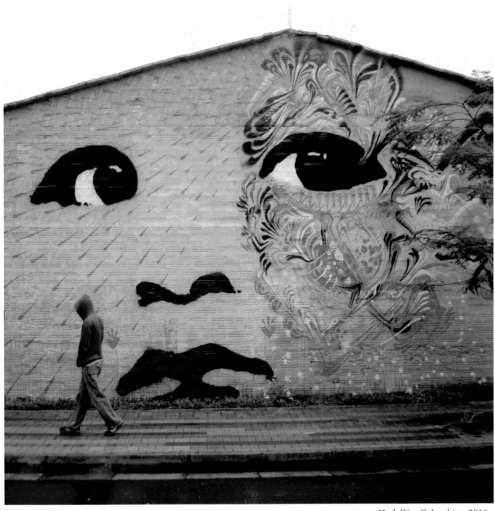

*Medellín, Colombia · 2010*

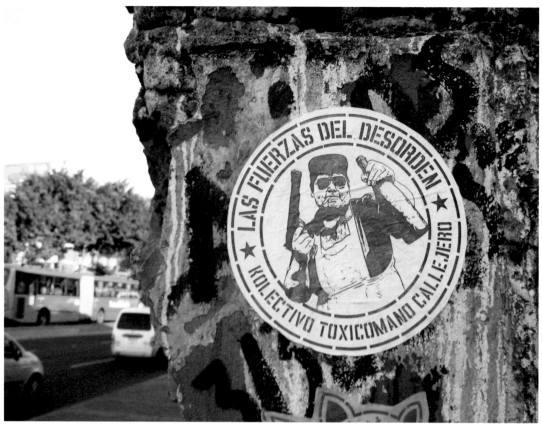

*Bogotá, Colombia · 2010*

# TOXICÓMANO

———————————————————— *During the whole time*
*I've spent wandering around Bogotá, I've been affected by*
*the music (especially punk and hip hop), party nights, girls,*
*world events, mass misinformation media, graphic design,*
*commercials, drug addicts, alcoholics...it all adds up when the*
*time comes to paint something in the street. Hic! – – –*

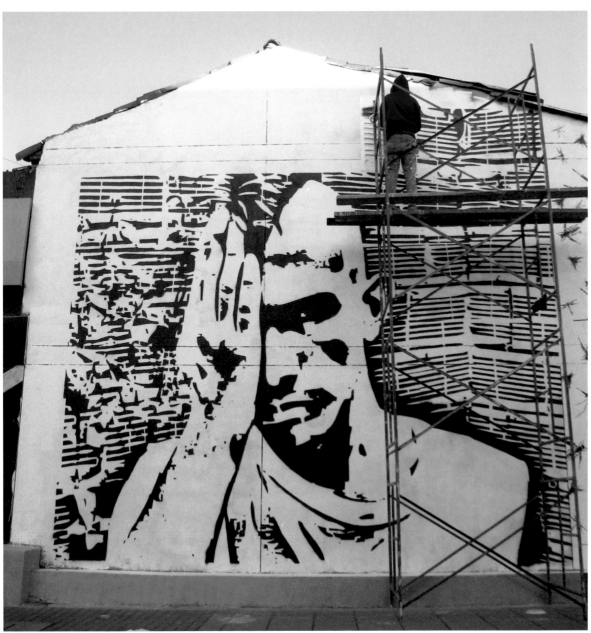

*Bogotá, Colombia · 2010*

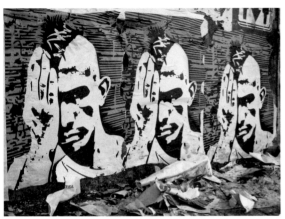

*Bogotá, Colombia · 2010*

· *Aire* ·

· *Buenos Aires Stencil* ·

· *Chu* ·

· *Defi* ·

· *Doma* ·

· *Emy Mariani* ·

· *Ever* ·

· *Grolou* ·

· *Gualicho* ·

· *Jaz* ·

· *Lean Frizzera* ·

· *Nazza* ·

· *Nerf* ·

· *Pastel* ·

· *Run Don't Walk* ·

· *Tec* ·

· *Triángulo Dorado* ·

· *Vomito Attack* ·

# ARGENTINA

**T**——————he birth of the local street art scene dates back to the end of the 1980s with just a few names like Rasta, Maze, El Pelado, and Cray showing up around the city—names that were made thanks mostly to trips to foreign countries and visiting artists that came to our unpopulated country including Os Gêmeos, Speto, and Binho from Brazil and Esher from Germany. Beginning in the year 2000 a whole new generation of artists still very influenced by classic graffiti hip hop began to cover the city and the trains—people like Dano, Zima y Wose, Teko and Nerf were the most important in this period and most of them are still active.

——— This was really a whole period of trial and error for the artists, still without much information about what these illegible letters really meant or the types of materials they should be using to make them. We just had about nine colors of cheap spray paint, with no decent type of cap or technique for using them. When somebody got a cap, always sent from abroad, they would take care of it like a child, taking the time to unblock it each time they used it, and we would also mix paint pouring it from one can to another, always risking that it would explode in the middle of the process. It was all very basic, but with the little information we were able to find on the early internet we were discovering artists and techniques and so we were able to form a scene and a style of Argentine graffiti.

——— After the great economic crisis in our country in 2001, many other artistic movements broke out on the streets searching for their place and their voice. That was when there was a boom in stencil art, especially political stencil art, which invaded the streets of Buenos Aires, Rosario and Córdoba. The best examples are Buenos Aires Stencil, Run Don't Walk, Dardo Malatesta and Vomito Attack. A whole new group of designers and illustrators accompanied this movement, which everybody began to call Street Art. Now not only the letters and the hermetic message of the graffiti could be seen in the streets of the city but also a whole new range of expression, which came from the stencils in the form of stickers and murals combining spray and traditional painting. A decline in our local currency in relation to the dollar meant prices shot up and artists had to get by with very few resources. Despite what you might expect in a time of crisis, this was a movement that was born and grew instead of petering out. And so this movement covered a country unified by a need for free public expression.

––– Today the street art movement is very large in our country. It is influenced by the absorption of different cultures, something that has always characterized Argentines, taking North American graffiti as a paradigm at the start, and later using content from local folklore like fileteado or even traditional political painting and the Latin American tradition of murals. The inclusion of local art in many of the most important institutions is proof that this whole movement has a strong presence in the country. The work of people like Pum Pum, Aire, Triángulo Dorado, Ever, Tec, Gualicho, Nerf, Poeta, and Doma is already reaching beyond local limits and can be seen in different parts of the world.

––– The ability of different movements of local street art to coexist in harmony has always been a unique trait in Argentina, where the majority of the artists work together with practically no fighting for turf or territory. Artistic collaboration between Latin American countries has always been very fluid. Far from what European countries experience with constant events and exhibitions in every country, in this region of the world, despite considerable distances, there is a communion between street art scenes in neighboring countries, which has resulted in few but rich combined shows and productions.

––– In Argentina and its main cities, street art has always been well received by both the community and the government. Persecution and imprisonment for using public spaces for art is practically nonexistent, which is why you can see artwork all around the city and not just in marginalized neighborhoods on the outskirts, as is normal in European and North American cities. This creates fertile ground for working in a relaxed manner on projects and having a more direct impact on a perpetually growing public, as is highlighted by the constant feedback between artist and neighborhood.

––– Here the painted walls span an enormous and varied territory, from paintings in front of the National Congress building, to luxury hotels in the most exclusive neighborhoods in the city, to abandoned public buildings. Paintings have been commissioned for subway stations and it is common to get permission for walls and spaces just by walking around the city.

––– From my perspective on the Argentine street art movement, the difference and growth in number and quality and maturity of the artists is very noticeable. A deep graffiti tradition manages to coexist with a whole new movement that is accepted in more open circles of traditional art without affecting this kind of paradise for painting. That this should occur in a region known for conflicts and large-scale social inequalities is something that should be protected and valued.

**Jaz** ––––––––––––––––––––––––––––––

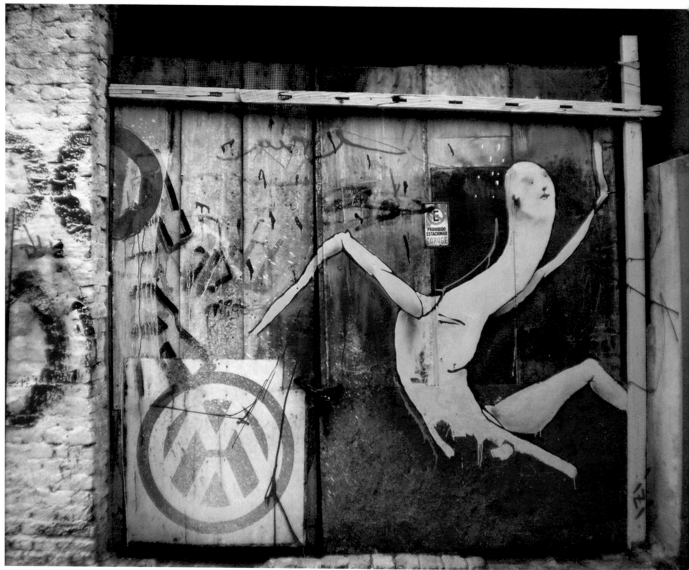

*Buenos Aires, Argentina · 2009*

# AIRE

– – – – – – – – – *I live in Buenos Aires and with the passing of time I transformed into Air. Light, loose, unstructured, and playful, daring to climb into those corners that the eye can see but doesn't know how to paint. That's how the days pass in my dear Buenos Aires, where I continue playing and being Air and I evaporate into each pore and tiny corner of those who have and want to have another vision of these walls. Air—belonging to everyone and no one. – – –*

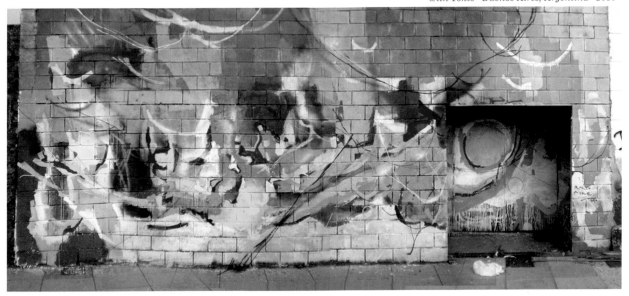

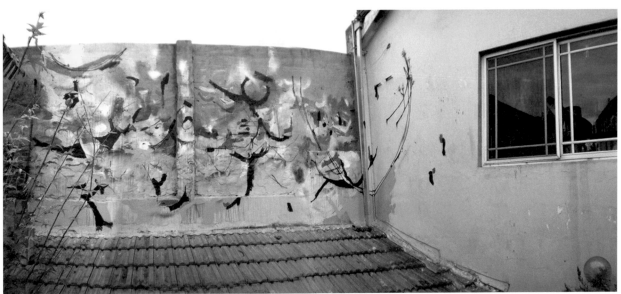

*with Tokio · Buenos Aires, Argentina · 2010*

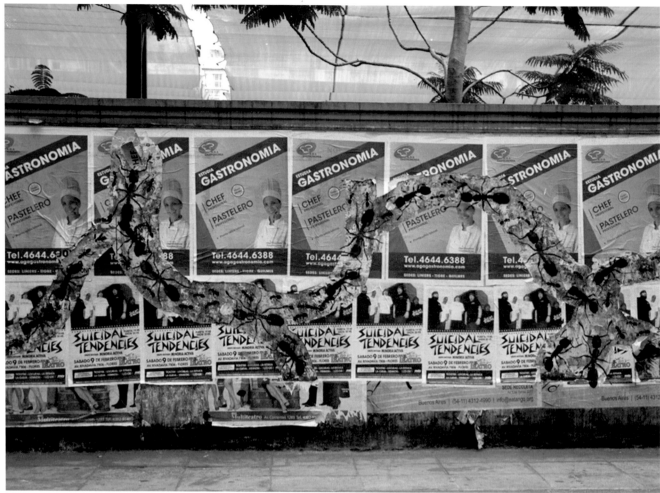

*Buenos Aires, Argentina · 2008*

# BUENOS AIRES STENCIL

———————————*Outdoor decorators? Stencil fundamentalists?*
*Buenos Aires' unconscious collective advertising agency? Vandals or*
*artists? Permission or forgiveness? The truth is... this whole "paint"*
*thing raises more questions than answers.* ———

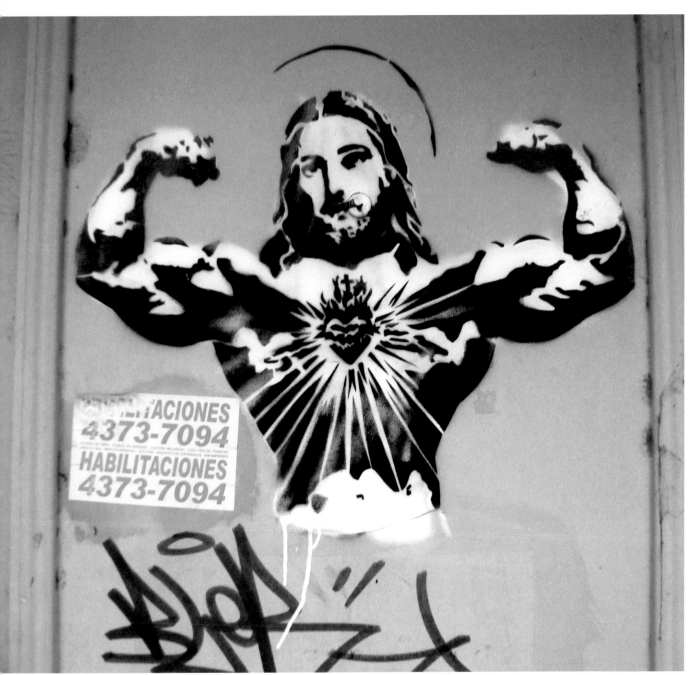

*Buenos Aires, Argentina · 2008*

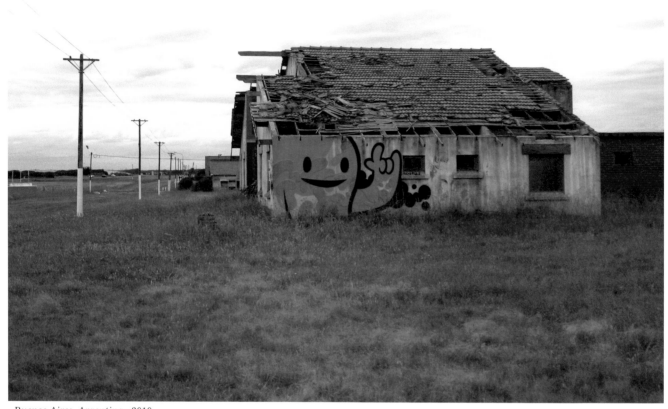

*Buenos Aires, Argentina · 2010*

*Buenos Aires, Argentina · 2009*

# CHU

– – – – – – – – Chu is the individual work of a member of the Doma collective, a place where he grows and develops as an artist, illustrator, and entertainer along with his friends. In 2003 he began to paint his characteristic series of figures on gray Buenos Aires with the idea of bringing color and happiness to the city. This project expanded, bringing these creatures to other corners of the planet. – – –

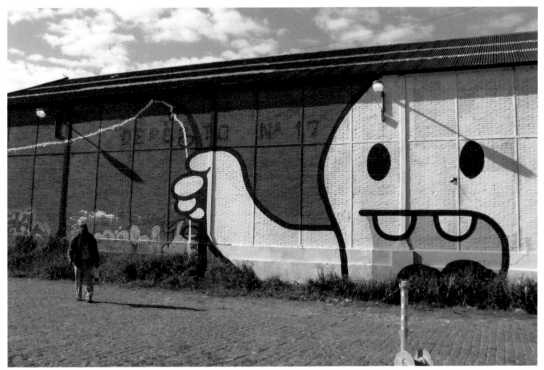

*Rosario, Argentina · 2008*

# DEFI

_––––––––– Painting saves me. –––_

_Buenos Aires, Argentina · 2008_

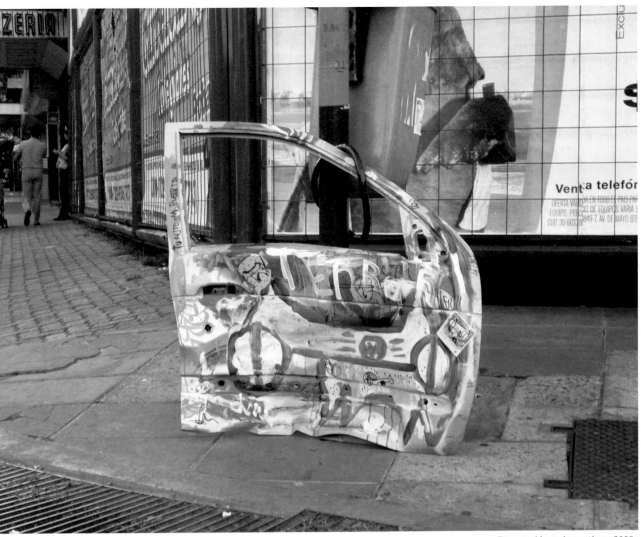

*Buenos Aires, Argentina · 2008*

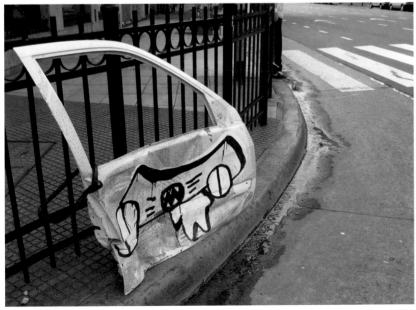

*Buenos Aires, Argentina · 2008*

*Berlin, Germany · 2007*

*Berlin, Germany · 2007*

# DOMA

—————————— *Doma is a collective of artists from Buenos Aires that arrived on the local street art scene in 1998 with stencils, installations, and campaigns of the absurd. After over 12 years of activity, they continue to develop through the creation of audiovisuals, characters, installation artwork, figures, etc. Their ironic conceptual style drives them to travel the world and meet brilliant people. ———*

# EMY MARIANI

*— — — — — — — — — — — — — — — — — — — — — — — On June 24, 1978 at 5:50 a.m.*
*I decided to be born 30 days ahead of schedule to testify to a worldwide*
*celebration full of blood and horror. At the age of 16 I graduated as an*
*advertising illustrator and two years later, in the style of advertising,*
*I decided to argue with the agency and dedicate myself to simply study*
*drawing. Although life smiles on me now, I will never stop drawing my*
*old friend, death. — — —*

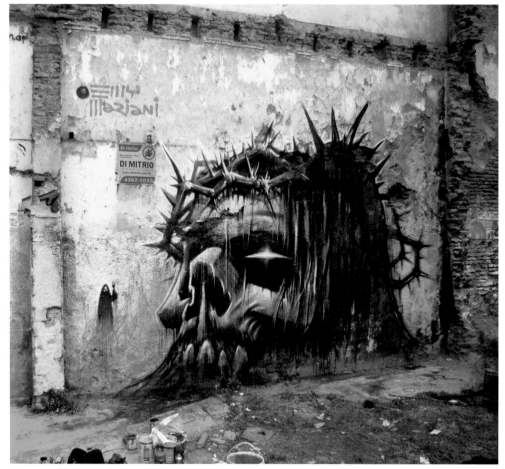

*Buenos Aires, Argentina · 2009*

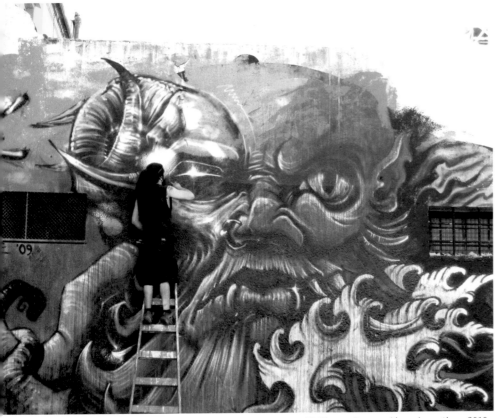

*with Virrey · Buenos Aires, Argentina · 2010*

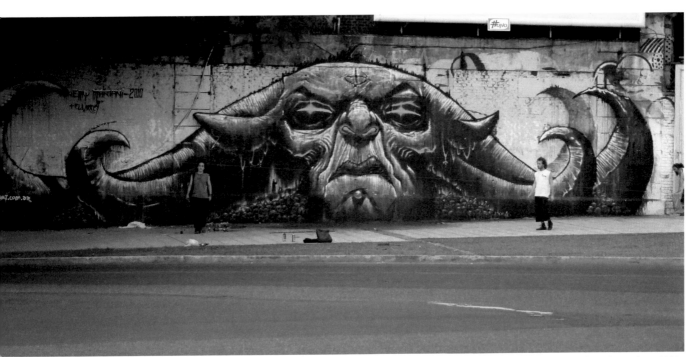

*with Hernan Coretta · Buenos Aires, Argentina · 2010*

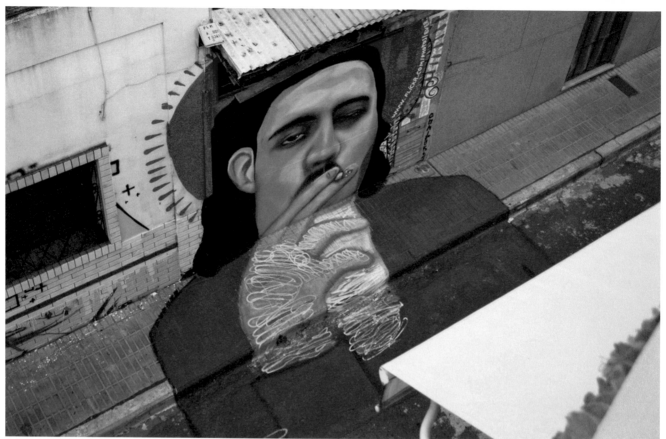

*Buenos Aires, Argentina · 2010*

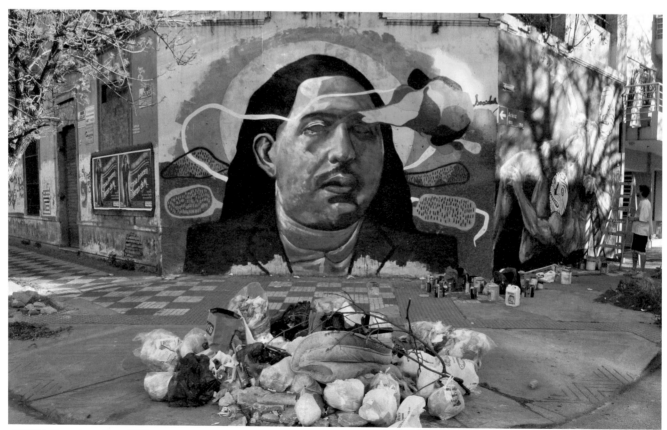

*Buenos Aires, Argentina · 2010*

# EVER

*—————————— Giving importance to the unimportant (using religious symbolism), so a normal character becomes deified. For example: when I paint my brother, people ask, "Who is he?" thinking that because I am painting him on a giant wall he must be someone important. When I tell them "It's my brother," they look at me sadly and say, "Oh, the poor boy died, didn't he?" And I tell them "No, I think he's at home watching TV." ———*

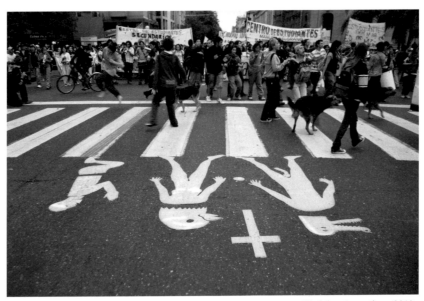

*Córdoba, Argentina · 2010*

# GROLOU

--------------- *In 2006 I left France to live in South America and since then I have only returned to my country once. In Argentina I got involved in street art, which was something new to me, and I couldn't stop. I want to transform neighborhoods into a window that encourages travel and imagination. Out in the open and for everyone! ---*

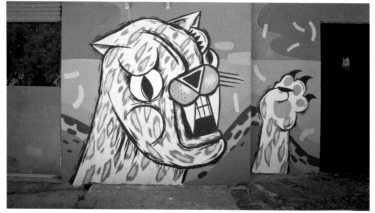

*Buenos Aires, Argentina · 2010*

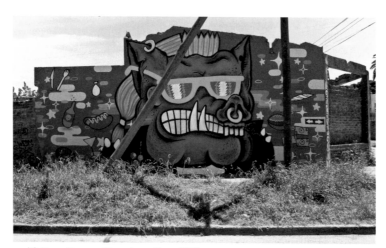

*with Ren · Buenos Aires, Argentina · 2010*

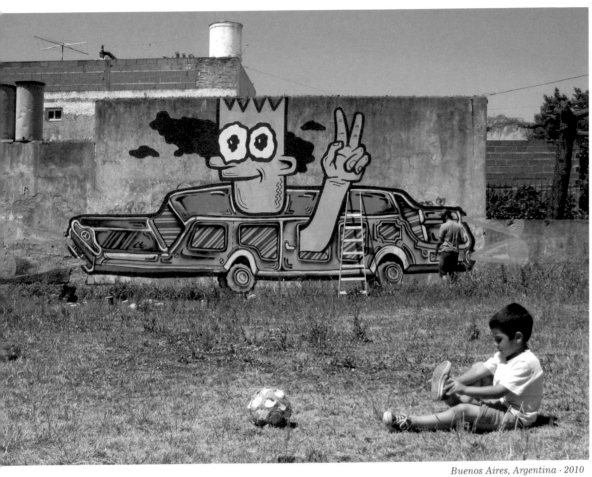

*Buenos Aires, Argentina · 2010*

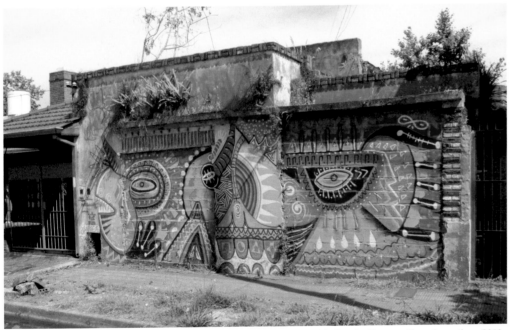

*with Sonrie · Buenos Aires, Argentina · 2010*

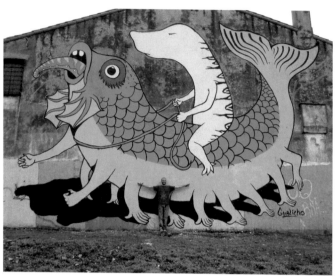

Buenos Aires, Argentina · 2008

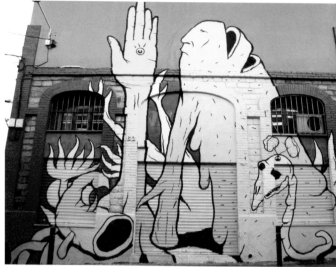

Barcelona, Spain · 2009

# GUALICHO

–––––––––––––––––––––– Gualicho is an ancient word that
means "spell"; although I prefer to use it as the ancient Chinese
used it: "Güi Chuan," which means boxing against demons or
celestial spells. My participation in street art in Buenos Aires was
very active from 2005–2008. Then I began to travel and paint in
cities in America, Europe, and Asia. I'm currently living in the
mountains in Córdoba Province. – – –

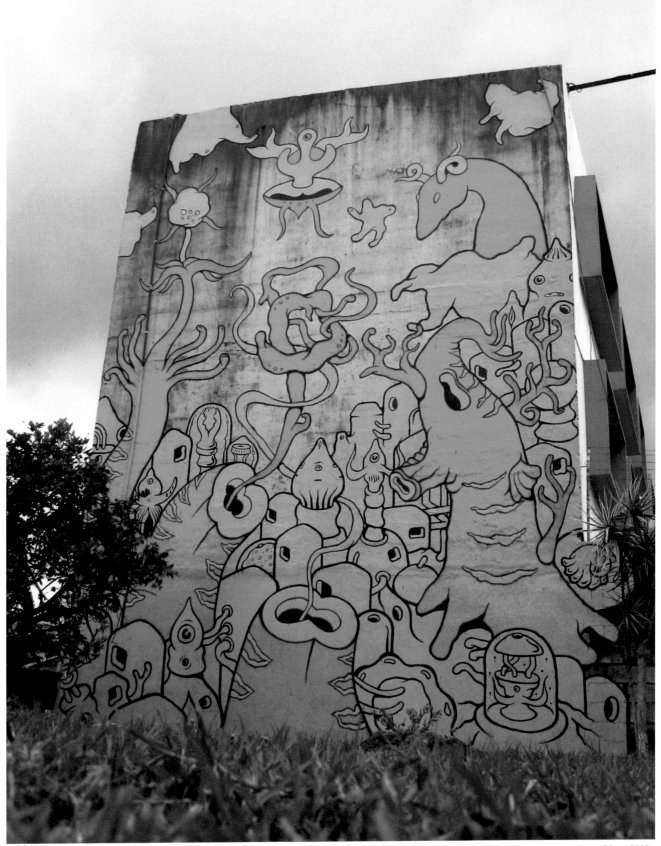

*San Juan, Costa Rica · 2009*

# JAZ

_------- I was born into a family of artists—musicians, painters, and sculptors. For as long as I can remember I've studied art, but it was painting in the street where I really found myself. Leaving my work to the grace of God without having to pile up artwork that nobody sees, on the contrary, out there is where I speak directly to the people. Amongst the noise and the elements is where I feel comfortable. ---_

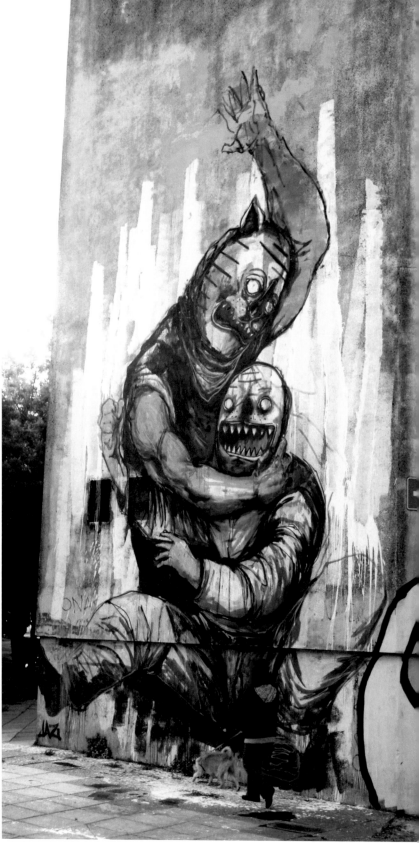

_Buenos Aires, Argentina · 2009_

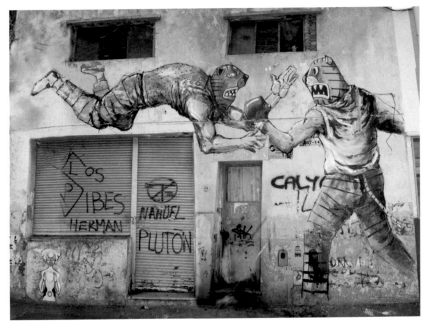

*Buenos Aires, Argentina · 2009*

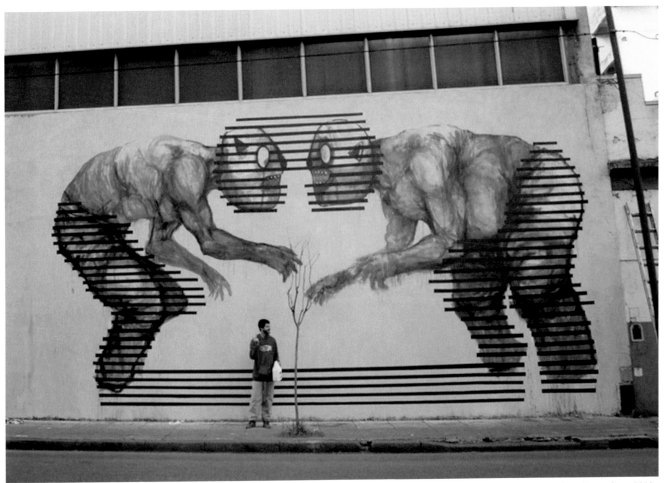

*Buenos Aires, Argentina · 2010*

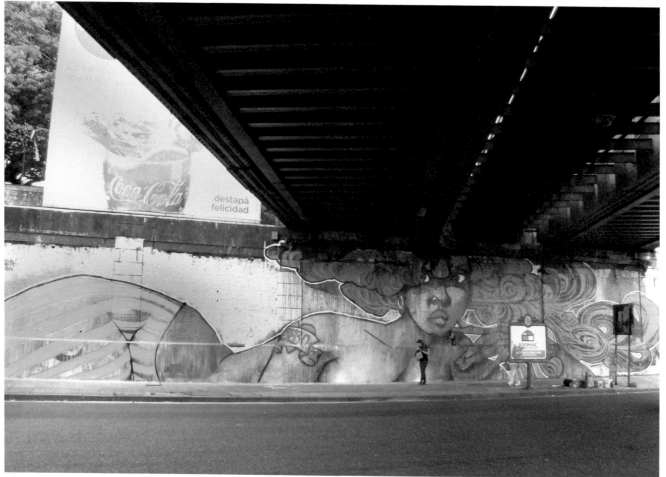

*Buenos Aires, Argentina · 2010*

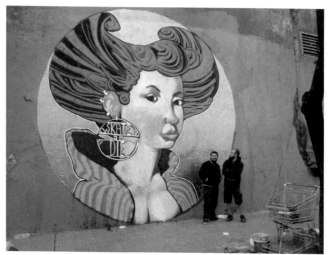

*Buenos Aires, Argentina · 2010*

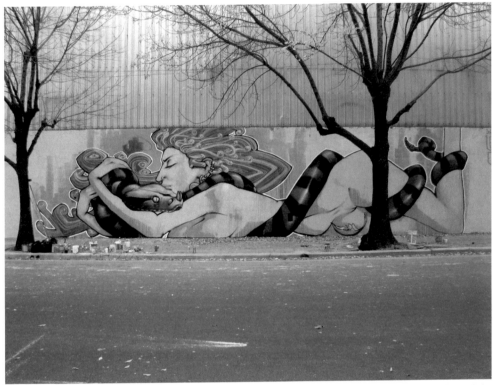

*with Emy Mariani · Buenos Aires, Argentina · 2010*

# LEAN FRIZZERA

------------------------------*Life gave me tools and placed me in this beautiful location. Each day I try to collaborate with identity and liberty and represent these Latin American lands. For me, street artwork is a way to give back with passion and dedication. ---*

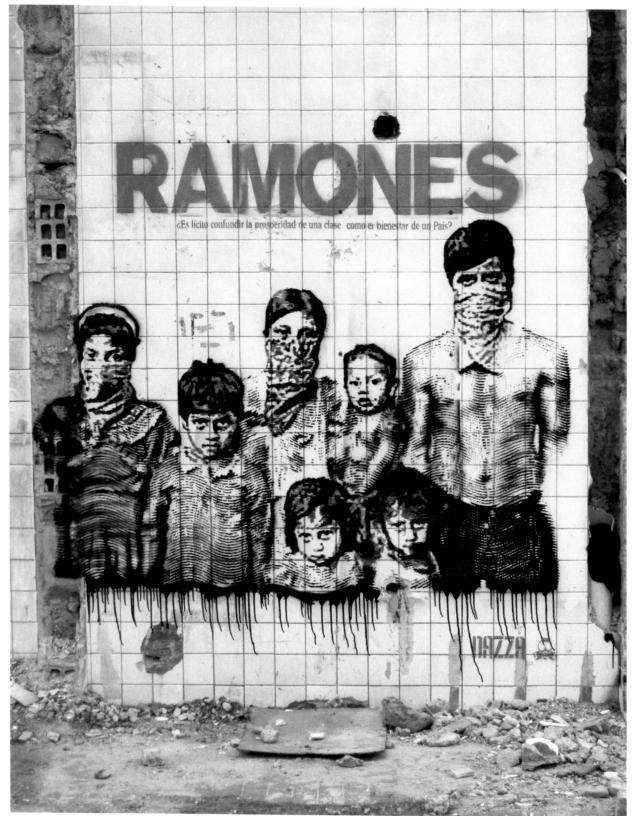

*Bogotá, Colombia · 2009*

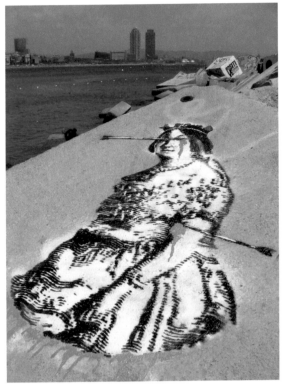

*Barcelona, Spain · 2008*

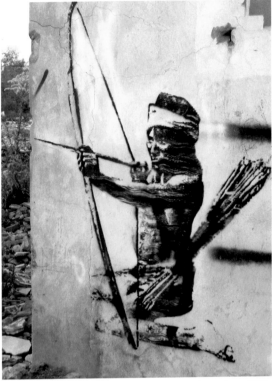

*Buenos Aires, Argentina · 2009*

# NAZZA

———————————— *I was born in 1978 in Tucuman, Argentina. I was raised and grew up in the Matanza neighborhood of Buenos Aires. I actively intervene in social life and I am devoted to my surroundings. I attempt to incite reaction, knowing I cannot change the world, but I can change my outlook on the world, and thoughts can be constructive: If your outlook changes, the world changes.* ———

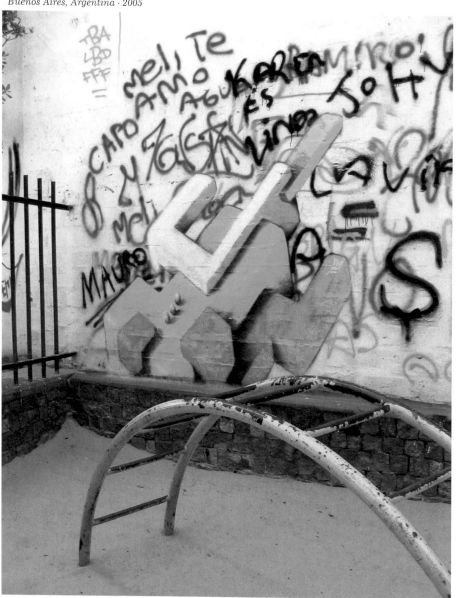

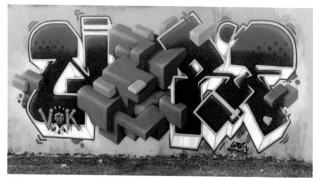

*Buenos Aires, Argentina · 2010*

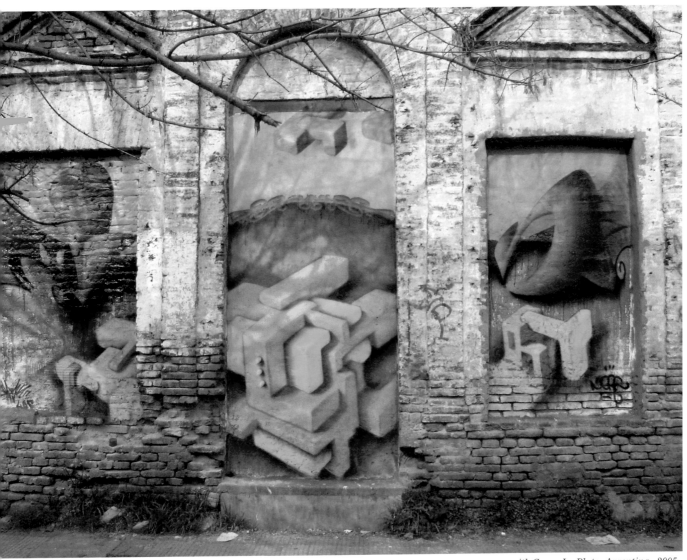

*with Caru · La Plata, Argentina · 2005*

# NERF

—————————— *I like graffiti in all its manifestations.*
*I let myself be inspired by all those who paint from the heart.*
*Graffiti doesn't have limits, you can always do something*
*new, and you can always learn something new.*
*I paint because it makes me feel free and it allows me*
*to be myself, without restrictions or rules.* — — —

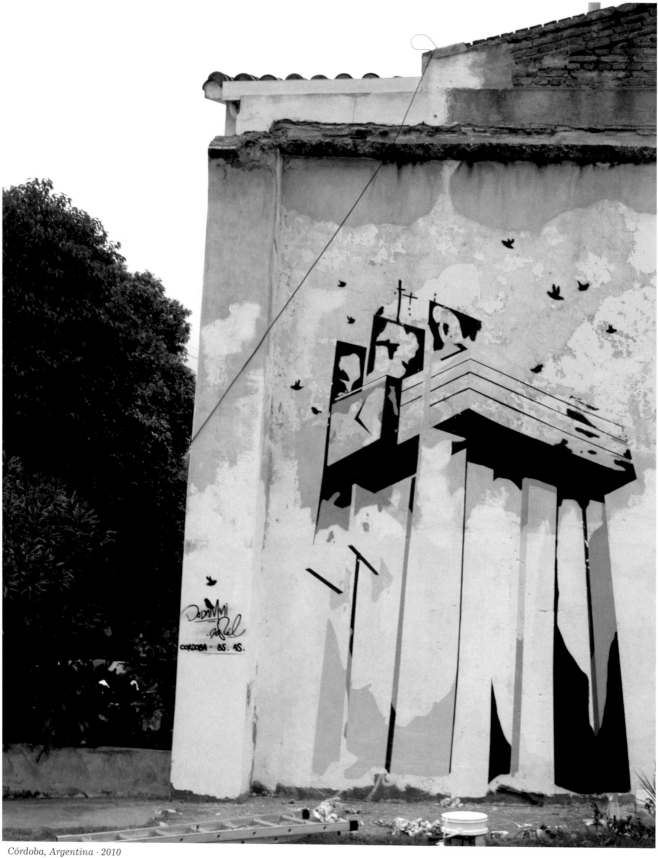

*Córdoba, Argentina · 2010*

# PASTEL

–––––––––––––– *In architecture from the 1930s
the architect Salamone is the one who began to clarify
the essence of concrete, the power of the material.
Conceptualizing this essence, I transfer it to walls or
fabric searching to re-document these buildings so they
maintain the monumental scale afforded them in relation
to the Argentine Pampas. –––*

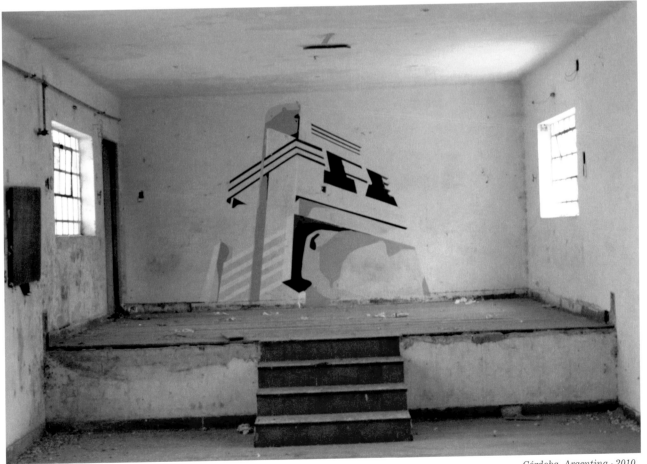

*Córdoba, Argentina · 2010*

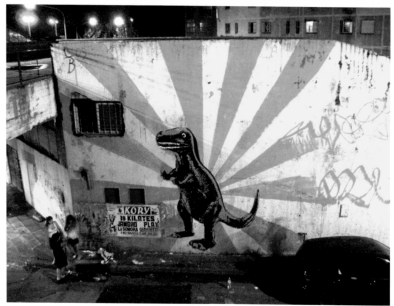

*with Tec · Buenos Aires, Argentina · 2010*

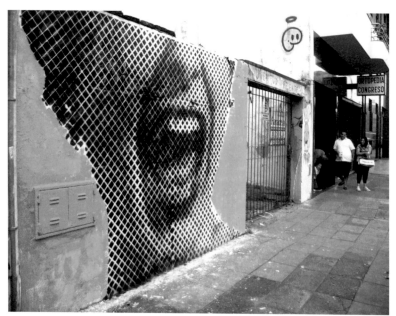

*Buenos Aires, Argentina · 2009*

# RUN DON'T WALK

– – – – – – – – – – *RDW began as a new, accidental collective in 2002, painting walls in the middle of the city. In those days we painted at the ideal height so a given stencil would be seen from the many buses that cross the narrow streets of Buenos Aires, in an almost futile attempt to change the routine of at least one passer-by. It appears many more people than we imagined saw those stencils… – – –*

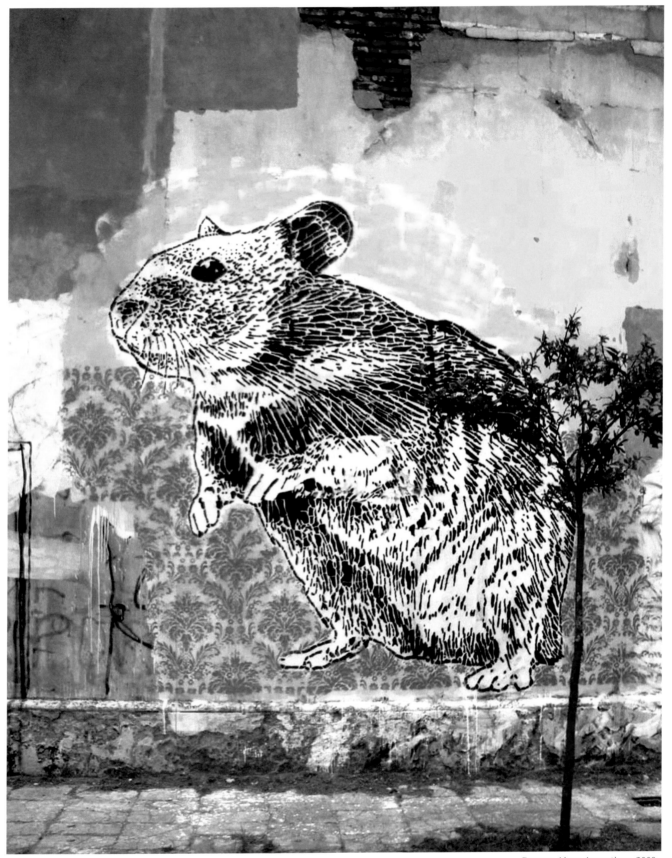

*Buenos Aires, Argentina · 2009*

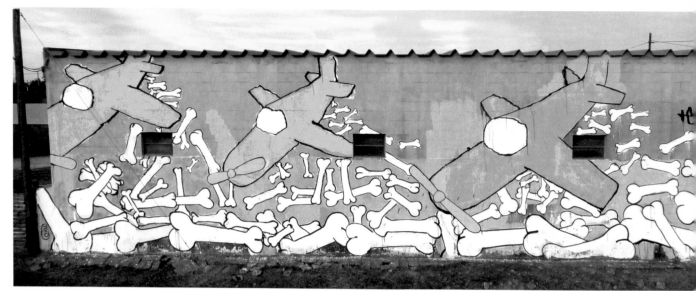

*Córdoba, Argentina · 2010*

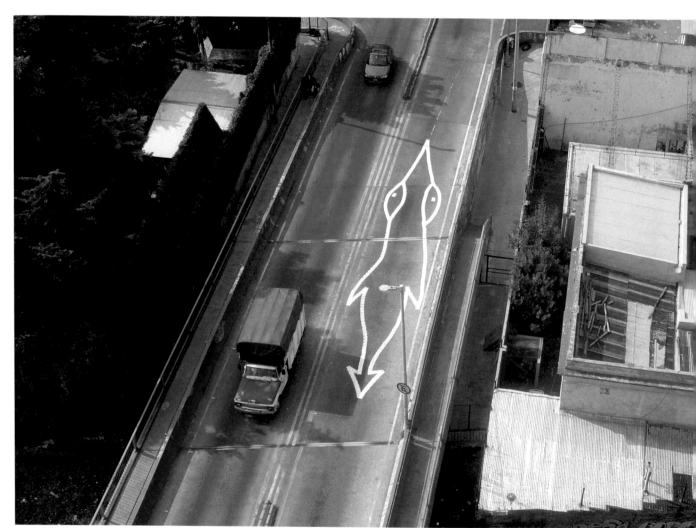

*Buenos Aires, Argentina · 2008*

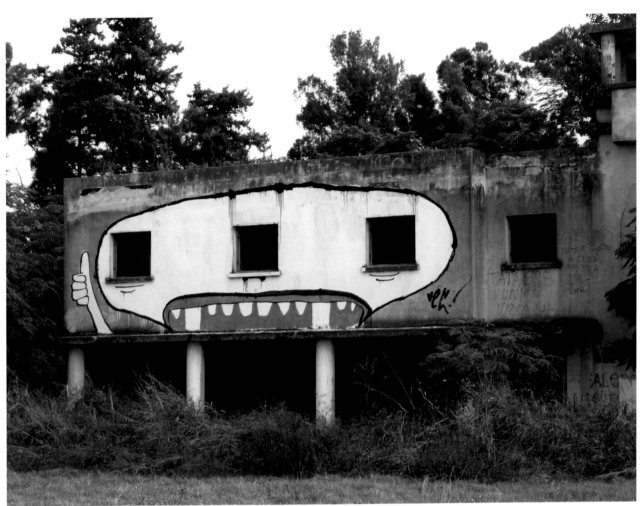

*Córdoba, Argentina · 2010*

# TEC

———————— *I was born in Córdoba, the city of cuarteto music and Fernet with Coca-cola. I paint because I don't know how to do anything else and I have sympathized with public actions ever since my grandmother took her table out onto the street and celebrated Christmas with the neighbors. Painting in cities that aren't painted yet is what fulfills me these days. ———*

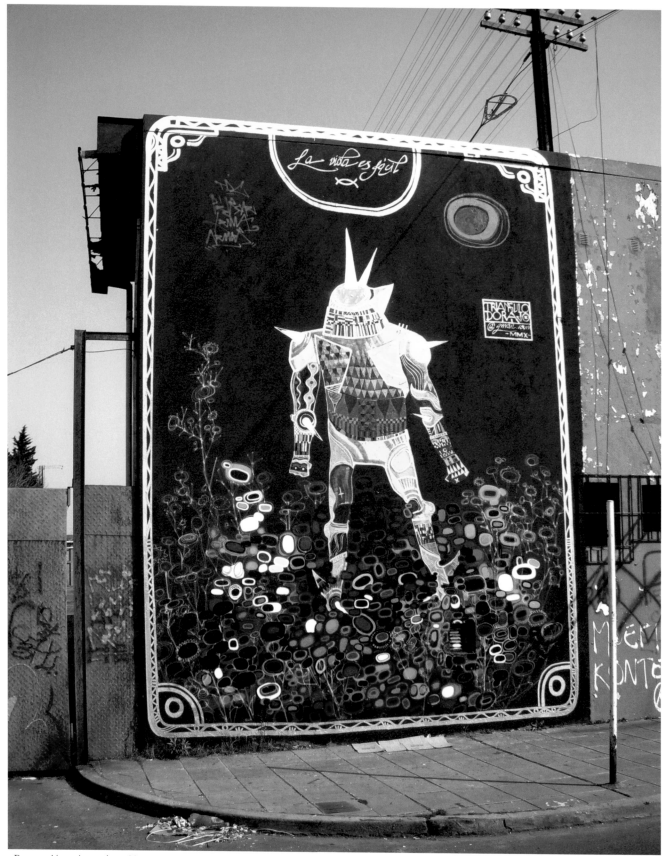

*Buenos Aires, Argentina · 2010*

# TRIÁNGULO DORADO

———————————— *We—Nemer, Lema, and Pedrone—began painting in the street individually in 2003–2004. We formed the crew in 2007, due to the need to communicate similar ideas and feelings. We are characterized by our group work achieving a singular image. We strive to create a space of reflection, remembering the elevated values of humankind. — — —*

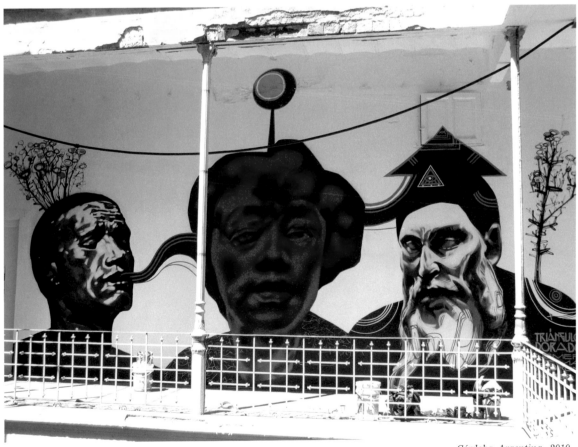

*Córdoba, Argentina · 2010*

# VOMITO ATTACK

———————————————————————— *Vomito Attack came about as a spontaneous response to the abuse of power that the mass media, big businesses, and politicians exercise. After witnessing the attack on the Twin Towers in 2001, I returned to Argentina during the worst economic crisis of our history. Protests and brutal repression by the police left forty dead in the streets. It was in that context that the group began to form and we went out to paint. ———*

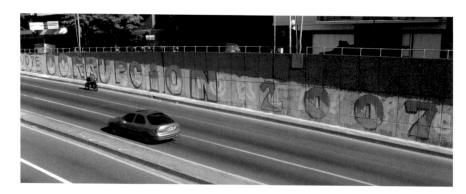

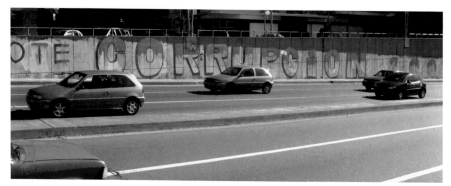

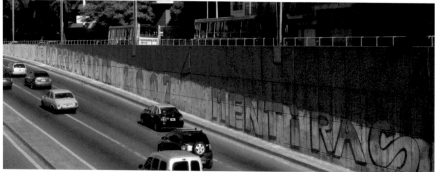

*Buenos Aires, Argentina · 2007*

· Agotok ·

· Aislap ·

· Blok ·

· Cekis ·

· Charquipunk ·

· Crudo ·

· Dees ·

· Esec ·

· Inti ·

· Kelp ·

· Don Lucho & Quillo ·

· Mato ·

· Piguan ·

· Pobre Pablo ·

· Ren ·

· Saile ·

· Yaikel ·

· Yisa ·

# CHILE

# G

———————rowing up in Santiago during a time
of repression almost made me believe that free
and public expression was a utopian ideal. I still
remember the political murals of the Camilo Torres,
Ramona Parra and Brigada Muralista, which
made a strong impression on me when I was a boy.
I think the opportunity to help fill in a part of the
design on a political mural forged in me a small but
sufficient hope that someday I would be able to do it
in on my own in a different context.

——— The great number of murals currently painted
in Chilean streets could be related to or compared
with the old practice of political mural painting
carried out in Santiago at the end of the 1960s,
when youth groups organized themselves in
brigades to create collective murals with specific
themes or simply for propaganda.

——— However, the street painting that emerged in
the 1990s was totally different from the political
murals because it was born in a different period
and with a new generation of young artists,
influenced mainly by the contemporary Western
culture coming from the United States and Europe.

——— Graffiti, an imported global culture mixed
with the Chilean muralist tradition, originated as a
consequence of a unique historical situation in our
country. The 1980s brought new influences to our

*culture through television and film, while at the same time popular expression of our own tradition was censored and prohibited. Towards the end of the 1980s, Chile went through a period of important changes in civic life, when liberty and civil rights came to be respected once again after the 17-year-long military dictatorship came to an end.*

*– – – The new situation in the country sparked the return of many exiled politicians, who came back to live with their families in a country in the middle of a political transition. I would say this is when what we know now as Chilean street art was formed. At the beginning of the 1990s, you began to see the first names of this new activity in the streets of Santiago, mainly made by people who had grown up outside of the country, many of whom were the children of exiled politicians and others who were not, who came from countries where graffiti and hip hop culture was already well developed. Some were Sent/Sten (Berlin), Sick888 (Paris), Dzeas (Los Angeles) and Jimmy Jeff (Italy).*

*– – – Even at this time there were already some local graffiti exponents who were mainly b-boys. These new signatures with spray paint, which were so different from the scrawling of soccer fans, gave me the desire to learn to do it and the determination to begin appropriating public space in a more open socio-political context.*

*– – – But in the mid-1990s, the growth of graffiti in the streets was noticeable, and some neighborhoods of the capital became points of reference for graffiti, such as Macul, La Florida, Nunoa, La Reina, Santiago Centro, Recoleta, and Huechuraba. You*

*began to see the names of different crews and a popular culture was in the process of forming. It was at this time that a group of Brazilian artists was invited to participate in the first international graffiti jam in Santiago in 1996. Among them were Binho, Os Gêmeos, Vitché, Speto, and Tinho from Brazil and Cray from Argentina. This cultural exchange was a key turning point in the evolution of Chilean graffiti. The local graffiti writers began to search for their own style, influenced now by other Latin American artists and our common history, and without the pressure to following traditional styles.*

*– – – Many years have passed since the first tags could be seen on the walls of the capital, which were then transformed into works of art that changed the city forever. At the beginning it would have been impossible to think we would be able to paint with the ease and liberty we have now. The growing openness of the common citizen to this type of expression and the development of new techniques and methods of work that allowed us to make do with our resources and were perfected over time, have helped the growth and popularization of this activity.*

*– – – The current state of the Chilean street art movement is without a doubt a reflection of this convergence of social situations, political experiences, and exchange of information between different people, which somehow explains the diversity of expression found on the streets at the last stop in Latin America (Chile).*

**Cekis** – – – – – – – – – – – – – – – – – – – – – – –

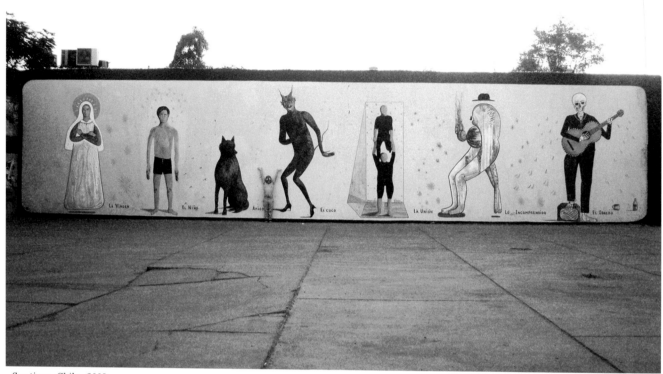

*Santiago, Chile · 2009*

# AGOTOK

––––––––––––––––– *We define ourselves as a self-taught collective without any formal art education. We are a step away from being artists and create our work without profit and illegally. We are currently active and in full force, and we support the belief in sustainable design, which is self-financed and has social content, evoking figures and symbols from South American popular culture, religion, and folklore.* –––

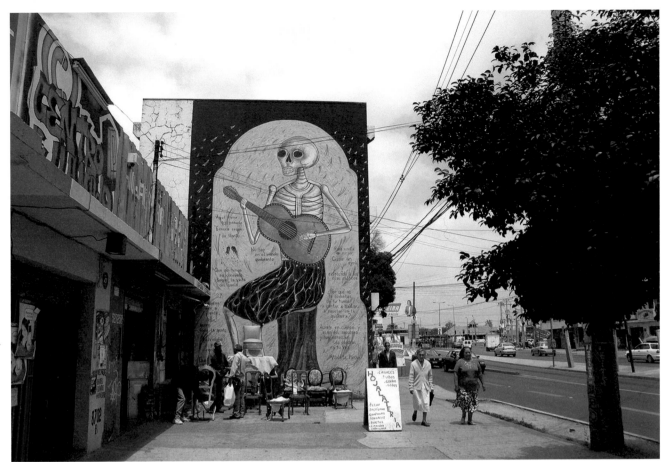

*Santiago, Chile · 2009*

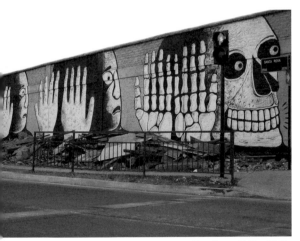

*Santiago, Chile · 2010*

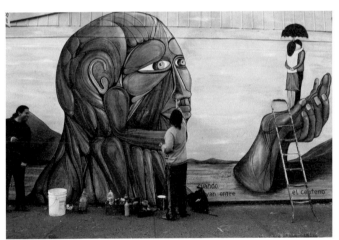

*Santiago, Chile · 2010*

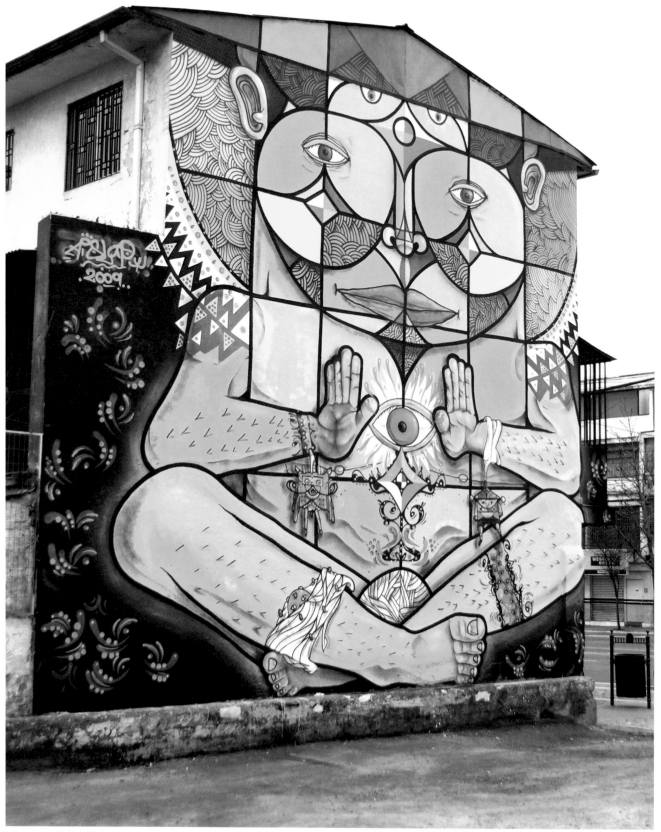

*Santiago, Chile · 2009*

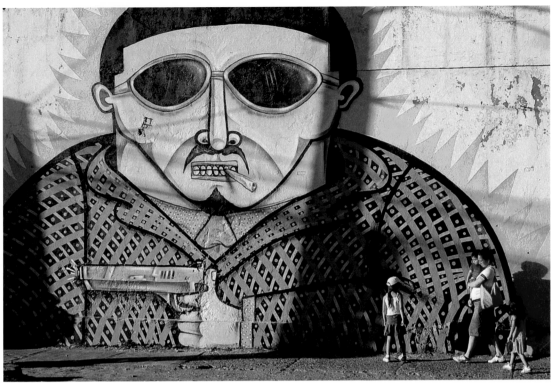

*Santiago, Chile · 2009*

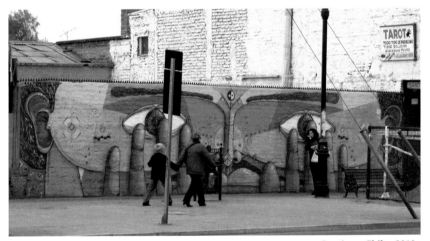

*Santiago, Chile · 2010*

# AISLAP

———————————— *We are Ais and Slap and together we form Aislap, which was born from our need to create something new, be original, and impose tendencies in our style. Our school of art has consisted of finding ourselves with the desire to paint and painting with what was available without compromising the quality of our work. We do everything from letters to murals, and the constant feedback between the two creates new styles that enter into our creative cycle. ———*

# BLOK

*—————————— It's like water…and its characteristics, that's approximately what I try to do in different ways. Often it's like a sport or a game with my friends. It's entertaining to see how these things change and grow with you. ———*

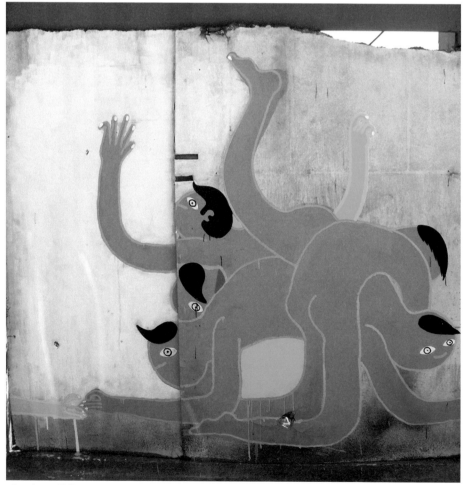

*Santiago, Chile · 2008*

*Santiago, Chile · 2008*

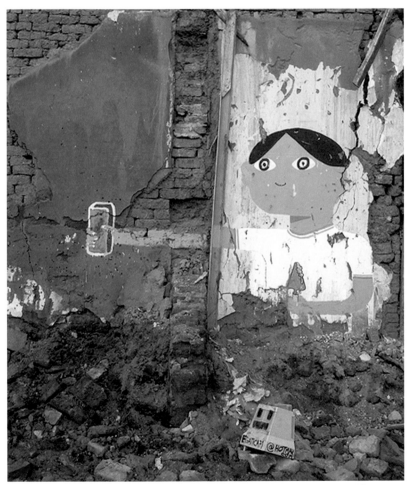

*Santiago, Chile · 2008*

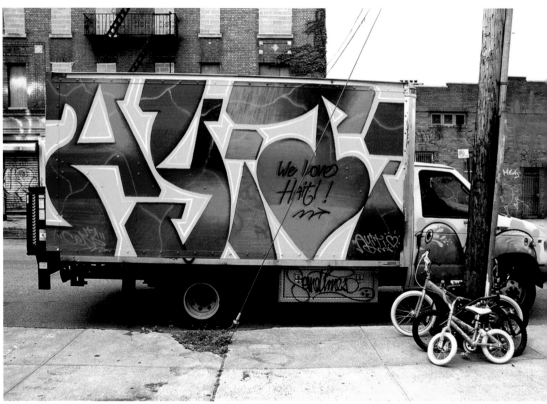

*New York, United States · 2010*

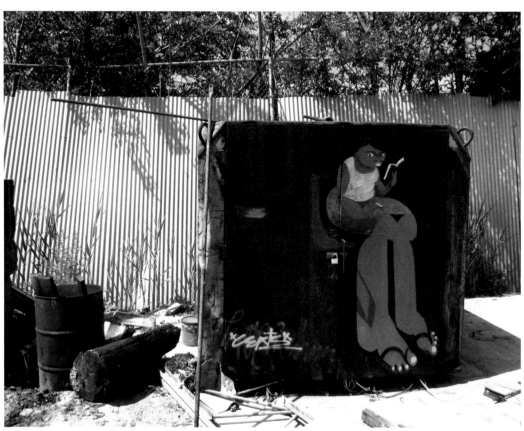

*New York, United States · 2006*

# CEKIS

*———————— A life of painting in the streets of Chile and Latin America is a difficult option for anybody, but it's been a way of life for a while now and it's real. The lack of resources and information in Latin America helps us improvise and create bonds between colleagues in order to learn from each other, exchange information, and thus evolve. ———*

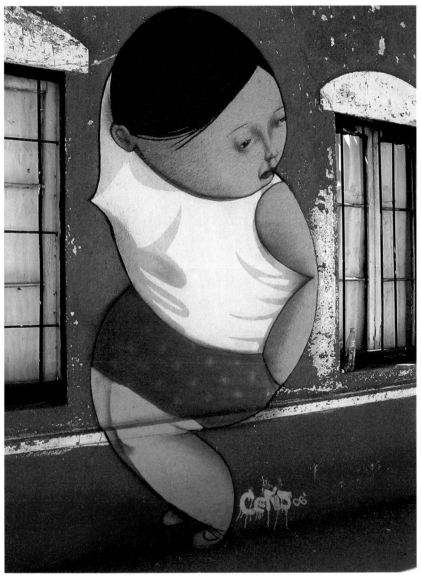

*Valparaíso, Chile · 2006*

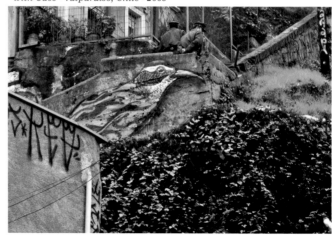

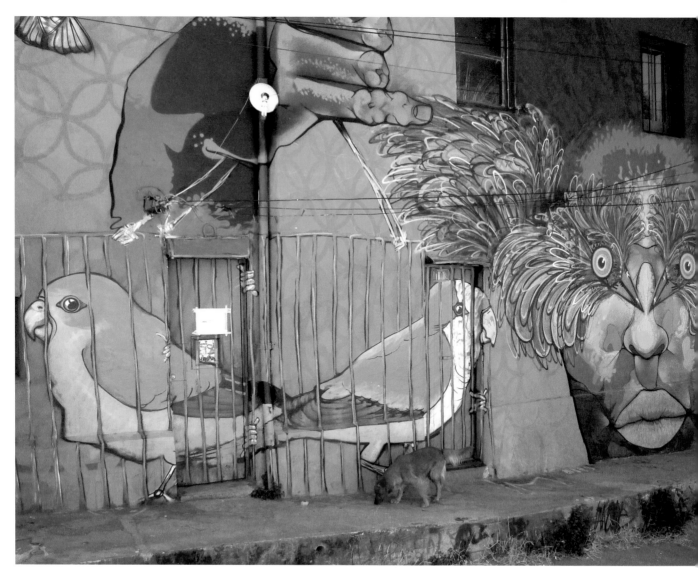

*with La Robot de Madera · Valparaíso, Chile · 2009*

# CHARQUIPUNK

—————————————————————————————————————— *I've been painting characters*
*on the walls of Valaparaíso since 2000, transforming them into icons of*
*the city. Influenced by pre-Columbian art and popular South American*
*traditions I obtained a palette of bright, burning colors from Andean*
*textiles. My innumerable travels around Latin America are reflected*
*in the murals I create with fellow artists from around the world.* ———

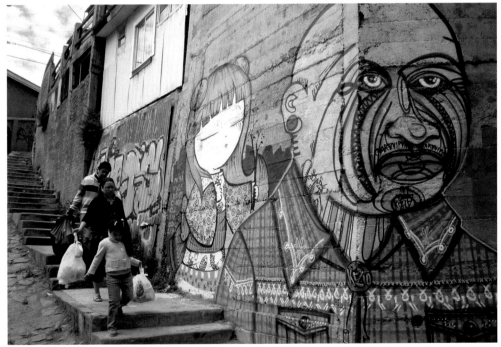

*with Julieta · Valparaíso, Chile · 2009*

# CRUDO

*——————————— It's like a bottle you toss into the sea: You throw it because you enjoy it, for fun. But you'd like someone to find it and try to understand it or think about it. I don't mean people who are obsessed and always do the same thing, but others. It's just that they "don't get it." They ask themselves: "Why? What does it mean? Are they paid for it? Stop messing around!" That's how I remain calm, with humor and irony. You don't have to fall apart. ———*

*Valparaíso, Chile · 2009*

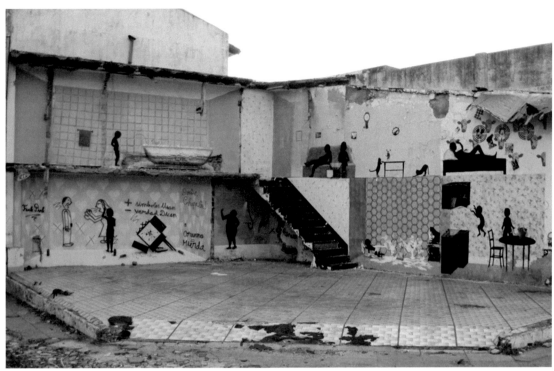

*Buenos Aires, Argentina · 2010*

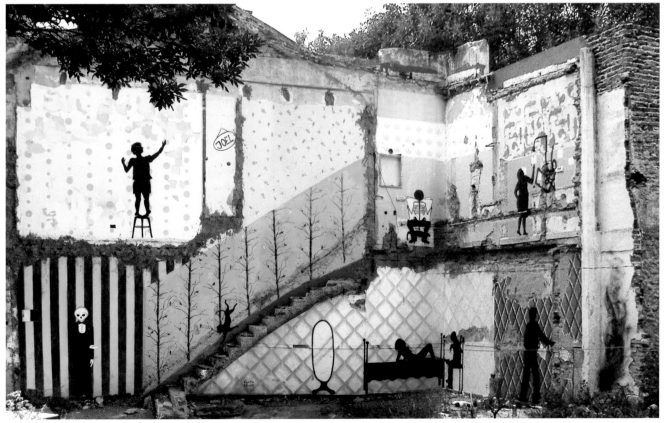

*with Facto · Buenos Aires, Argentina · 2010*

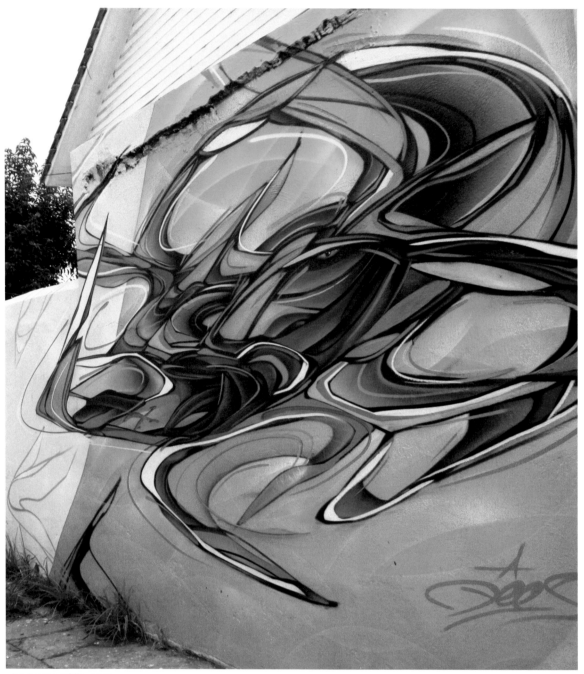

*La Serena, Chile · 2009*

# DEES

_— — — — — — — — — I'm a designer and graffiti writer from Contulmo in the Bio-Bio region of Chile. I joined the scene in 1998, painting my first lines in Concepción and Coquimbo. That's how I began to liberate myself from the everyday in an abstract way. Through graffiti I began to adapt and transform colors and their surroundings, turning my philosophy about living every moment into reality, and along the way enhancing the gray monotonous corners of the city. — — —_

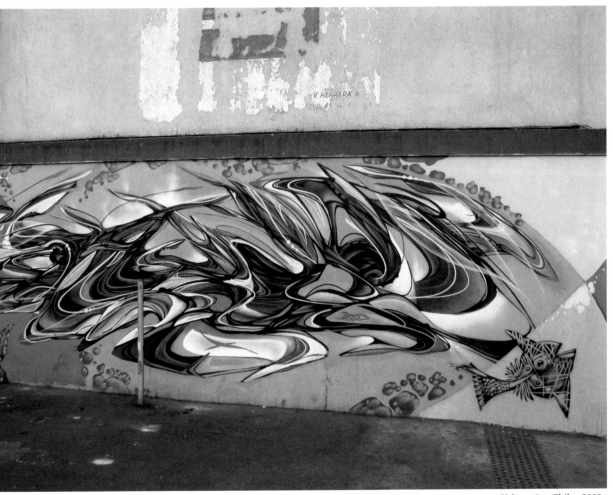

_Valparaíso, Chile · 2009_

# ESEC

*————————— Art is subjective but it should have a purpose when the intervention is made in public spaces. ———*

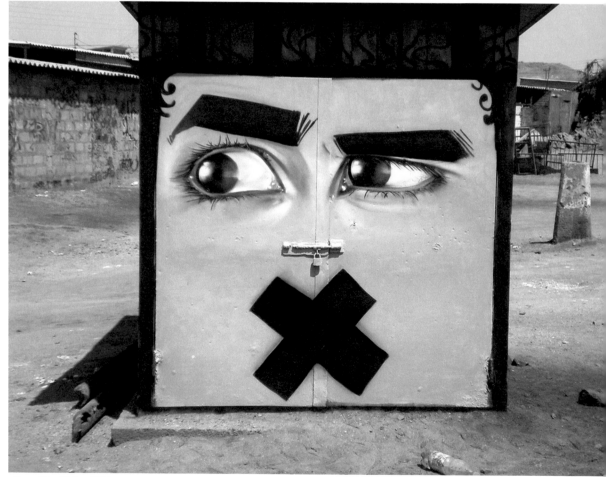

*Tocopilla, Chile · 2006*

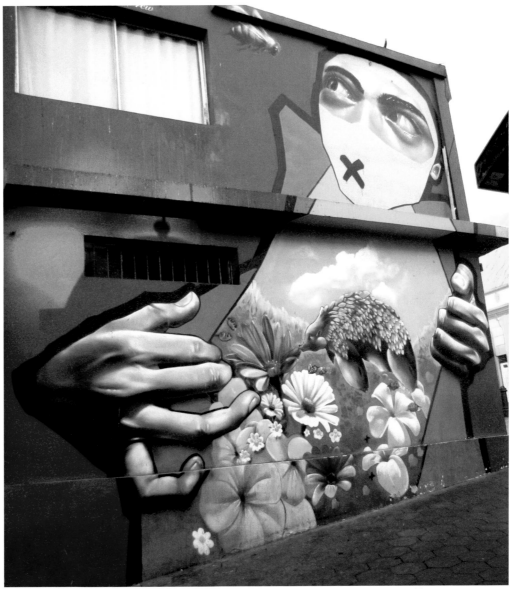

*with Erre and Ibarek · Tocopilla, Chile · 2009*

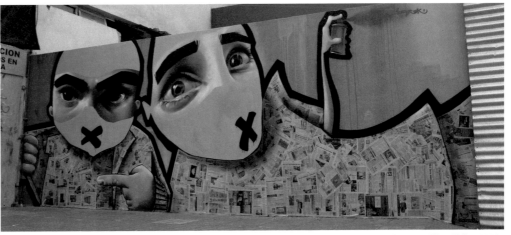

*with Ibarek · Tocopilla, Chile · 2008*

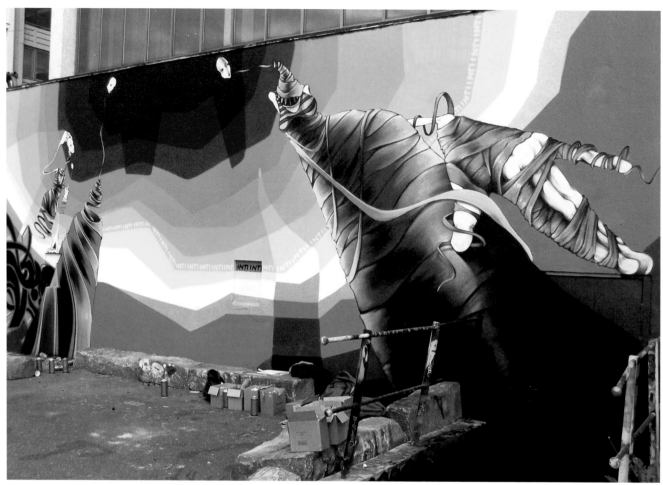

*Bergen, Norway · 2008*

# INTI

———————— *I'm a Chilean artist from the city of Valparaíso. I was influenced by Latin American murals and began to search for a local language to characterize my work. The abuse of iconography and saturated colors can be seen in my work, reminiscent of pre-Columbian art fused with the vast aesthetic of graffiti.* –––

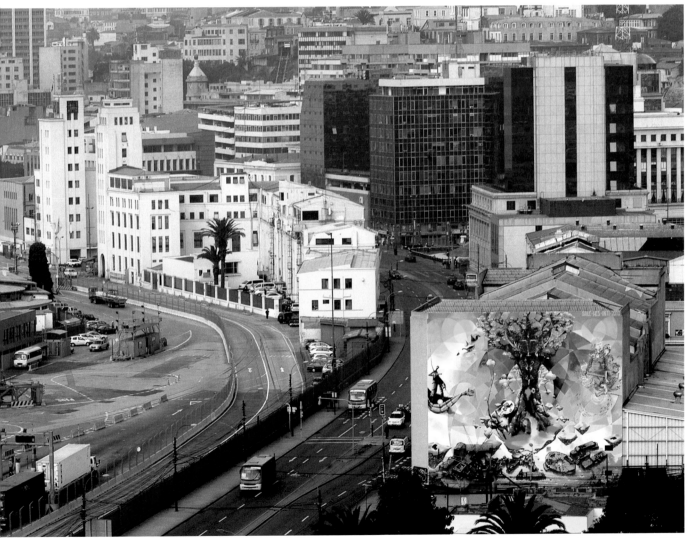

*with Hes and Saile · Valparaíso, Chile · 2010*

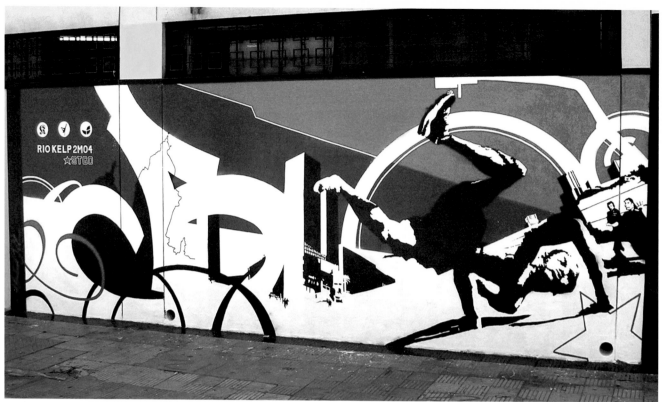

*with Rio · Santiago, Chile · 2004*

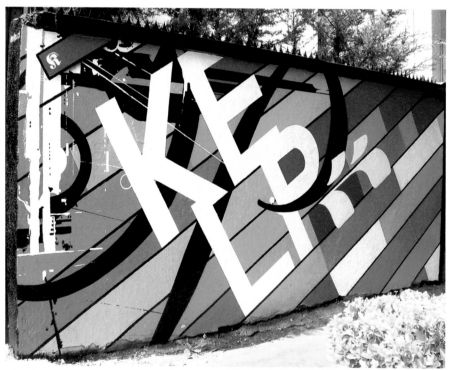

*Santiago, Chile · 2008*

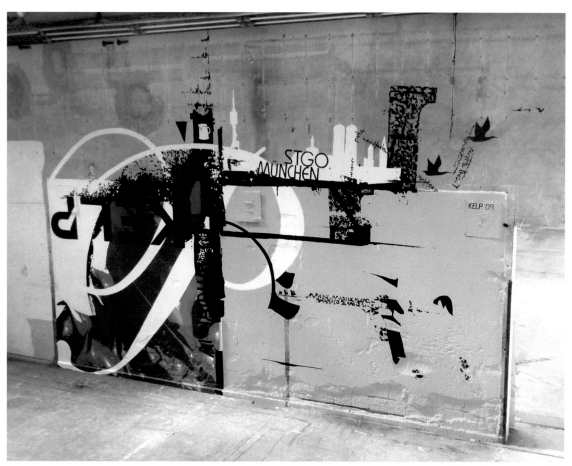

*Munich, Germany · 2009*

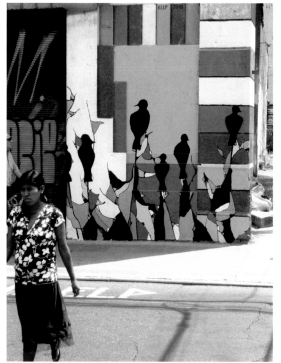

*Santiago, Chile · 2010*

# KELP

————————— *I began photographing graffiti in 1996 in Santiago. I investigated, drew, conversed, and wandered around different places to paint and see murals. By night or by day I was accompanied by tagging and friends. With time I painted bigger and more complex murals to cheer up the passers-by with color and messages. My job is to communicate to the public with the aim of bringing graffiti to the passers-by. ———*

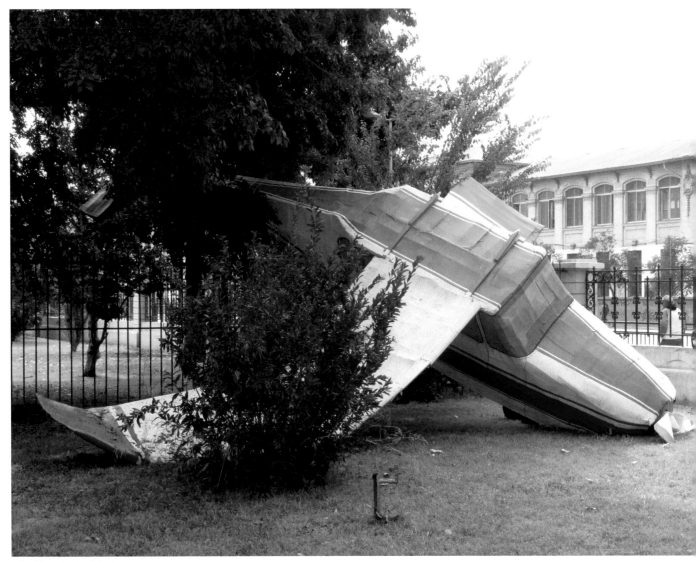

*Santiago, Chile · 2010*

# DON LUCHO & QUILLO

*— — — — — — — — — — — — — — — — — — — — — — — — — — — — — — — — Don Lucho: A couple of years ago*
*I began to wonder what was going on in the streets. Maybe I used to walk too fast, although since*
*then I haven't discovered any mysteries or lies, except those from advertising. But what*
*I did realize is that most people still walk too fast and they don't question anything.*

*Quillo: I've lived in Santiago, Chile since I was a child, and I've always thought it was a gray city.*
*I'd like to contribute to something that lifts it out of its homogeneity for the common passer-by but*
*with the ability to surprise. Not like a commercial, but like a moment of revelation that is at once*
*everyday and absurd. — — —*

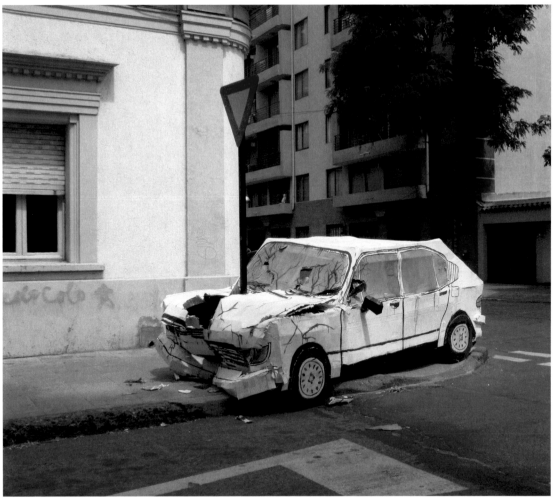

*Santiago, Chile · 2009*

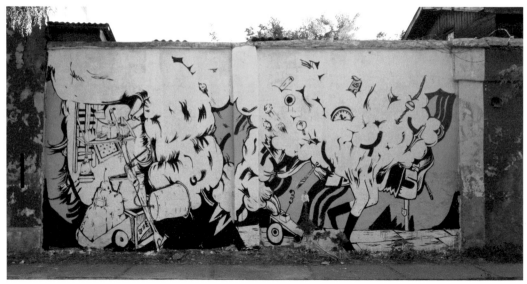

*Santiago, Chile · 2007*

# MATO

––––––––––*Latin America is like a big collage produced by hybrid cultures, sustained by the garbage of the global village. I think of my paintings as diagrams and systems of relationships with a spectator, whoever he or she may be. It's a way of presenting ideas and problems, climates and mental situations, emotions, vague and concrete ideas about the human condition and the real world and the culture we form a part of. –––*

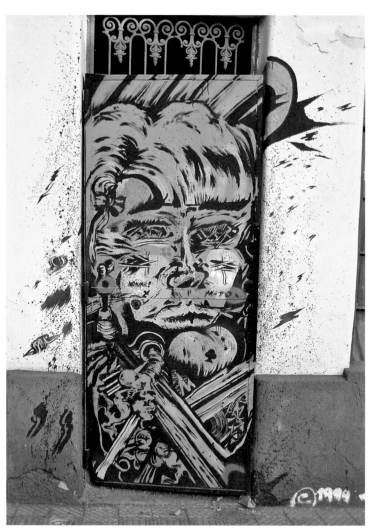

*Santiago, Chile · 2009*

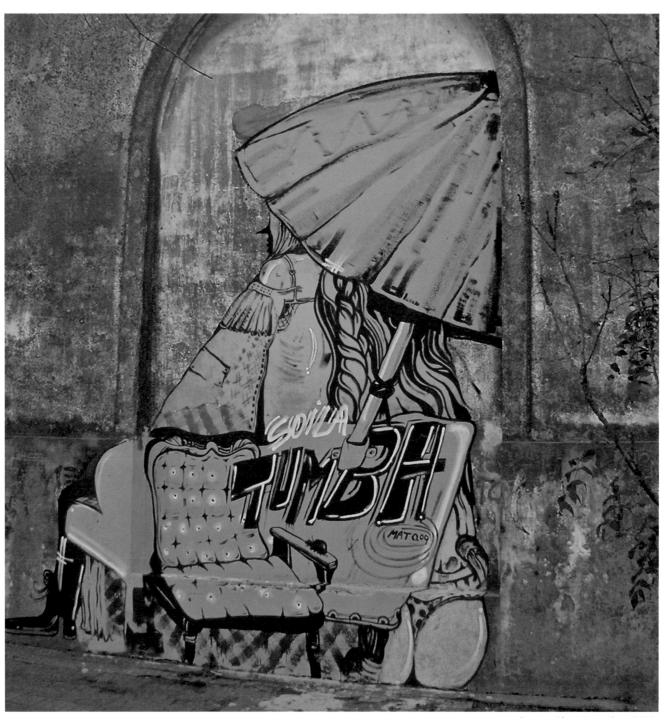

*Buenos Aires, Argentina · 2010*

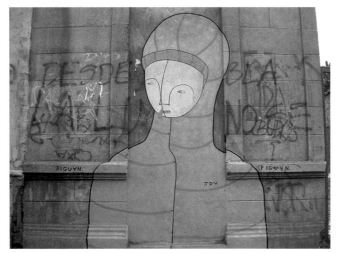

*Santiago, Chile · 2005*

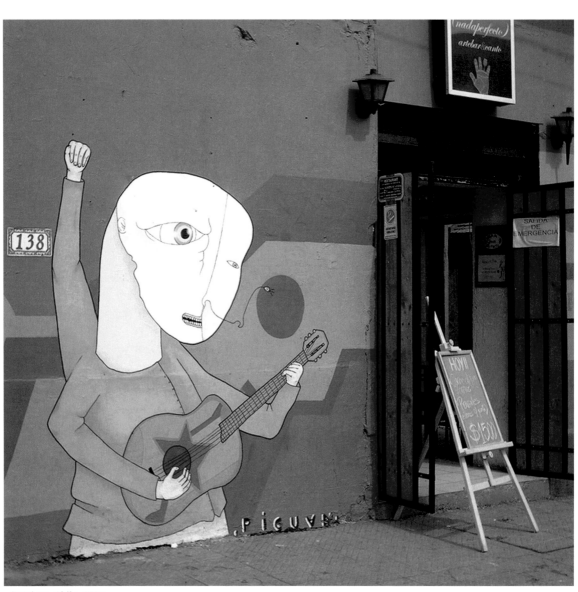

*Santiago, Chile · 2008*

# PIGUAN

*——————————— Most of my murals are made without sketches, I don't worry about drawing first to be able to paint. I just choose the place and allow what I feel to come out of my stomach. I like the paint to speak for itself. People's free interpretation is what enables me to understand why I paint. ———*

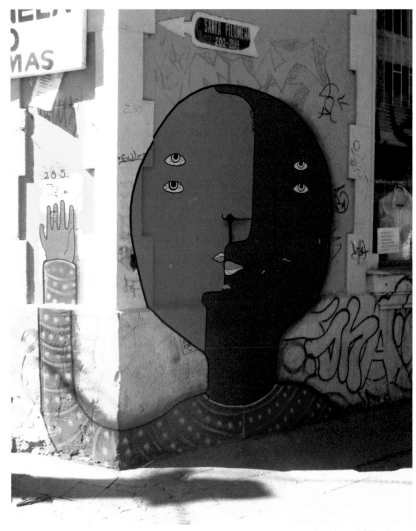

*Santiago, Chile · 2006*

163

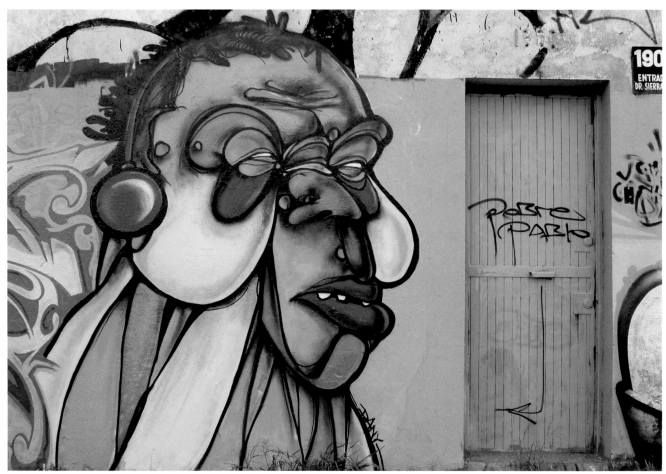

*Santiago, Chile · 2007*

# POBRE
# PABLO

———————— *My country suffered a terrible military dictatorship over three decades ago; this devastated our culture and identity. Chilean people lack attitude, are fearful, and poor of spirit and materialistic. Education is horrible, as is the health system, there's a lot of poverty and it's sad. Rather than talking about my graffiti, I prefer to use this space as a window onto the surroundings we Chilean artists have. ———*

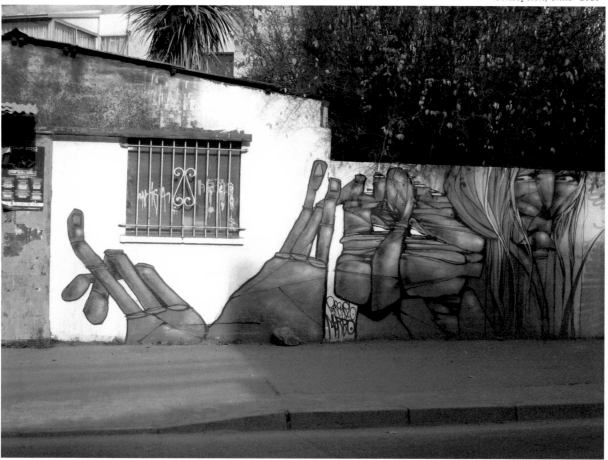

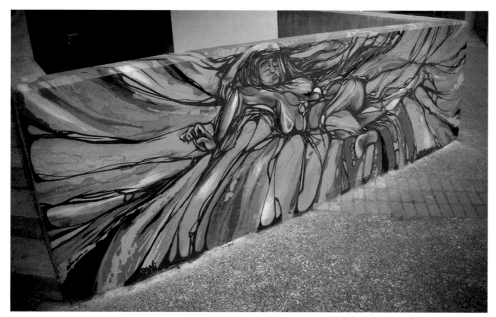

*Santiago, Chile · 2008*

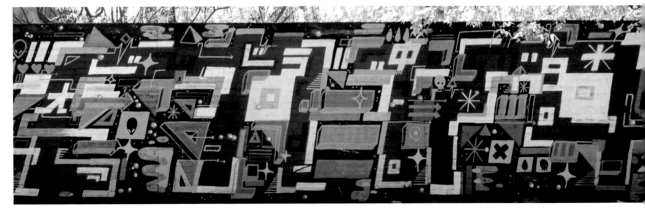

*Buenos Aires, Argentina · 2010*

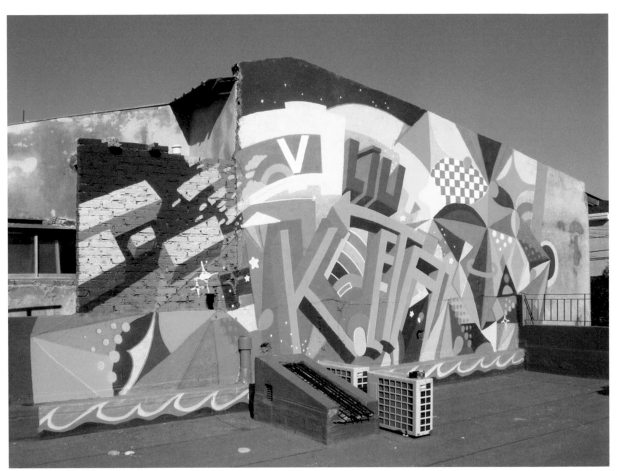

*with Grolou · Buenos Aires, Argentina · 2010*

# REN

–––––––– *As an active member of the WSDM crew, Ren has been able to integrate his professional life as a graphic designer with his passion for urban intervention to create a unique and recognizable geometric style, which is at once both fluid and contrasting. His work turns the streets into an immense laboratory of free experimentation where the results demonstrate the creativity of contemporary Chile. –––*

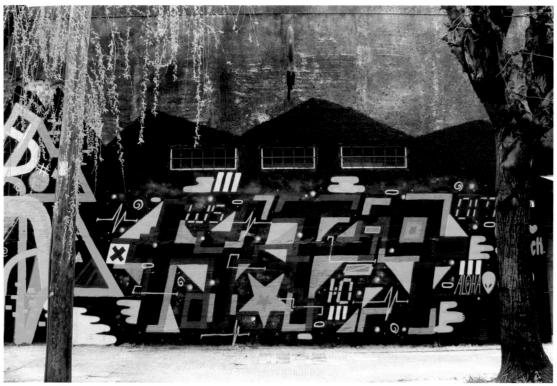

*Buenos Aires, Argentina · 2010*

# SAILE

*– – – – – – – – – – – I was born in 1983 and cartoons were my primary artistic reference. My first contact with street art was in 1996 through my brother, which is how I learned about the essence of this art. In 2000 we created the Que Miras? crew, using graffiti as our primary lifestyle, and began to work as artists. – – –*

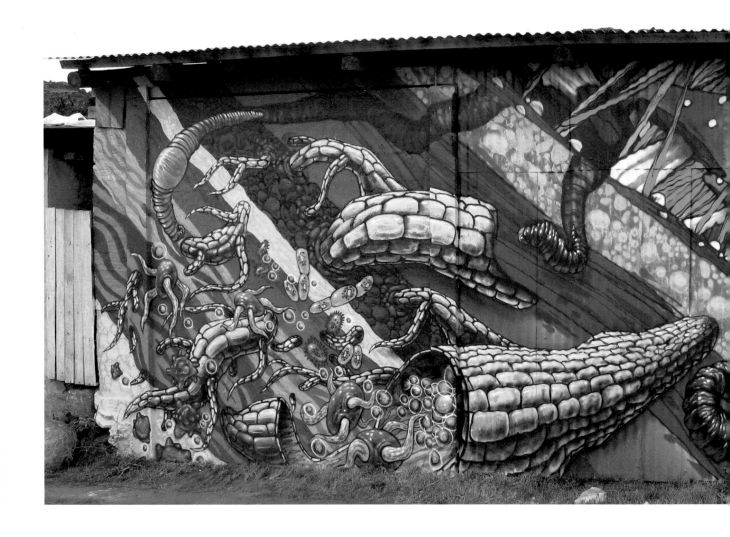

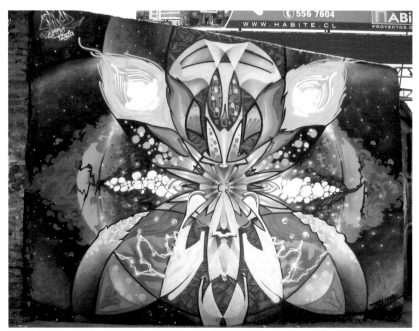

*with Portal · Santiago, Chile · 2010*

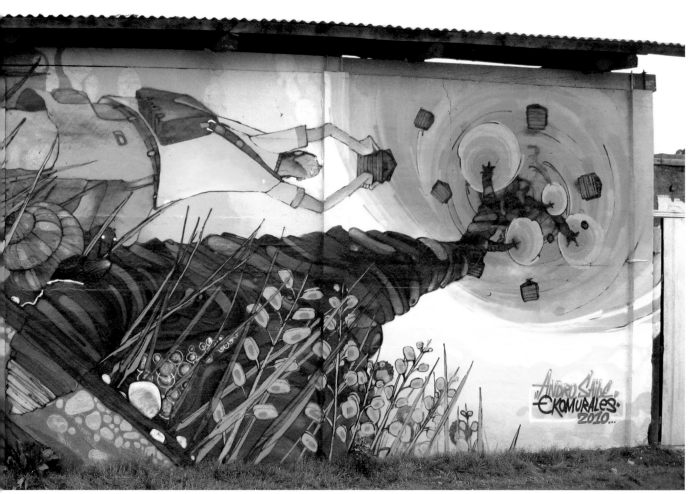

*with Andro · Lolol, Chile · 2010*

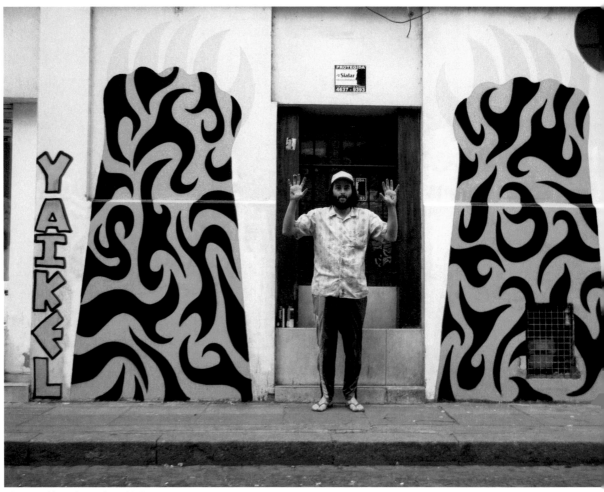

*Buenos Aires, Argentina · 2010*

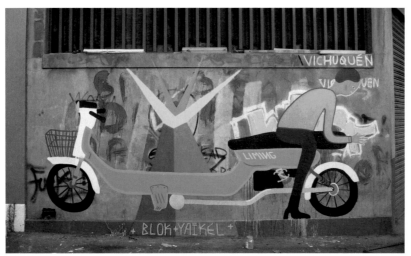

*with Blok · Santiago, Chile · 2009*

# YAIKEL

*———————————— I refer to nature and the search for truth in order to speak about what I believe deserves to be revealed —exploring the relationship between man and nature. There's a strange equilibrium in the use of geometry, which is just what ancient cultures also archieved. ———*

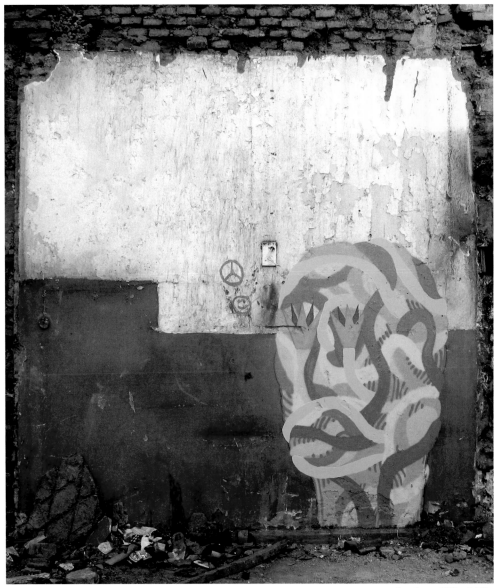

*Santiago, Chile · 2009*

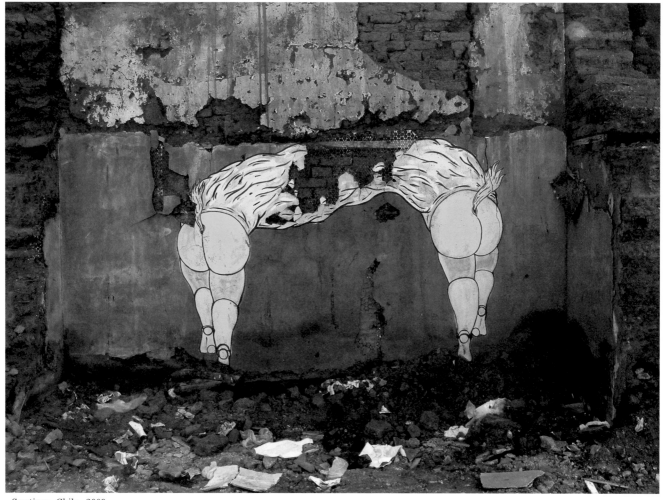

Santiago, Chile · 2009

# YISA

————————— My public work has political intentions
as it is situated in run-down and deteriorating places.
It's a gesture which is given in tension by a range of
strong, bold colors that act like conceptual maps of ideas
regarding the dominion of the church, the capital, etc.
Finishing my process with a photograph is a gesture
that allows me to accept the temporary nature of a work
made in public. ———

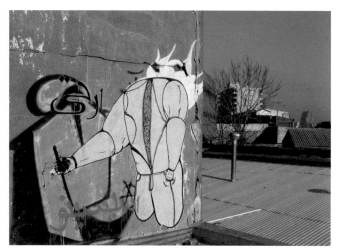

*Santiago, Chile · 2008*

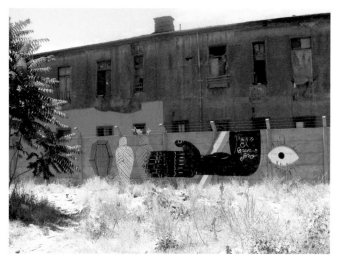

*Santiago, Chile · 2010*

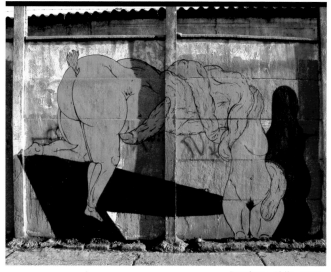

*Santiago, Chile · 2008*

· Basik ·
· Decertor ·
· Faber ·
· Fuma Kaka ·
· Jade ·
· Marco Sueño ·
· Naf ·
· Pésimo ·
· Physe ·
· Seimiek ·
· Wesr ·

# PERU

I

— — — — — *n Peru the majority of the street art scene is centered on Lima, the capital of the country with the highest population density due to migration during the last decades.*

— — — *The rise of street art in Lima happened at the end of the 1970s when the country was militarized due to subversive groups taking up arms. The street was then a dangerous place. Bombs, kidnappings, curfews, and barricades were common in those days. City dwellers saw the street as a hostile place, where any expression or cultural activity would be viewed as suspicious, and living an isolated life with your back to the street became normal. Painting, protesting, and expressing yourself in the middle of the conflict was risky; political and subversive paintings appeared and disappeared.*

— — — *In the 1980s groups like the Bestias, Huayco, and La Gente del Averno produced resistance art, breaking the silence with political and social complaints, communicating through murals, posters, and installations in the middle of all the disinformation, blackouts, repression, and death. They created some spaces of free cultural exchange.*

— — — *From the musical scene, bands like Narcosis and Leuzemia came out with slogans like "you have*

*have to destroy before you build" and "the rest can go to hell," which show the nonconformity that a large sector of the youth felt in the face of existing models.*

*——— At the end of this decade, gangs formed from groups of soccer fans began to take to the streets and create the first signatures with spray paint. Names like Trinchera Norte, Comando Sur, Secuaces, Sepulcro, Locura, Sicarios and Cabezas Azules saturated the corners of the city with basic signatures inspired by the fonts used by gangs and rock bands.*

*——— In the 1990s the armed conflict dissipated and the political situation of the country gained a certain amount of stability. Along with a freer flow of information and the influence of the United States the first tags and throw ups appeared. Writers like Trans, Nozer, and Tibuk invaded the street with their graffiti. Some magazines and the internet inspired a new and growing generation, and groups like TR, Aerosoldiers, BHC, Efebele, and DMJC emerged.*

*——— This new generation inspired by graffiti remains rebellious but without such political and social aims. They developed a more colorful and refined aesthetic. Faced with the rising cost of spray paint, the limited color options, and the difficulty of getting caps, they began to experiment with new materials to generate a new aesthetic and their own language. By the year 2000, latex paint, enamels, stencils, rollers, and posters marked a new phase in the urban aesthetic.*

*——— The street sculptures of the Asombroso Circo Fantasma from the Fumakaka crew, sticker projects, and posters like those by Giuseppe de Bernadi and Marco Saldaña open up new possibilities for intervention. This is not only centered on the search for new materials, but also on the creation and use of new tools, such as fire extinguishers and fumigators full of paint, providing the option of painting in new formats. The use of sculpting tools was brought to the streets and the first etchings on concrete appeared.*

*——— By the end of 2000, the city, already densely populated, began to grow vertically, making it very easy to find houses set for demolition, which can be used as places for experimentation and the exchange of ideas.*

*——— As in most cities, street art is illegal. Lima continues to be a city with a high level of delinquency. People painting and intervening in the street is not a priority of the authorities. The majority of the police will detain you only to find out how much money they can get out of you.*

*——— Cultural developments are scarce, and municipalities keep punishing street expressions, holdovers of what they experienced in the 1980s and 1990s. Public space is allotted to commercial and political campaigns. Freedom of expression in the street belongs to those who can pay for it. Faced with this situation, street artists find ingenious ways to communicate. Groups like DMJC, Fumakaka, DA2C, Chikos Bestia, and GFC stay vigilant in sabotaging the system and creating new spaces for expression.*

**Naf** ————————————————————————

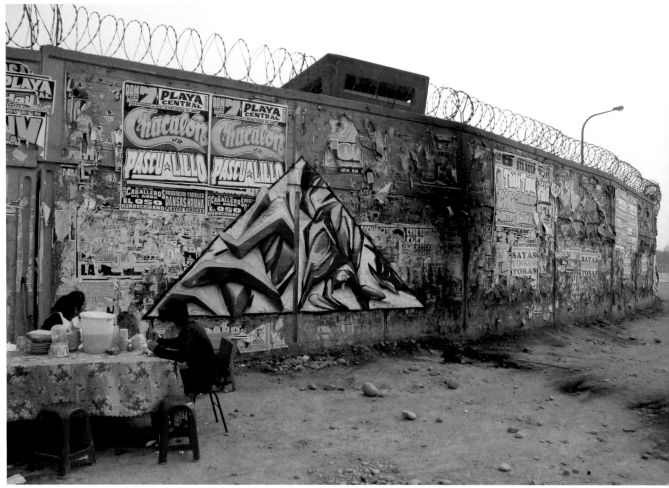

*Lima, Peru · 2010*

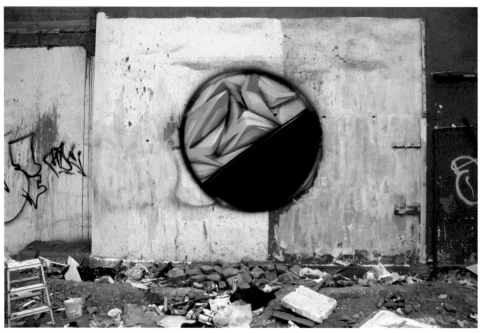

*Lima, Peru · 2010*

# BASIK

––––––––––––– *I define the way I paint as a blend of diverse elements, street art and graphic design, and I am particularly interested in aspects like three-dimensionality, perspective, aggression, and the intrusion into public space. I like to generate contrast, placing art where people don't expect to see it, or where there tends to be nothing more than garbage and deterioration.* –––

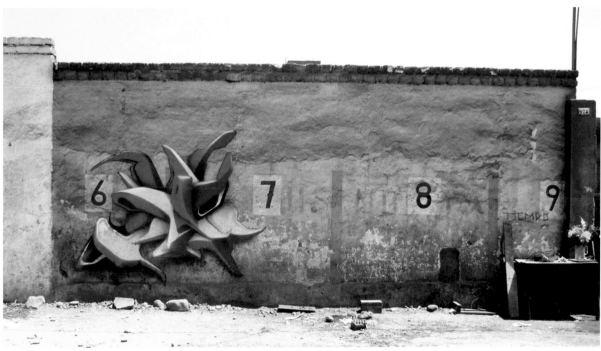

*Lima, Peru · 2010*

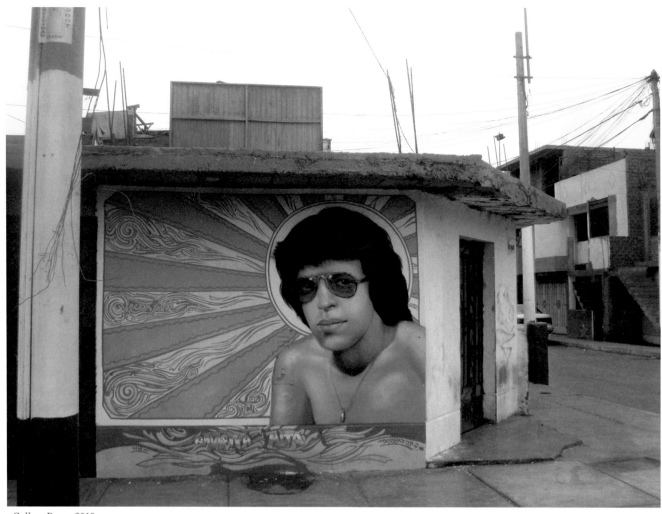

Callao, Peru · 2010

# DECERTOR

––––––––––––––––––––––––– *Soon after I began to paint,*
*I understood the power of images and the responsibility of painting in the*
*street, especially in a country where art does not hold an important place in*
*daily life. That's why I decided to orient my figurative work towards socially*
*themed content that people can identify with, without neglecting technique*
*and improving my skills.* –––

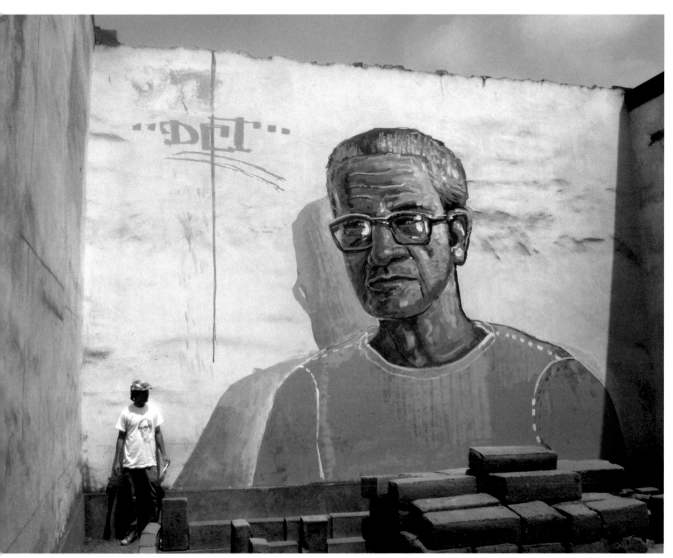

*Lima, Peru · 2010*

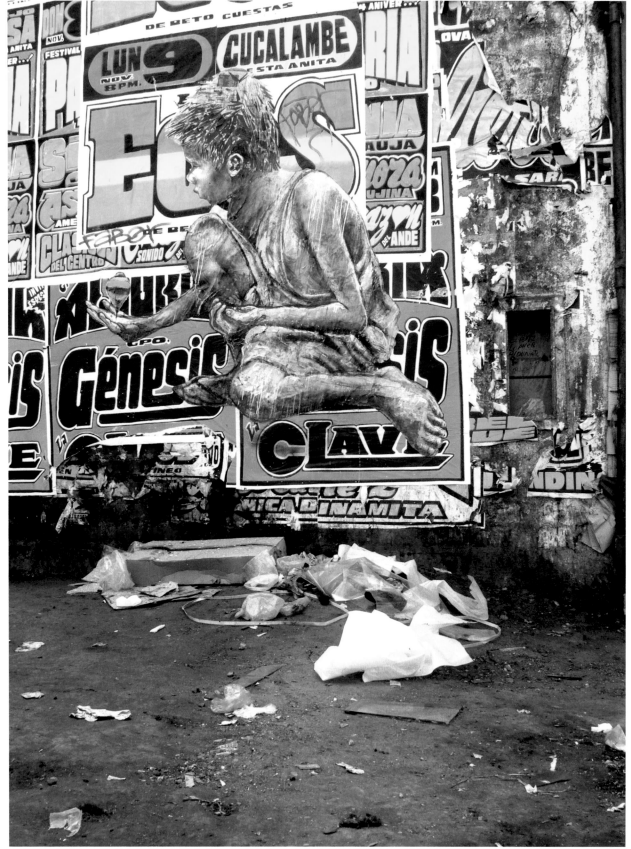

*Lima, Peru · 2009*

# FABER

*–––––––––––– The city of Lima is a big influence and inspiration in my process of creation. Architecture, colors, and emerging Peruvian culture, as well as disorder and chaos generate a need to give back all this energy by converting it into forms and colors in my murals. –––*

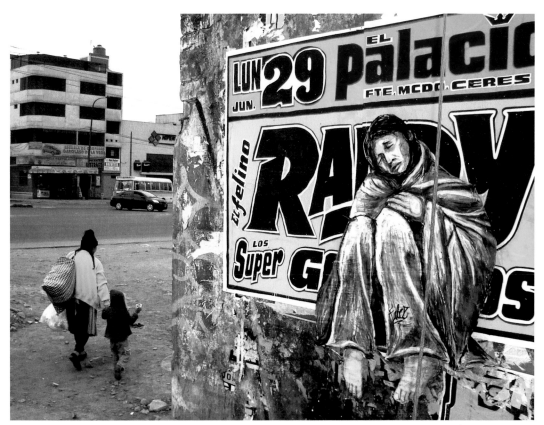

*Lima, Peru · 2009*

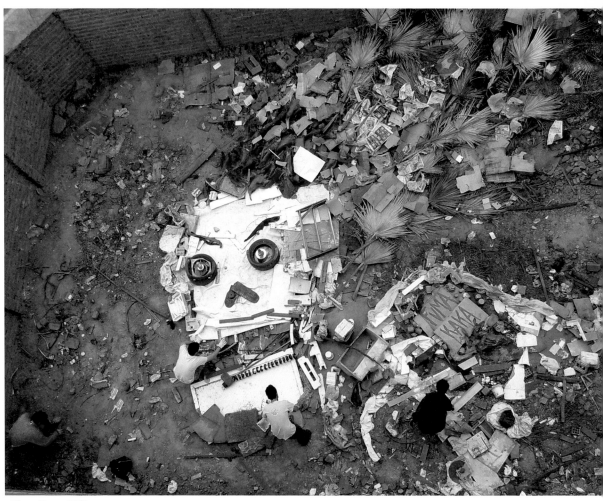

*Lima, Peru · 2008*

# FUMA KAKA

–––––––––––––––––––––– *We are a group of friends
—Ioke, Mekilu, Naf, Oso, and Seimiek—that got together in
Lima ten years ago. We dedicate our time to taking over the
streets with monstrous beings through sculpture, interactive
installations, graffiti, and actions staged in teardowns. Our
creatures have invaded the streets, museums and cultural
centers in cities throughout the world. Be warned, they could
appear soon around the corner from your street. –––*

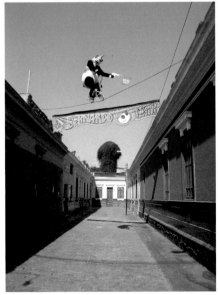

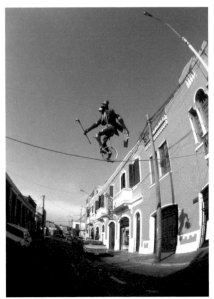

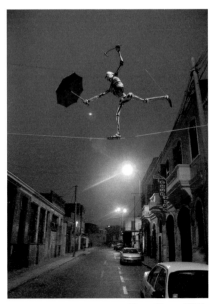

*Lima, Peru · 2007*

*Lima, Peru · 2007*

*Lima, Peru · 2007*

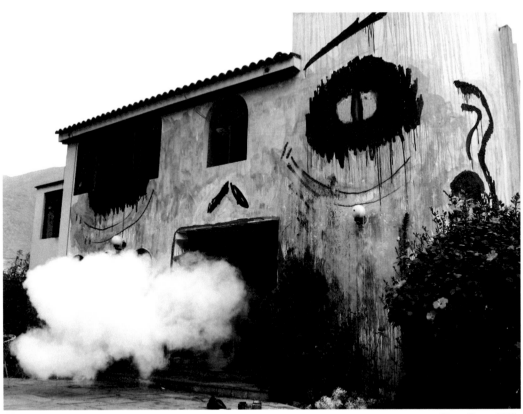

*Lima, Peru · 2009*

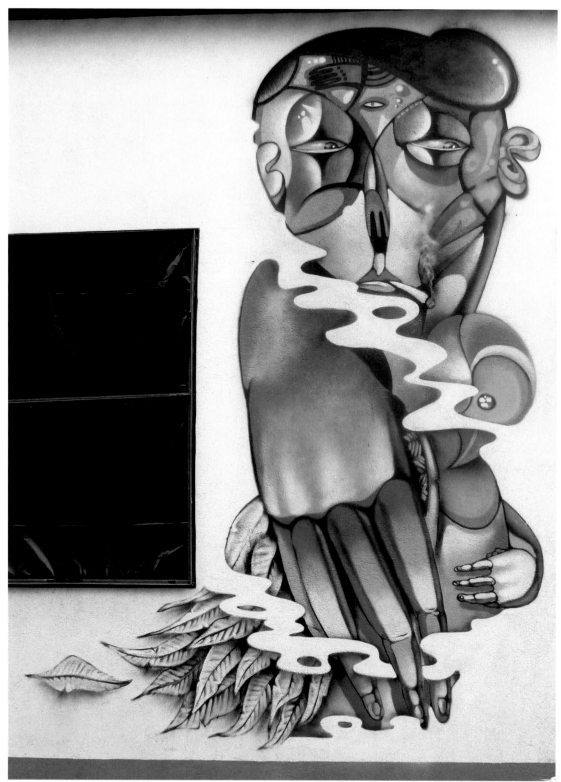

Gap, France · 2010

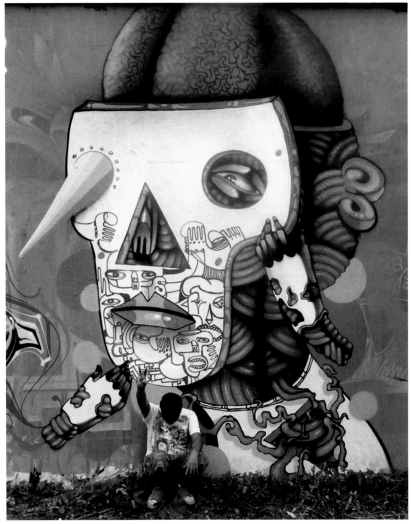

*Gap, France · 2010*

# JADE

————————— *The origin of my work is a solitary line dancing to the compass of my hand, it is born and dies in less than a second. I use my subconscious to compose this solitary line meeting other similar lines and falling in love; I culminate glances and create static souls, but I cannot understand what they are all about. I just understand simple sensations: happiness, satisfaction, and something that's close to an obsession with being gigantic.* ———

# MARCO SUEÑO

*—————————————————— I practice street art as a means of reflection, exploring themes like cultural identity, politics, and migration through photography, confronting passers-by with photographs in large formats, and generating new channels of communication in the streets. My work connects visual anthropology, street art, reality, nature, and the mysticism of native communities. ———*

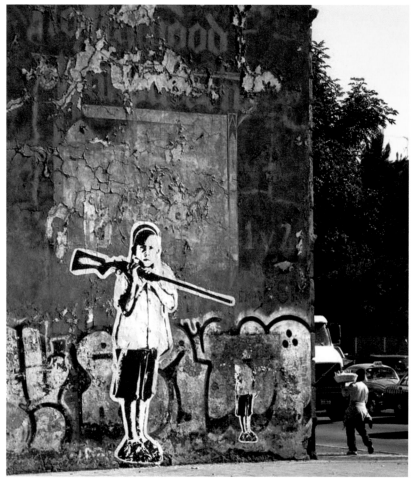

*Mexico City, Mexico · 2010*

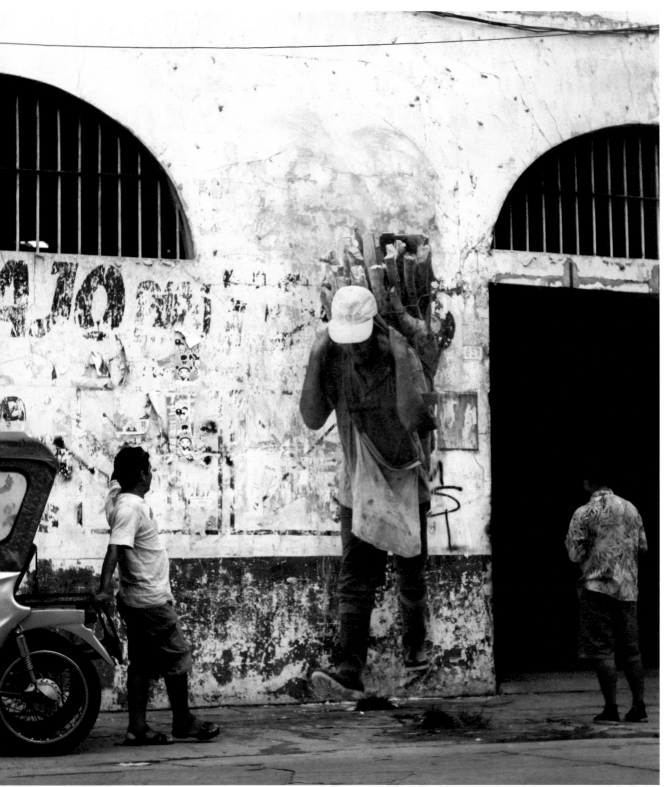

*Iquitos, Peru · 2010*

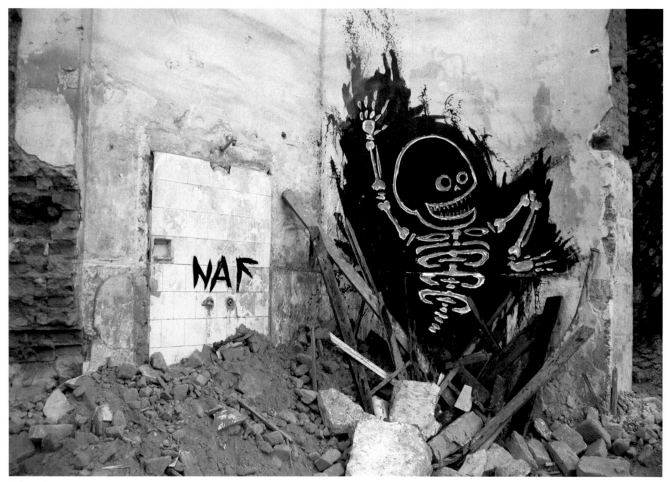

*Lima, Peru · 2010*

*Lima, Peru · 2009*

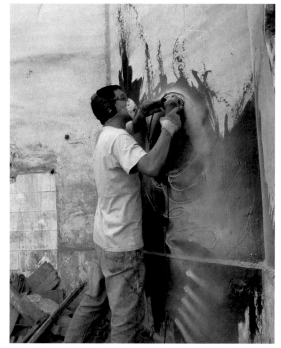

*Lima, Peru · 2010*

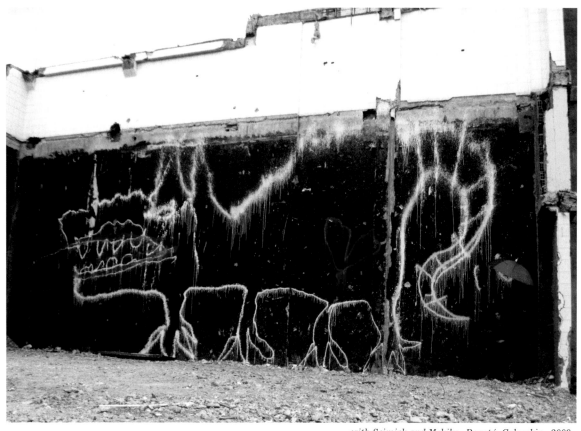

*with Seimiek and Mekilu · Bogotá, Colombia · 2009*

# NAF

———————*Fuma Kaka crew member. The interventions
I make in the streets range from graffiti to sculpture.
Working in theater and demolished buildings gives me
many ideas about materials and techniques, which I adapt
and reinvent for application in the street. I aim to break
the monotony and anonymity of the city, proposing new
uses for public space. —— —*

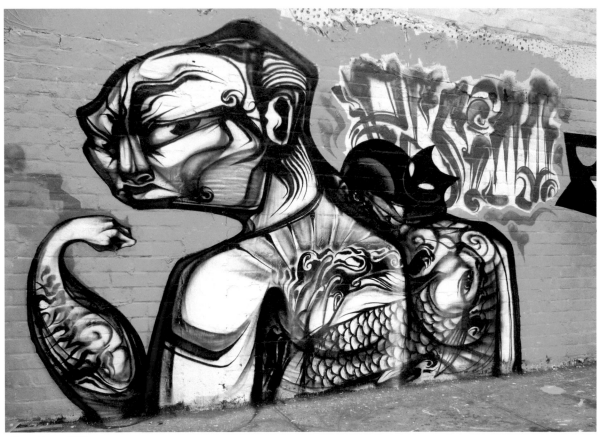

*Lima, Peru · 2010*

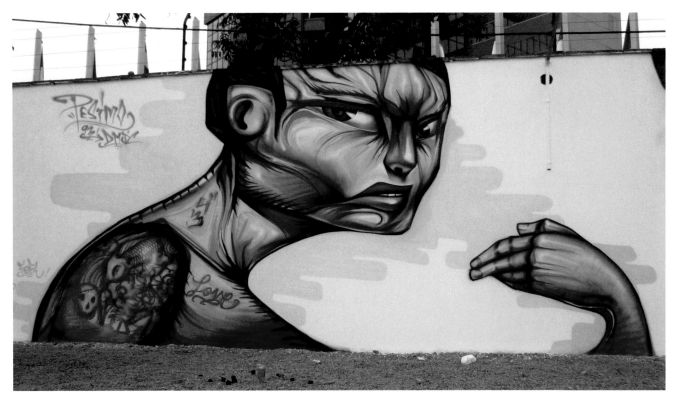

*Lima, Peru · 2009*

# PÉSIMO

———————————— *I belong to the DMJC crew, the first active graffiti group in Peru, recognized in Lima for provoking the explosion of street art and graffiti in my country. My work is heavily influenced by daily life; I show people, emphasizing their attributes to lend importance to gestures and glances.* ———

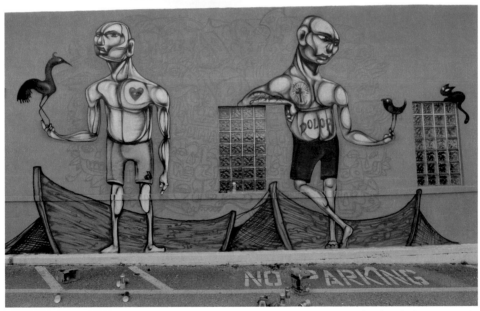

*Miami, United States · 2010*

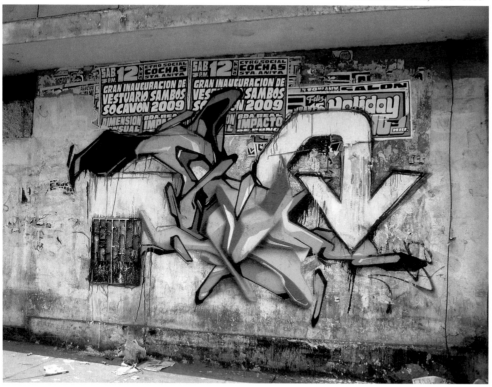

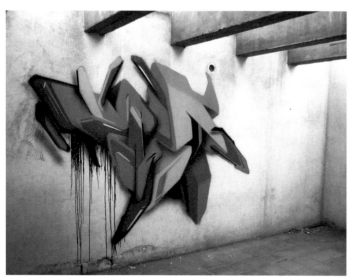

*Lima, Peru · 2010*

# PHYSE

— — — — — — — — — — — — *Searching for perfection has led me to create new artistic and graphic forms. My digital style has been taken to the streets and shown in galleries. Action and passion for what I do bring me to deconstruct graffiti so much so that I encounter new styles in my process of artistic development. The search for the perfect work of art allows me to continue doing what I love most, painting.* — — —

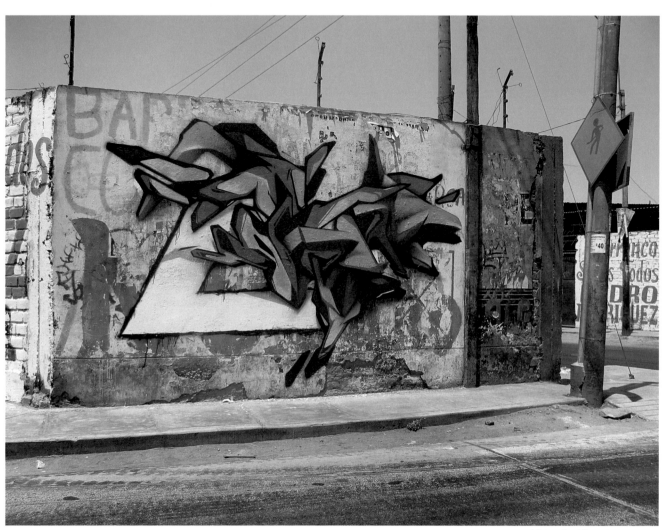

*with Basik · Lima, Peru · 2010*

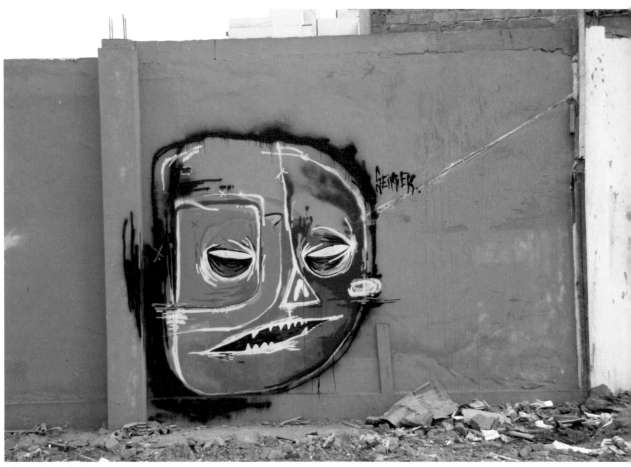

*Lima, Peru · 2010*

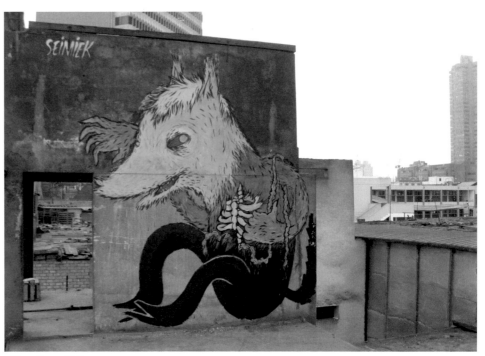

*Lima, Peru · 2009*

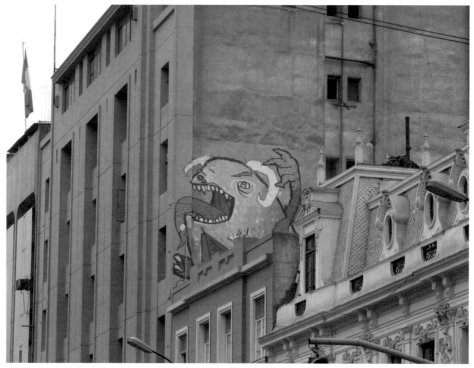

*Lima, Peru · 2008*

# SEIMIEK

––––––––––––––––– *Painting from the 1990s until today, I am a faithful member of the Fuma Kaka crew with a style inspired by all of the dark things in Peru mixed with aspects of a dark fantasy world!* –––

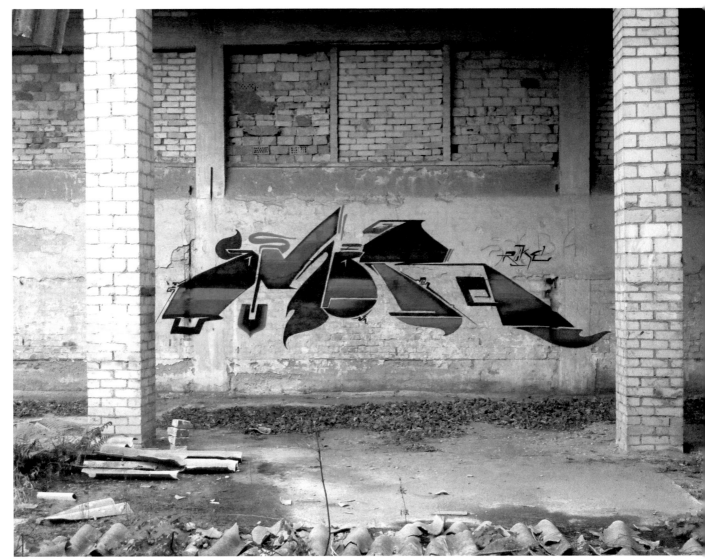

*Postdam, Germany · 2010*

# WESR

*––––––––– I think I am
a bad street artist because I don't
know how to leave my art in the
street, I can't let go of it easily;
what I've left there stays with
my in my heart, the paint stains
on me are just shadows of those
hanging strings that hold us
together. I get sad when I see them
treated poorly, although it makes
me happy to observe their process,
and seeing how time passes over
them makes me proud. –––*

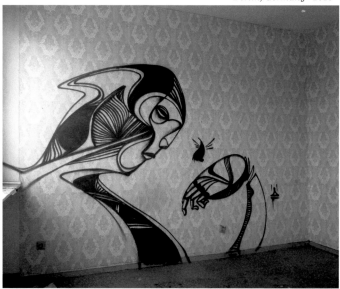

*Berlin, Germany · 2010*

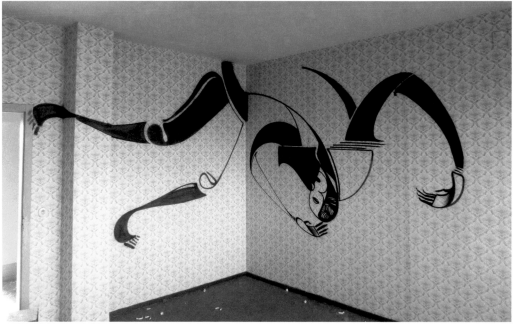

*Berlin, Germany · 2010*

· Blast ·

· Buytronick ·

· Dhear ·

· Dose - Zenzontle ·

· Edgar Argaez ·

· Huízar ·

· Mugre ·

· Neuzz ·

· Saner ·

· Said Dokins ·

· Sego ·

· Seher ·

· Smithe ·

· Tomás Güereña ·

# MEXICO

**T**———————he history of Mexican street art can be traced back to the pre-Hispanic period, with the tlacuilos and the murals painted on the interiors of the Mayan and Aztec palaces with their colors and impressive forms. In contemporary history it is vital to mention the mural movement and its great masters, such as Siqueiros, Orozco, Rivera, Tamayo, and González Camarena. The muralists have something in common. The art they create can be seen by everyone in public spaces.

——— When speaking of muralism, one cannot omit the element of protest. Student movements, such as the one in 1968, mark a page of graphic street art history when murals became the means of expression used for criticizing the system and demanding social justice with political and social content in this historic time, which culminated in the terrible student massacre of October, 1968.

——— Then one has to remember artistic groups that took over public spaces in the middle of the 1970s. The high point came in 1978 with groups like Suma, Mira, Tepito Arte Acá, and Março or Proceso Pentágono marking the moment.

——— All of this is part of the cultural heritage of contemporary urban graphics. This is where we locate graffiti, which for years has been a very important social detonator. It first appeared on the scene in Mexico in the 1970s, when complaints burst out from groups like Los Panchitos, along with the Cholo movement and groups like rockers and punks. It isn't until the middle of the 1980s when, due to immigration, a cultural exchange began and the aesthetics of graffiti from the United States began to be used.

——— Little by little, interest in taking over public space with graffiti grew. In Mexico City, the premiering of movies like **Flashdance** (which included a breakdancing scene) awakened interest in this culture. That's how the hip hop movement came to be known and graffiti began to gain strength and grow in the metropolitan area.

——— At the beginning and middle of the 1990s crews emerged, including PEC, LEP, DFK, SF, CHK, AC, and JS. Many of them could be seen in different corners of the city through their signatures, letters, and colors. Everything began to be mixed in the city. And so a new Mexican urban graphic style was born. This movement impressed and influenced many of today's graffiti writers.

——— Throughout these two decades many writers have paraded through the scene looking for their

*own identity, risking everything, and creating a polemic within the movement, since by creating and experimenting the credibility of each writer is put into question.*

*——— Some of the forms of intervention that can currently be seen in Mexico are:*
*Sticker: a medium which has not yet exploded since the majority of the designs are copies of some image from television or a comic. Among the best-known artists are Dr. Rabias, Mr. Fly, Fize, Al Natural.*
*Wheatpasting: Few images have been powerful since artists do not often use this method. Among those who have experimented with this technique are Acamonchi, support groups for La Otra Campaña (aligned with EZLN), and some crews, like Propa Gangsta.*
*New Mural: This is how the young people who have passed through traditional graffiti and continue to search beyond it are identified. Different streams, such as popular graphics, traditions, comics, nature, and daily life, influence them. They have taken over spaces to experiment with it, much like the pioneers of the 1980s. Currently we have the Neza Arte Nel collective and the master Alfredo Arcos. Some of the important players that come from the graffiti scene and have become new muralists are Sego, Dhear, Smithe, Seher, Une, Sanez, and Neuzz.*
*Interventions: They charge themselves with playing with their surroundings to decontextualize space and give it new meaning. Some of them are Said Dokins, Ana Santos, and Kid Ghe.*
*Graffiti: The 2A crew, SBS Crew, BNB Crew, Maintain team, EYOS (Gdl), Humo SF, and Peque VRS SF, among others, continue to paint illegally and legally, keeping this scene alive.*

*Stencil: We currently see names like Wachavato (Sinaloa) who reproduces images from Northern culture, the Azaro group, which was important in the conflict Oaxaca went through in 2006, as well as Arte Jaguar, Lápiztola (Oaxaca), and Guerrilla Visual. All of these groups have political activism in common.*

*——— Mexico is currently a laboratory for experimentation that makes up the contemporary street art scene. Stencils, graffiti, stickers, posters, and other tools allow public space to be used in different ways. The most important thing is a determination to take over these spaces. The Mexican scene, with its important history, is the focus of attention for foreign countries who are interested in every sense in our rich culture and want to know what is going on in this country.*

*——— This is how Mexico opens its veins and shows what it is made of. Influences from other countries have been left in the past since we now have our own unique identity. Mexico is, without a doubt, an entrepreneurial country in the worldwide street art scene.*

**Saner** - - - - - - - - - - - - - - - - - - - - - - - - -

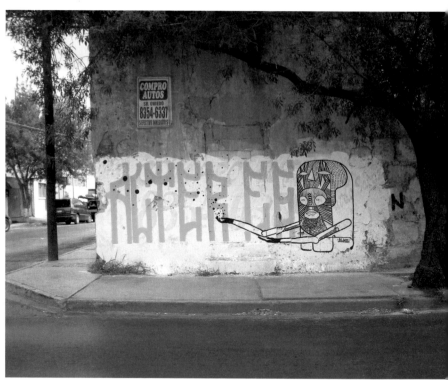

*Monterrey, Mexico · 2010*

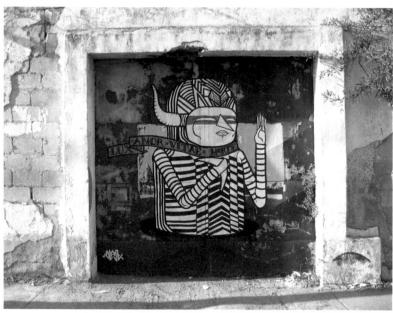

*with Lux · Monterrey, Mexico · 2008*

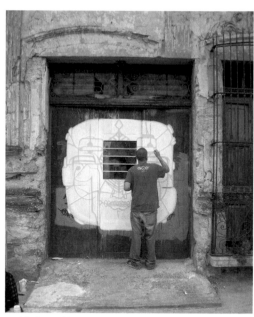

*with Dose · Monterrey, Mexico · 2009*

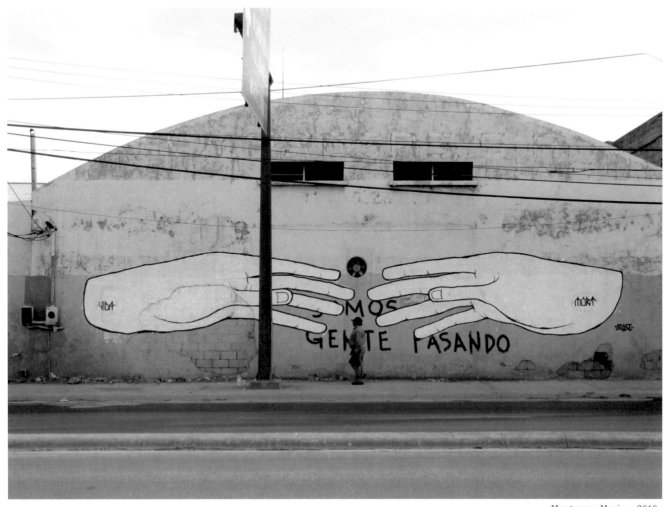

# BLAST

— — — — — — — — — — *My passion for writing, drawing, and painting in the street started when I was about 11 years old when I began to mark my neighborhood with a small tag. This helped me get to know hip hop culture and the codes implied in painting on the streets, gradually going deeper to work on more universal themes and understanding my surroundings and everything that makes up my days.* – – –

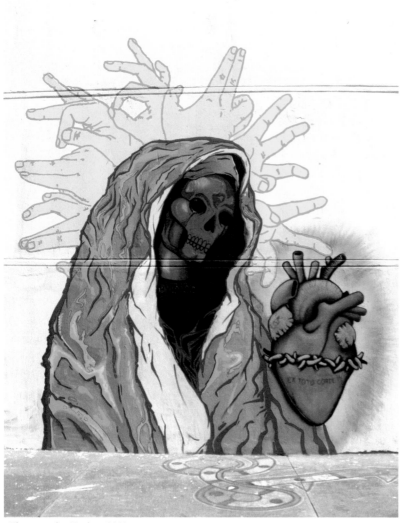

*Tlanepantla, Mexico · 2010*

# BUYTRONICK

------------------------- *Buytronick, Buk, Mirate, Brutal, Rex,
Propagangsta, and Gwez are the names I have taken during my ten years in the world
of street art in Mexico City. I am an admirer of the street and its chaotic scenes in
Mexico City, and there's nothing like praising them more! I use posters, paste, aerosol
paintings, and other objects of creation and destruction. –––*

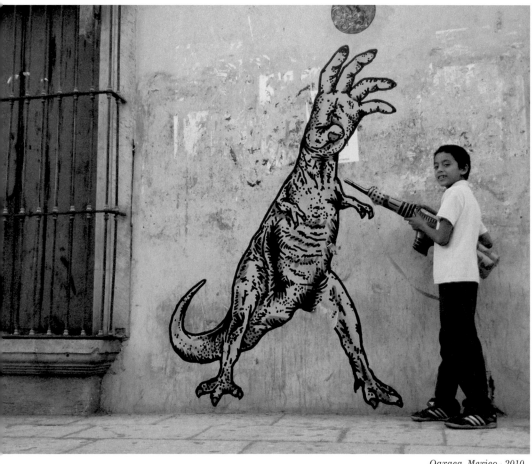

*Oaxaca, Mexico · 2010*

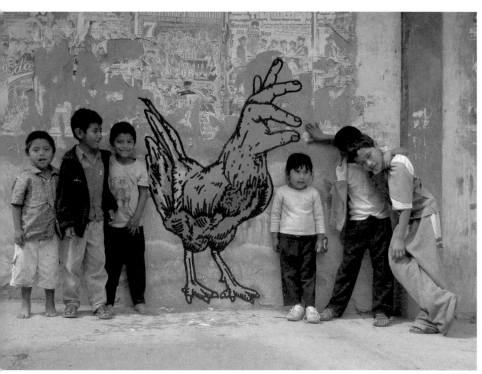

*Xalpatlàhuac, Mexico · 2010*

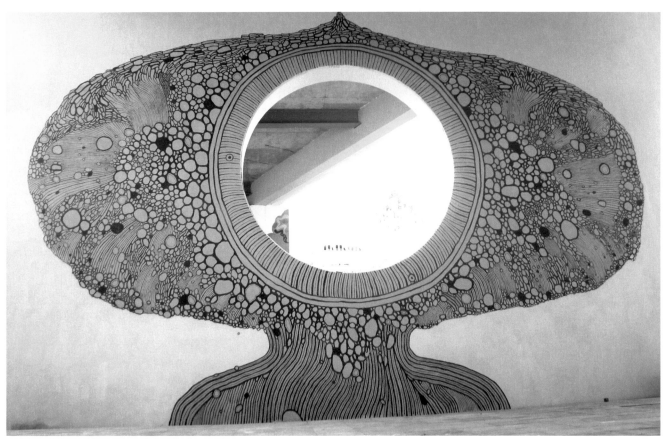

*Puebla, Mexico · 2010*

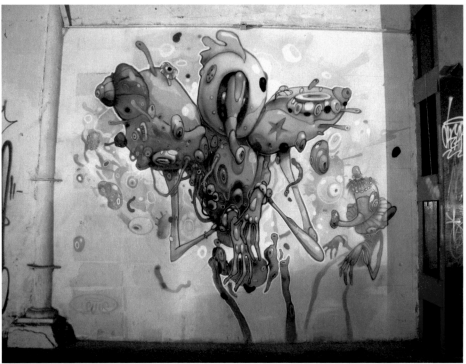

*Barcelona, Spain · 2010*

# DHEAR

*—————————— I'm a graffiti writer and visual artist, and I look for new channels through which to investigate techniques and aesthetics. I strengthen my technique and way of thinking by presenting a work of art that attempts to portray different phenomena related to nature, far from attempting a discourse rooted in a pre-Hispanic view of the world, cosmology, or ecological appeal. ———*

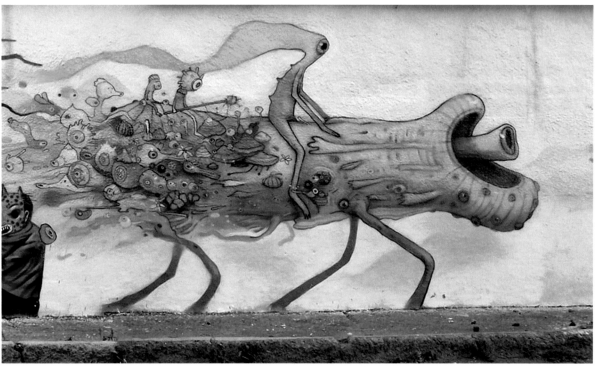

*Mexico City, Mexico · 2010*

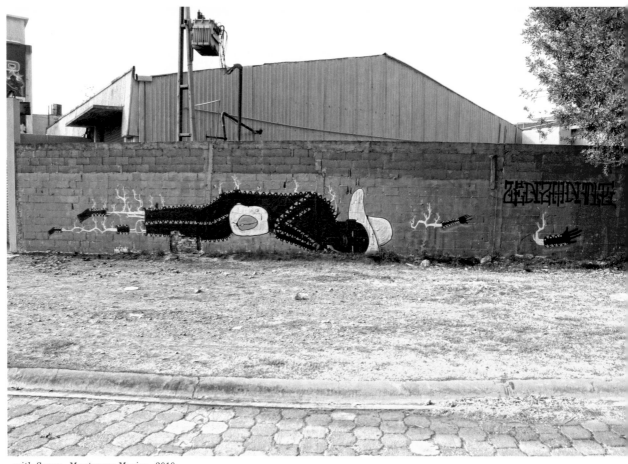

*with Sanez · Monterrey, Mexico · 2010*

# DOSE-ZENZONTLE

-------------------------------------------- *I generally paint for myself although I am aware that by being in the streets it belongs to everyone, and I try to paint my characters in a way that provokes curiosity in passers-by, so they interpret them in different ways, and smile, and stand there thinking, to give them a little bit of color in the monotony of days and trajectories. ---*

*Monterrey, Mexico · 2009*

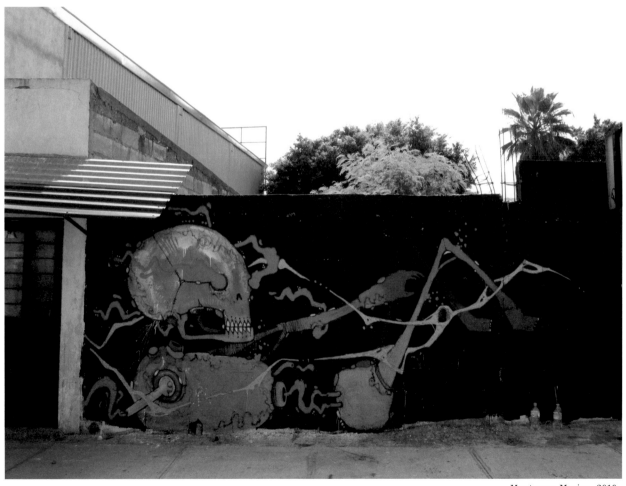

*Monterrey, Mexico · 2010*

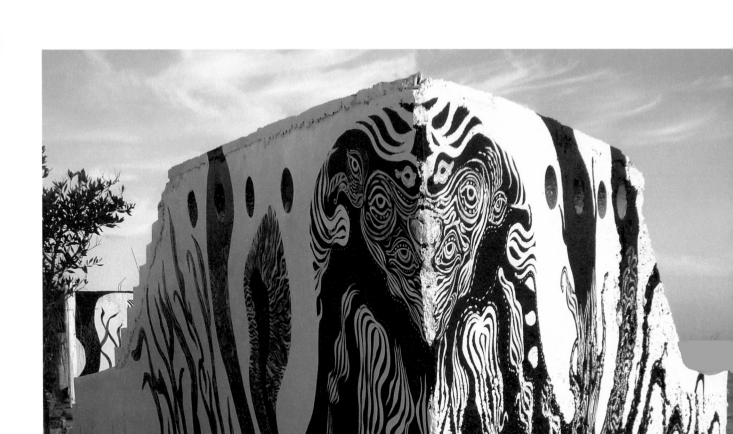

*Bacalar Lagoon, Mexico · 2010*

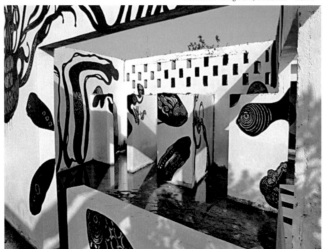

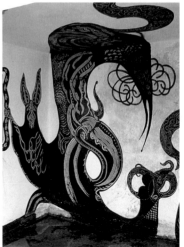

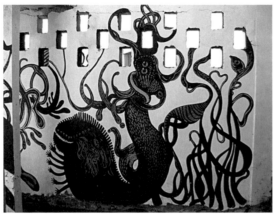

Bacalar Lagoon, Mexico · 2010

Bacalar Lagoon, Mexico · 2010

# EDGAR ARGAEZ

----------------------------------- *Beyond themes, the energy of my work is concentrated around my appetites, my vitality. In the manner of musicians, I like to improvise with my ornamental grammar, constructing free forms that are always growing. I use movement from my whole body to translate all of this power onto murals, and I can clearly say I let my libido take off through these lines. ---*

# HUÍZAR

*———————————— I seek to contribute in places where art is non-existent, mainly in public spaces. I consider my work as an abstract message, an involvement with society, and the development of a vocation. To the extent that I can improve this vocation, the bigger my contribution to culture will be. ———*

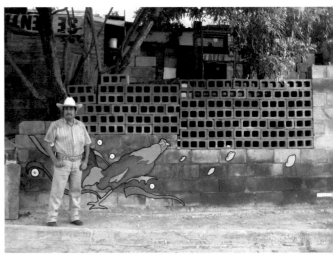

*Nuevo León, Mexico · 2010*

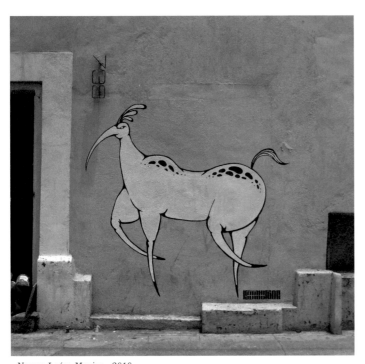

*Nuevo León, Mexico · 2010*

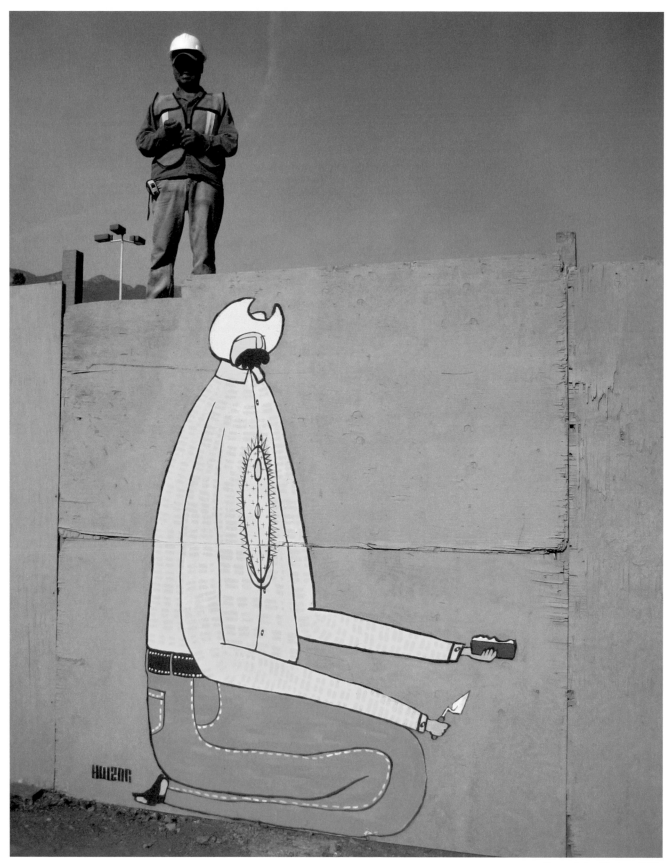

*Nuevo León, Mexico · 2010*

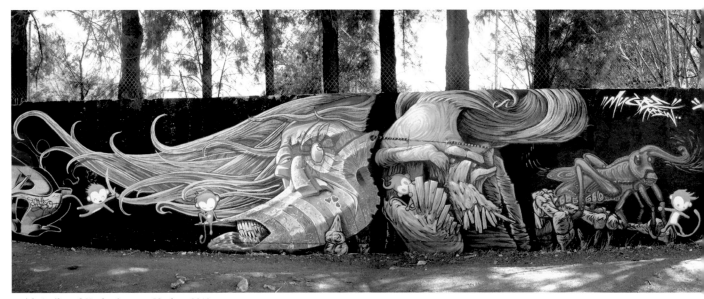

*with Aztik and Urak · Oaxaca, Mexico · 2010*

# MUGRE

———————————— *Mugre Crew is the fusion between two street artists, Cix and Mone who together form Mugre, which is like a child who tells the story of what he sees around him—frustrations, dreams, memories, fears, and happiness with big canvases of humor. He uses the street and other mediums to do so. The Mugre kid was born in November 2007 in Mexico City and since he suffers from the curse of Peter Pan, it appears he will do this eternally. ———*

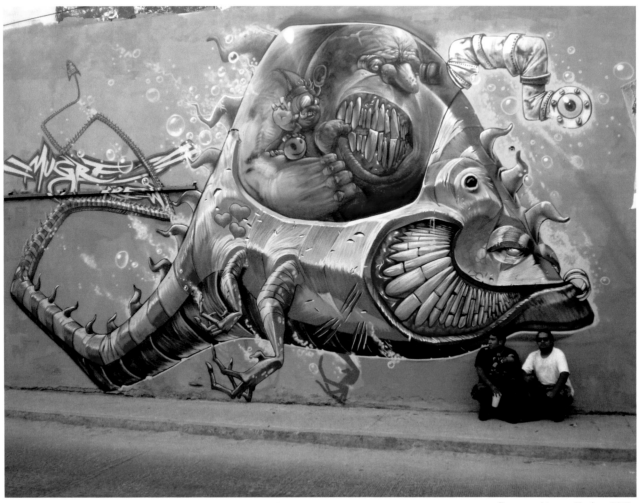

*Guerrero Atoyac, Mexico · 2010*

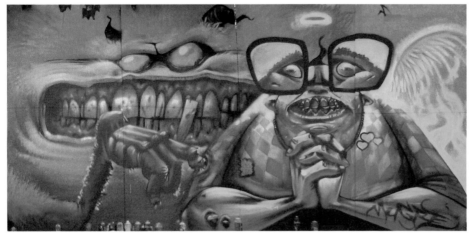

*Mexico City, Mexico · 2010*

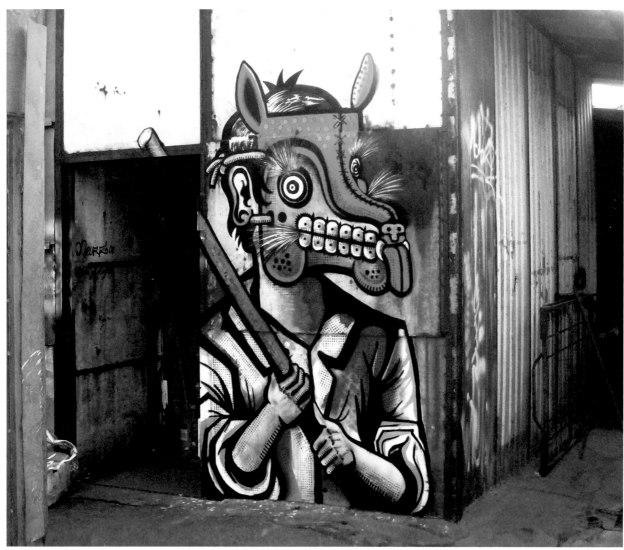

Mexico City, Mexico · 2008

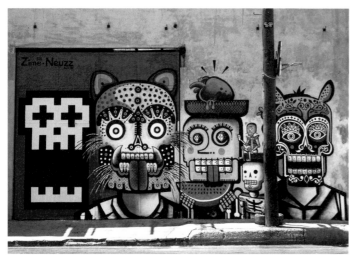

with Zime · Mexico City, Mexico · 2009

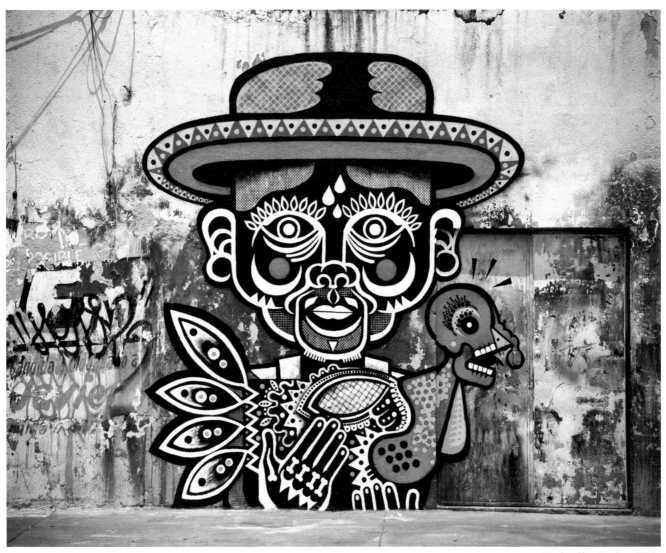

# NEUZZ

———————————— *My family and I are from Santiago Ihuitlán Plumas, a little mestizo town located in the Mixteca area in the state of Oaxaca. As a child, my parents and grandparents told me tales about ghosts, witches, and nahuales. A lot of these stories and characters are what inspire an important part of my work today, adding elements like masks, skulls, and disguised characters.* ———

# SANER

*—————————————— The dream-maker. At this stage, during which I am getting closer to public and private space, I take this means of expression as a laboratory where everything is allowed. To build and destroy, to reinvent myself through each work, whether it's in the street, in a closed space, or a design. I imagine the power of independence. My only objective is to create. To do this, I look for new challenges and impossible things as well. ———*

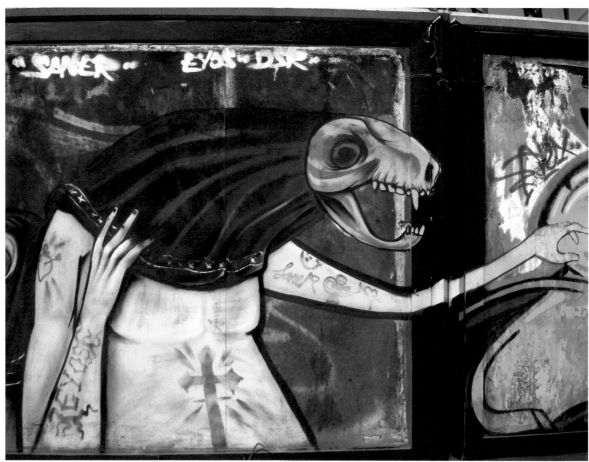

*Ecatepec, Mexico · 2009*

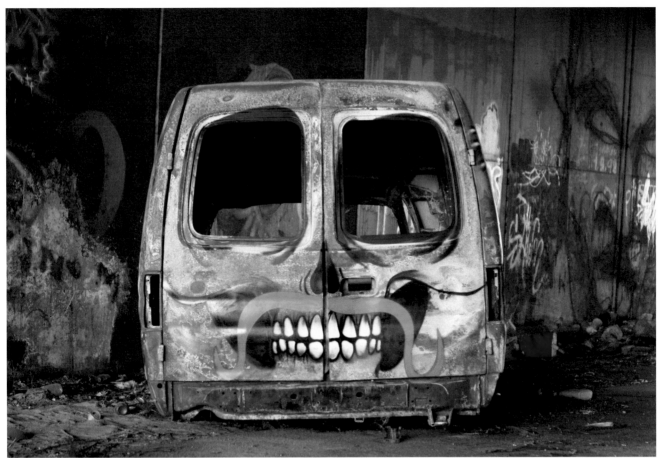

*Madrid, Spain · 2010*

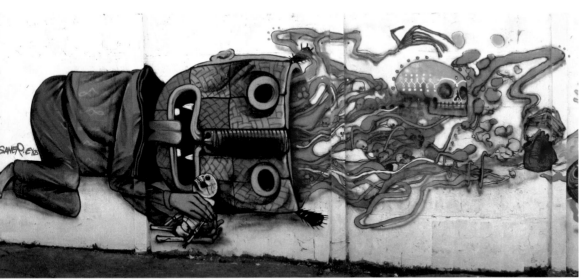

*with Seth · Mexico City, Mexico · 2010*

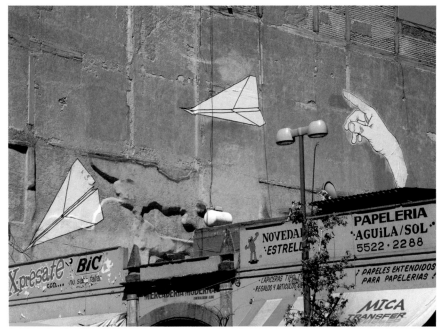

*Mexico City, Mexico · 2010*

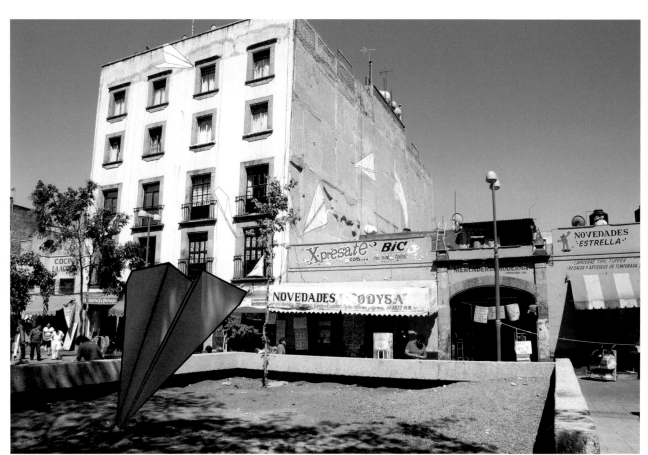

*Mexico City, Mexico · 2010*

# SAID DOKINS

———————————————————————— *My work is focused on reflections on death, history, and power in our society today. My intention is to satirize the way in which the elite exercise their power as though it were child's play through mechanisms of control, intimidation, and normalization. This work is based on the Mexican government's lies in relation to the death of the Secretary of State in a supposed air accident. ———*

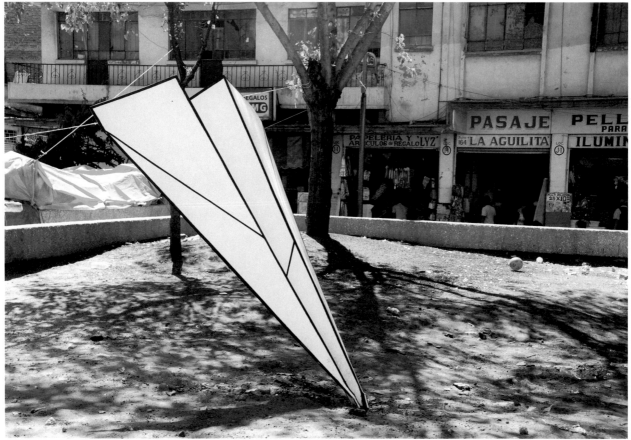

*Mexico City, Mexico · 2010*

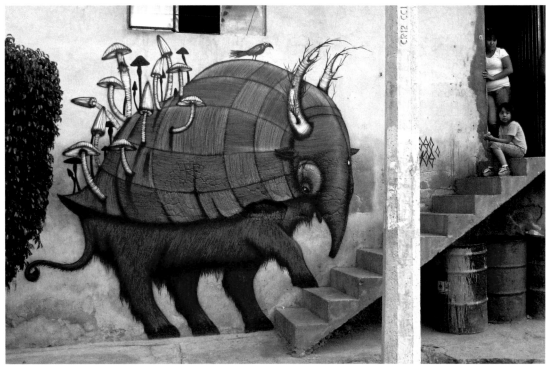

*Mexico City, Mexico · 2009*

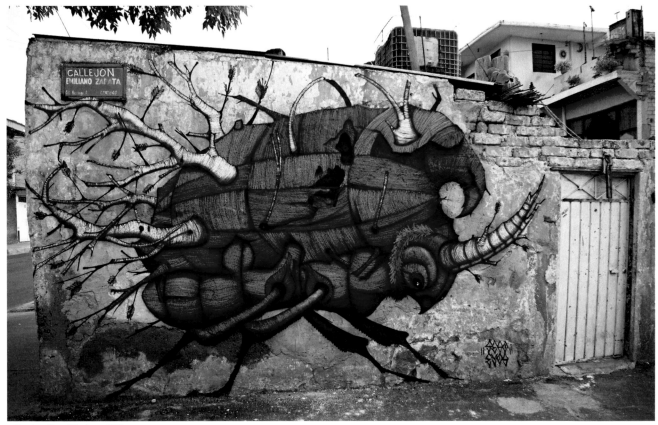

*Mexico City, Mexico · 2009*

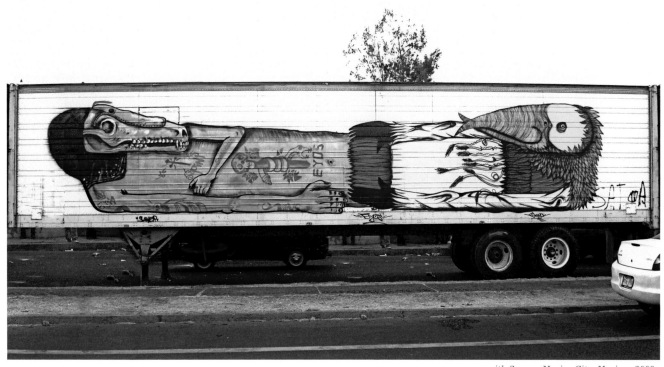

# SEGO

————————— I was born and grew up in Mexico City, where I currently live. When I was eight years old I moved with my family to Oaxaca in the Istmo area of Tehuantepec, a wild area with beaches where I was in direct contact with nature, plants, and native animals. Here lie my creative roots and this is where I draw my inspiration on my journey to become a self-taught artist in the streets and cities of America and Europe. –––

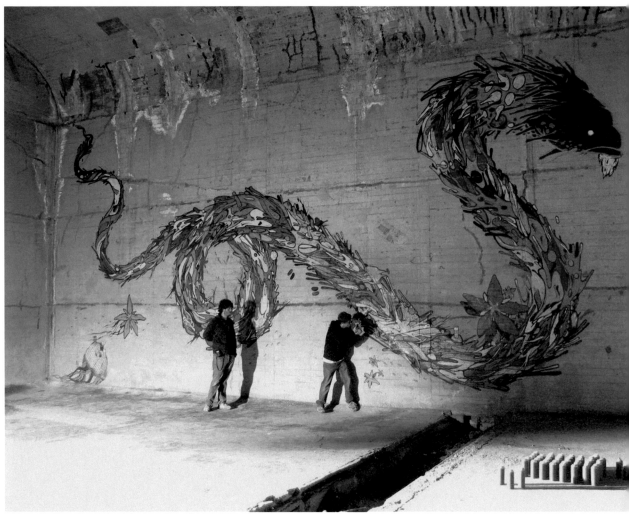

Mexico City, Mexico · 2009

# SEHER

—————————— *My inspiration is drawn from the surrealist movement, from Japanese comics, and tendencies from the recent postmodern movement know as "superflat." I try to transmit a perfect application of color on an abstract thematic base with the aim of expressing states of animation with an organic vision from the surrealist world.* ———

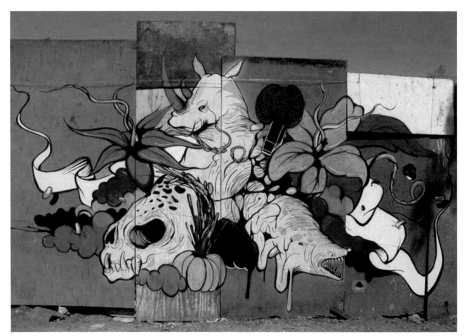

*Mexico City, Mexico · 2009*

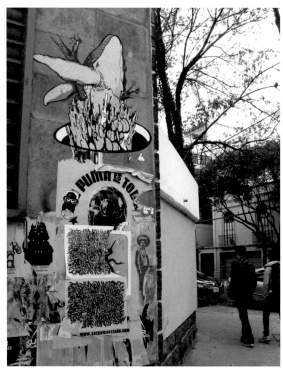

*Mexico City, Mexico · 2010*

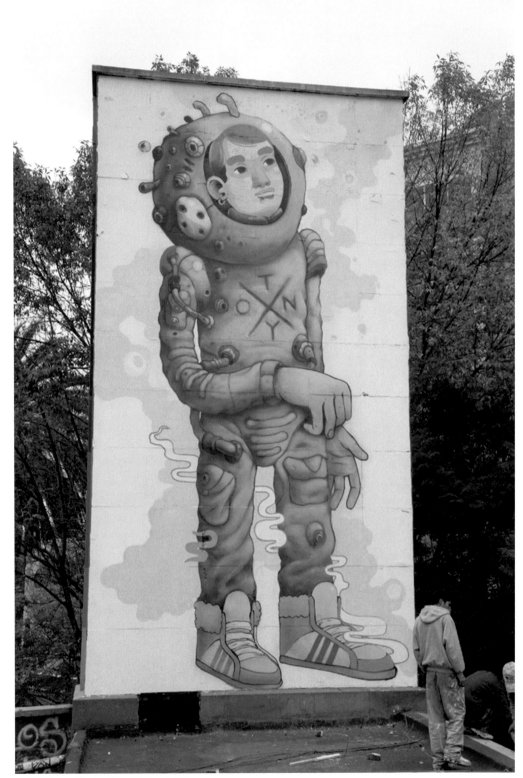

*with Dhear · Mexico City, Mexico · 2010*

# SMITHE

—————————————— *I draw detached, fragmented, and melting faces only to combine them again according to my own whim. I create characters from inexplicable backgrounds as well as puzzles made of water and anatomy or disquieting maps. My lines are sometimes violent, acidic, humorous, and cruel. My intention is often to enter into dialog on three levels: what is happening, how I think about it, and the sensation I am trying to provoke in the viewer. ———*

*Mexico City, Mexico · 2010*

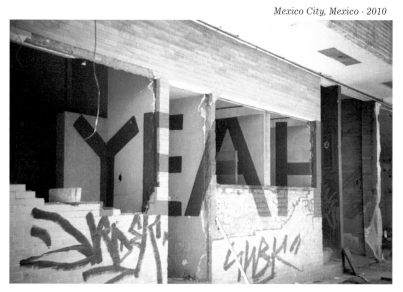

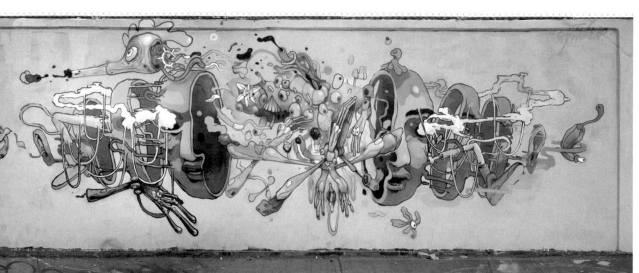

*with Dhear · Mexico City, Mexico · 2010*

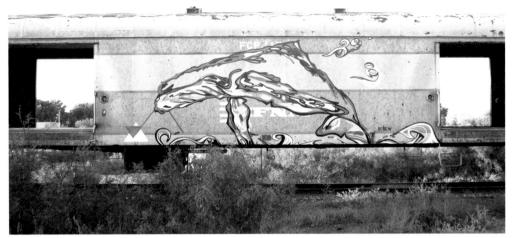

*Coahuila, Mexico · 2008*

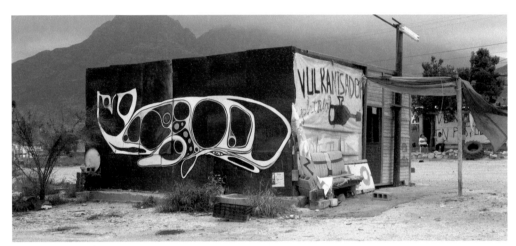

*Nuevo León, Mexico · 2008*

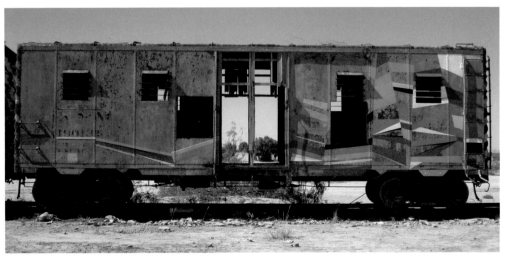

*Coahuila, Mexico · 2008*

# TOMÁS GÜEREÑA

*------------------------------------ Graffiti is like*
*a lifestyle to me, it's like expressing a diary: expression that is pure,*
*natural, and primitive. It is seeing, evaluating, and interacting with your*
*surroundings. I try to offer a free message that invites people to reflect.*
*It's conceived as a visual relief, it's my contribution to society. I work with*
*the basic criteria of composition, existent resources, reevaluation, and*
*improvisation, attempting to fuse the work with its context. – – –*

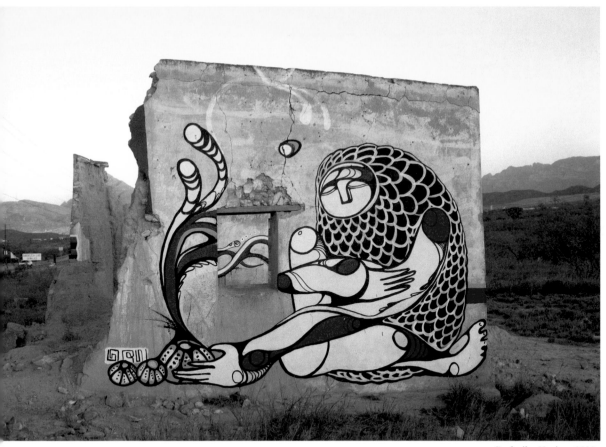

*Coahuila, Mexico · 2008*

# CUBA

· Jorge Rodríguez Gerada ·

# ECUADOR

· Estone ·

# PARAGUAY

· Oz Montania ·

# PUERTO RICO

· La Pandilla ·

# TRINIDAD & TOBAGO

· Wendell McShine ·

# URUGUAY

· Alfalfa ·

# VENEZUELA

· Dixon - Royal ·

· Flix ·

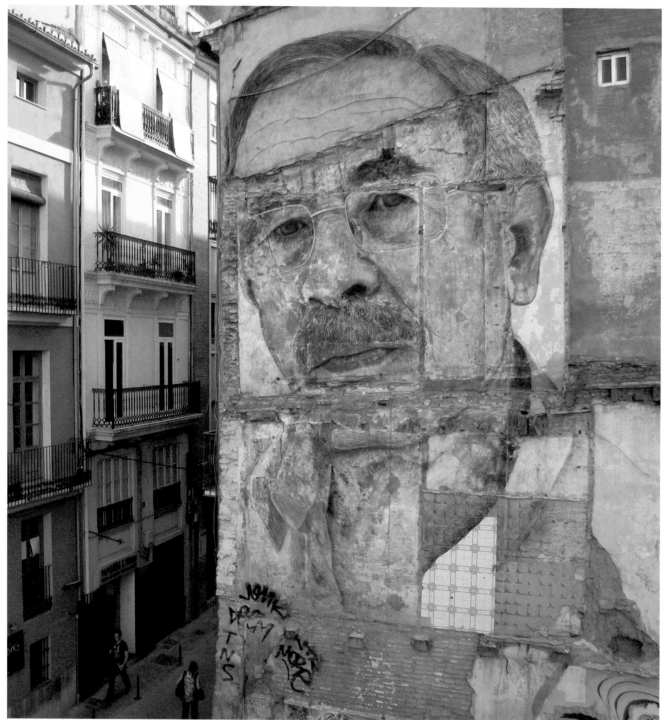

*Valencia, Spain · 2009*

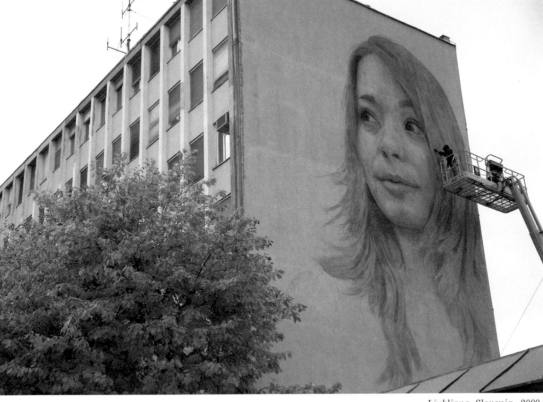

*Ljubljana, Slovenia · 2009*

# JORGE RODRÍGUEZ GERADA

------------------ *I'm a Cuban-American and I began my career in the early 1990s as one of the founders of Culture Jamming in New York. My idea is to show that we must all be seen with dignity. I think our identity should come from within, not from the brands we wear. We should question who selects our cultural icons, our models of conduct and valor. ---*

# ESTONE

––––––––––––––– *I live in the city of Quito in Ecuador, a city where painting in the streets is a new thing which is not greatly appreciated by the people, where I must find a way to discover spaces to paint and where the paint is not of the best quality. But desires and dreams make me continue painting in the streets with more effort each time, and my angel of death grows with its hands stained with colors.* –––

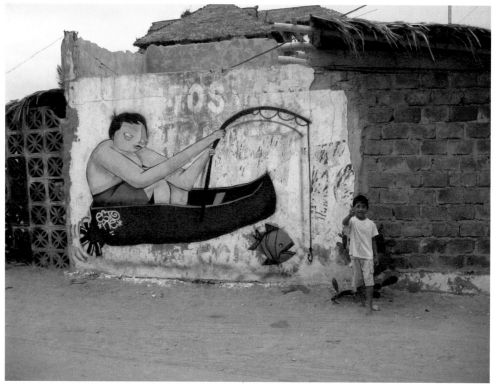

*Canoa, Ecuador · 2009*

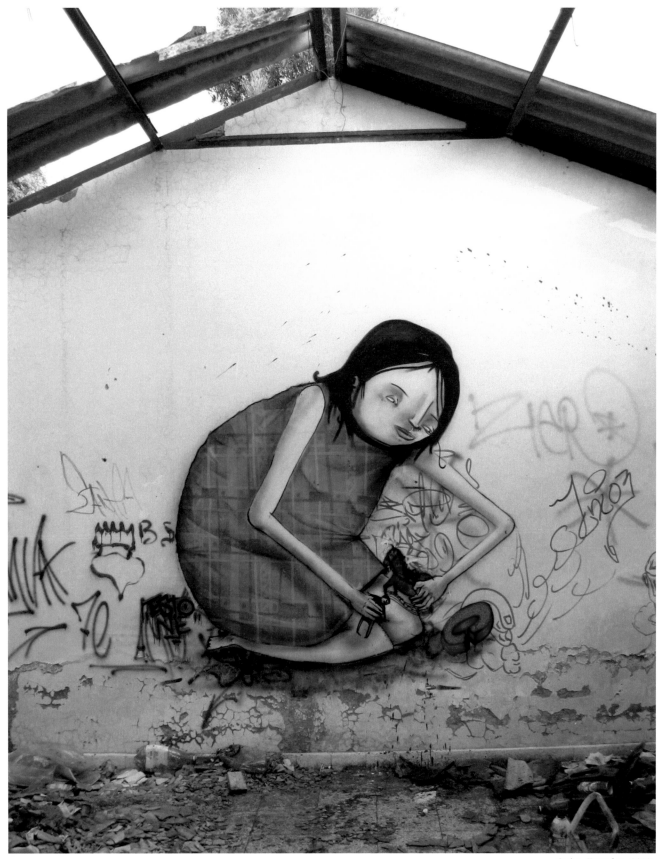

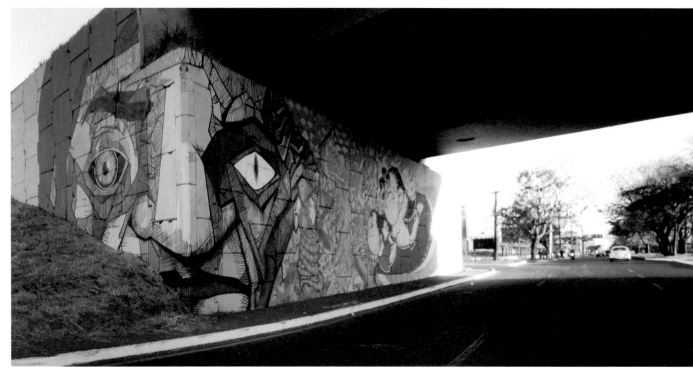

*with Renato Pontello and We · Fos do Iguazu, Brazil · 2010*

# OZ MONTANIA

———————————————————— *Street art in Paraguay is in its incipient phase, but growing quickly. Individual efforts bore fruit but after the formation of the Jopara collective, of which I am a member, we noticed the reach we had if we joined forces. Street art has an enormous intrinsic power that we are only just beginning to discover.* ———

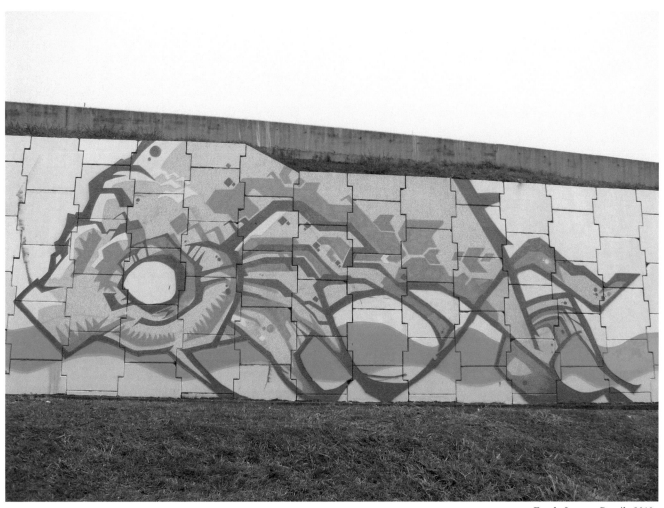

*Fos do Iguazu, Brasil · 2010*

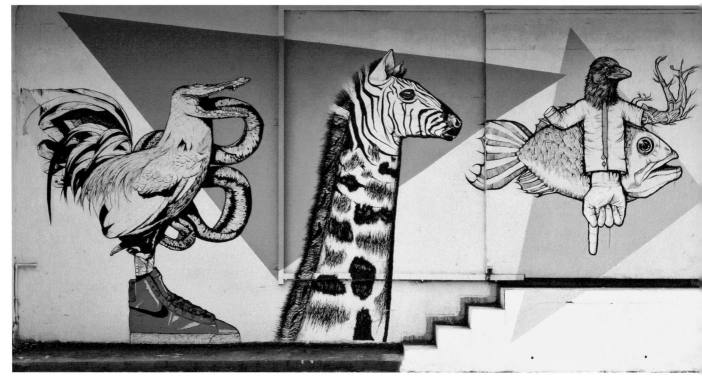

*Santurce, Puerto Rico · 2010*

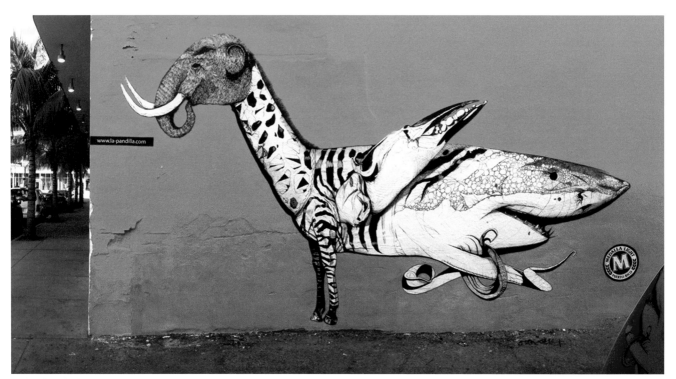

*Miami, United States · 2010*

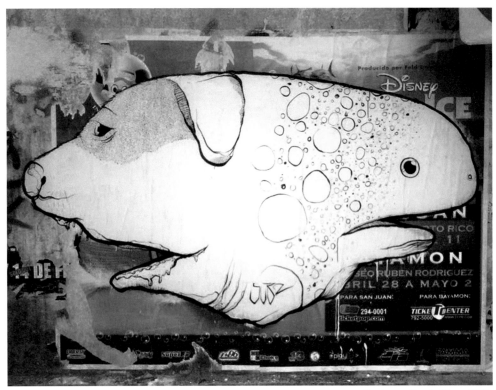

*Santurce, Puerto Rico · 2010*

# LA PANDILLA

———————————————————————— *A hunger for art united us.*
*With leftover paint and a lot of desire to create, La Pandilla was born.*
*We are an art collective made up of Alexis Díaz and Juan Fernández.*
*Our desire to create isn't limited to the geographical space we currently*
*inhabit. Our mission is to express ourselves in other contexts. To travel*
*so our art form travels around the world. ———*

# WENDELL McSHINE

———————————— *I reflect upon the things around me and make them fantastic. My imagery is embedded in spirituality and combines with elements of the mundane. I'm creating new concepts of urban mythology. When I work on the streets infinite worlds of possibilities open up. It's a large-scale format so it takes imagination to fill up the space; all of this contributes to more depth in my visual language. ———*

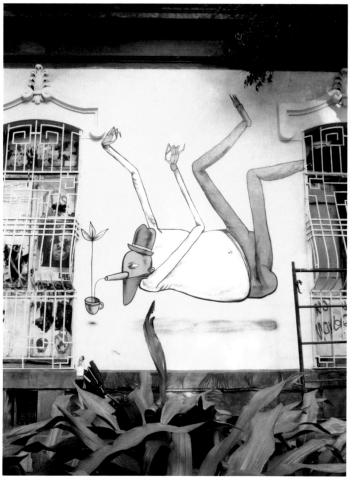

*Cholula, México · 2010*

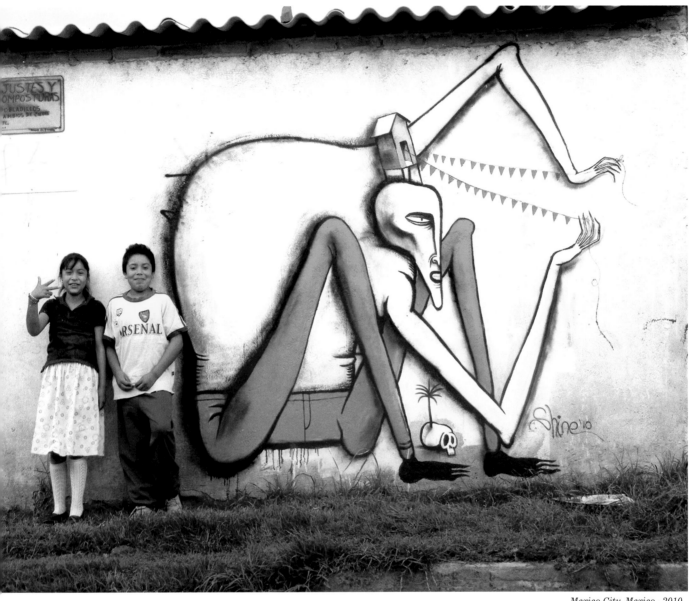

*Mexico City, Mexico · 2010*

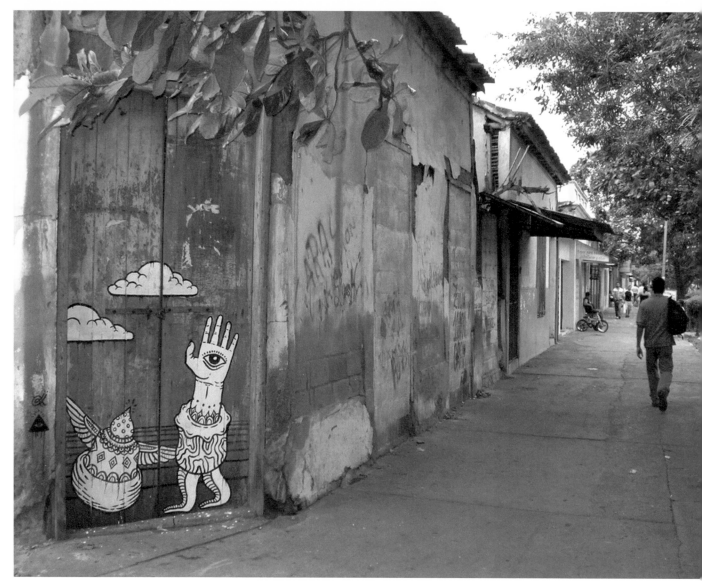

*Montevideo, Uruguay · 2010*

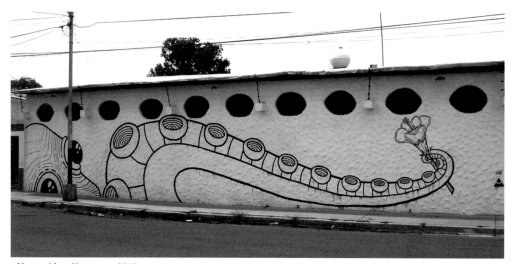

*Montevideo, Uruguay · 2010*

# ALFALFA

*—————————————— Forms and beings that come from worlds near ours appear in the streets of Uruguay, inviting those who are attracted by the stories written between the lines and colors that tell about what is happening on the hidden side of the wall. ———*

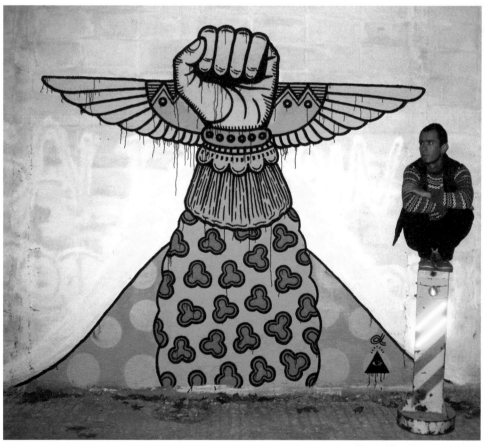

*Montevideo, Uruguay · 2010*

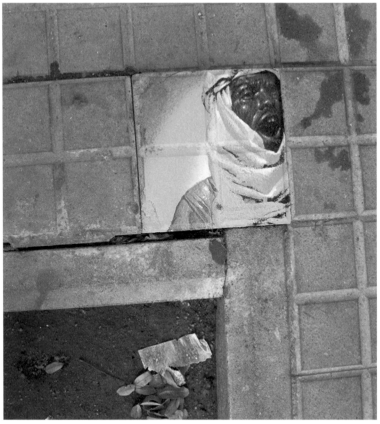

*Barcelona, Spain · 2008*

# DIXON-ROYAL

------------------------*I am a hypocrite! I talk angry
talk about sweatshops and people's "lack of vision" on environmental
issues, but I buy underwear made in Turkey and take long, hot showers.
So I'm not much of a good example. Having said this though, my ideas
are true to my feelings, and my feelings are true to my art. I tend to make
paintings with a message that fossilizes my ideas, and in that way I can use
them as my guide or bible. ---*

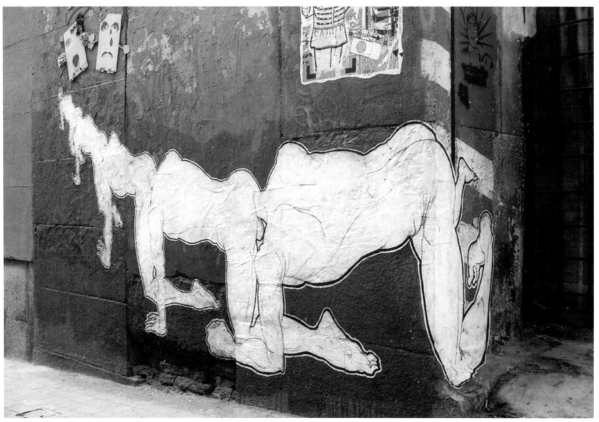

*Madrid, Spain · 2010*

*Barcelona, Spain · 2010*

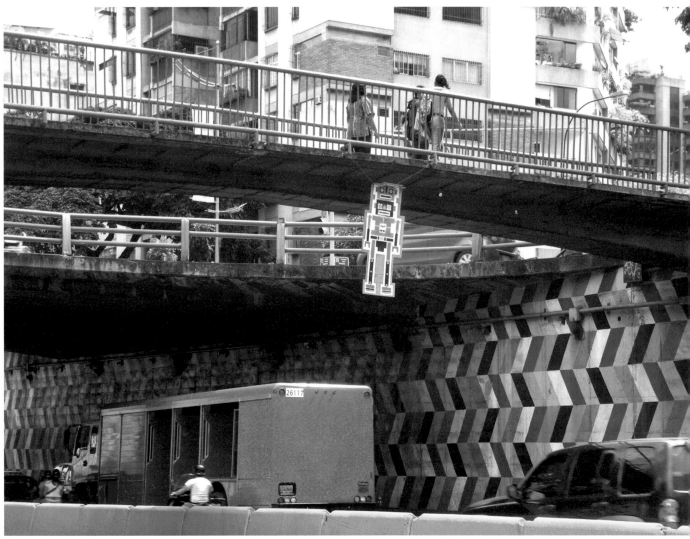

Caracas, Venezuela · 2010

# FLIX

————————— *Intervening in urban spaces with various methods, I try to interrupt the gray monotony shrouding the lives of the city's inhabitants. Urban space is the scenery upon which we play out our little stories. I'm interested in creating interventions that break through the psyche of passers-by, awakening emotions and worries made evident by the paradoxes and absurdities of daily situations.* ———

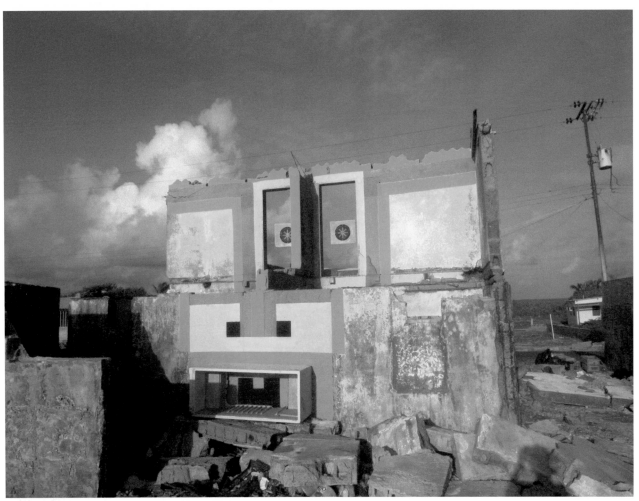

*Paraguaná, Venezuela · 2010*

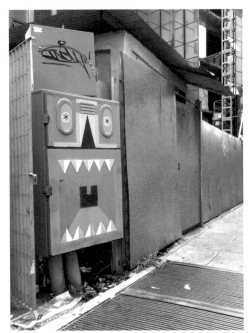

*Caracas, Venezuela · 2010*

*To Léon*

*NUEVO MUNDO · Latin American Street Art*

Edited by Maximiliano Ruiz
Text by Maximiliano Ruiz

Cover and layout by Isaac Gimeno
Cover photography and work by Selon

Project management by Julian Sorge for Gestalten
Production management by Martin Bretschneider for Gestalten
Proofreading by Bettina Klein
Printed by Druckerei Grammlich, Pliezhausen
Made in Germany

Published by Gestalten, Berlin 2011
ISBN 978-3-89955-337-6

For more information, please visit *www.gestalten.com*

Bibliographic information published by the Deutsche Nationalbibliothek.
*The Deutsche Nationalbibliothek lists this publication in the Deutsche Nationalbibliografie; detailed bibliographic data is available online at http://dnb.d-nb.de.*

*None of the content in this book was published in exchange for payment by commercial parties or designers; the inclusion of all work is based solely on its artistic merit.*

*This book was printed according to the internationally accepted ISO 14001 standards for environmental protection, which specify requirements for an environmental management system.*

*This book was printed on paper certified by FSC®, which ensures responsible paper sources.*

**Mixed Sources**
Product group from well-managed
forests and other controlled sources
www.fsc.org  Cert no. IMO-COC-028001
© 1996 Forest Stewardship Council

*Gestalten is a climate-neutral company and so are our products. We collaborate with the non-profit carbon offset provider myclimate (www.myclimate.org) to neutralize the company's carbon footprint produced through our worldwide business activities by investing in projects that reduce $CO_2$ emissions (www.gestalten.com/myclimate).*